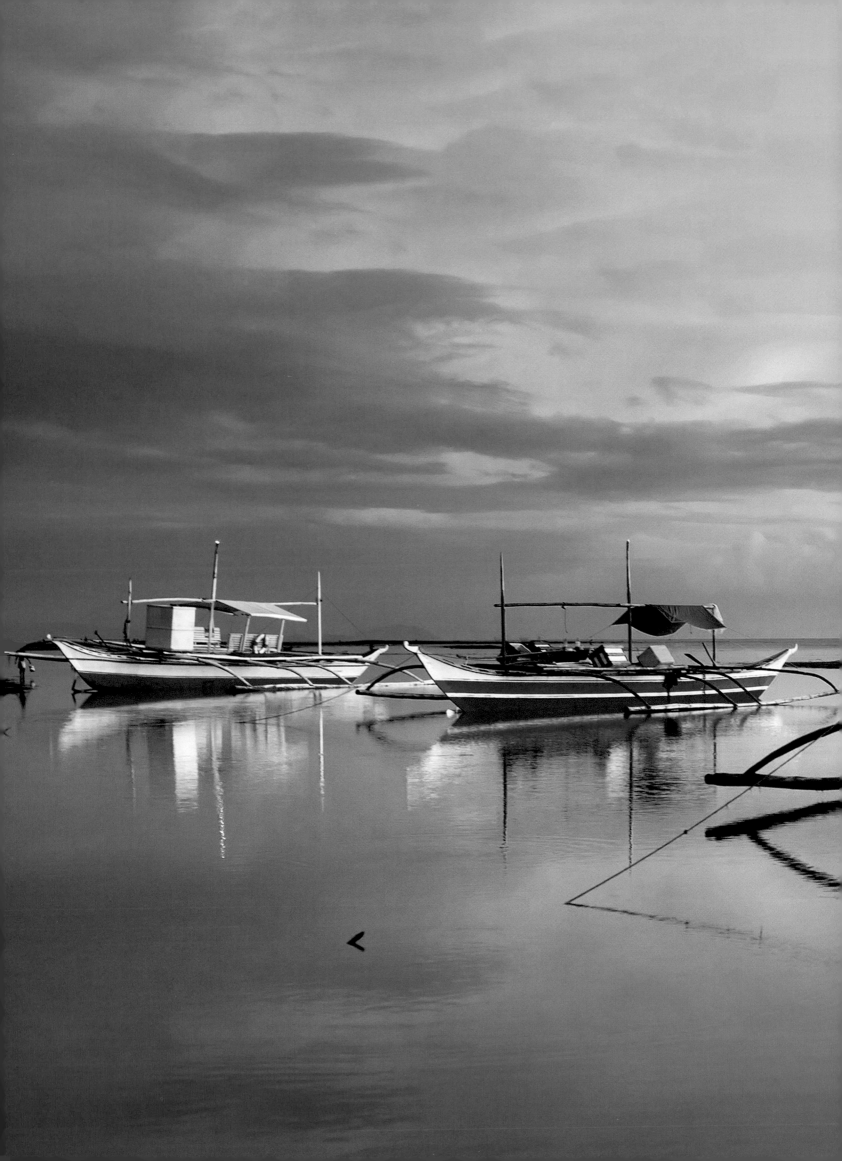

JOURNEY THROUGH THE
PHILIPPINES

An Unforgettable Journey from Manila to Mindanao and Beyond!

Kiki Deere

TUTTLE Publishing
Tokyo | Rutland, Vermont | Singapore

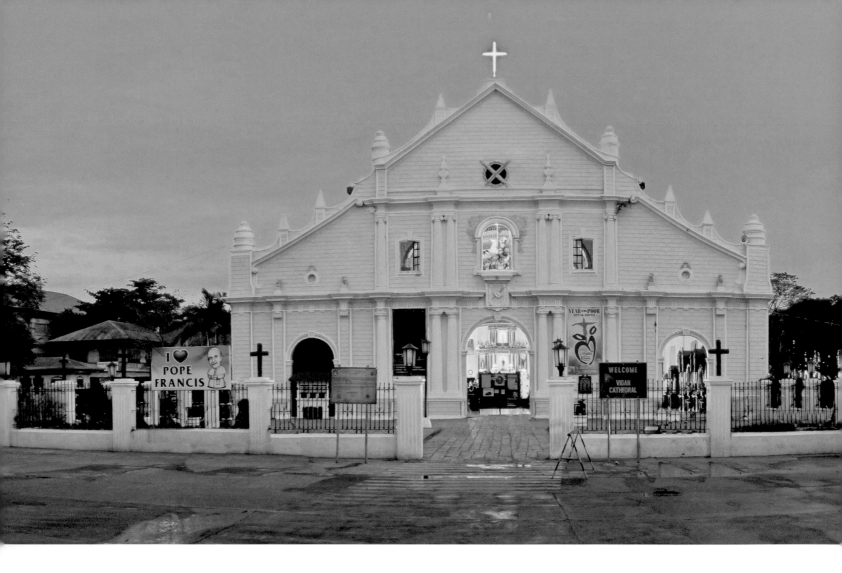

CONTENTS

PART TWO: EXPLORING THE PHILIPPINES

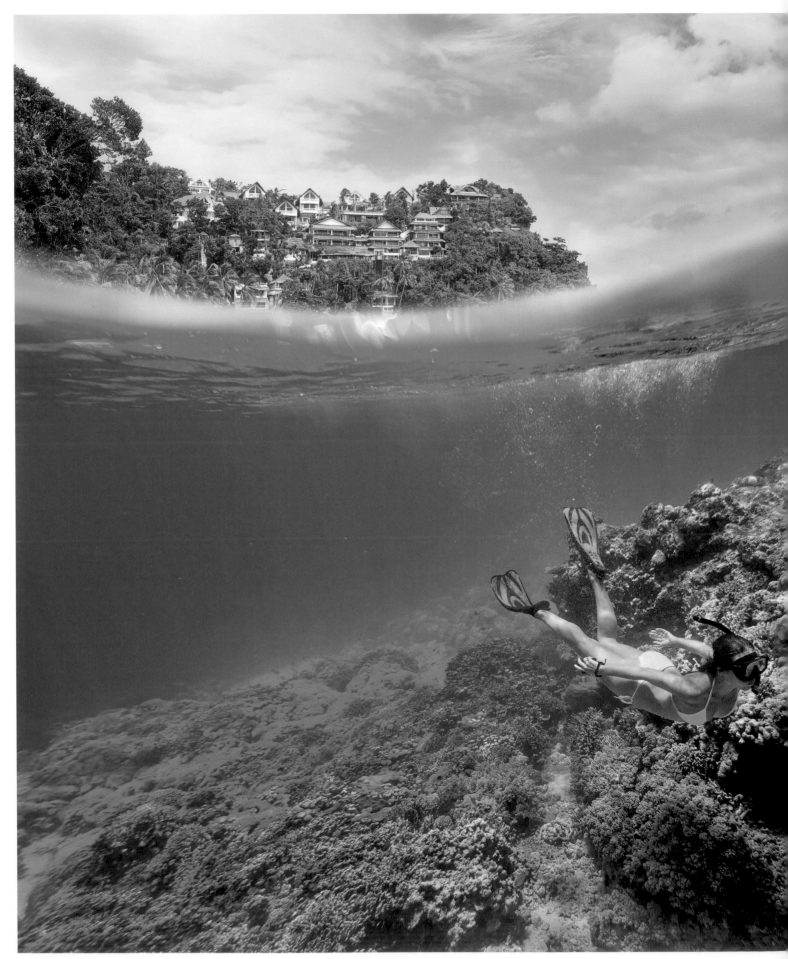

INSIDE FRONT COVER Mount Mayon is the highest point of the Bicol region and the Albay province. **HALF TITLE** The sun sets in El Nido in Palawan, bathing the sky in gentle hues of yellow and red.

TITLE PAGE Traditional Philippine outrigger boats called *bangkas* reflect in the calm waters of the sea. **CONTENTS PAGE** The cathedral of the colonial city of Vigan was built in earthquake baroque style.

BELOW With its crystal clear waters and pristine coral reefs, the Philippines offers exceptional snorkeling and diving opportunities.

OPPOSITE PAGE, BOTTOM Mount Mayon is one of the country's most active volcanoes; it has erupted over 40 times.

ISLANDS OF AMAZING DIVERSITY

Often underrated by travelers, the Philippines is an enticing location offering incredibly diverse landscapes. Home to bubbling volcanoes, jungle-clad peaks and some of the best diving in the world, there's a great deal on offer to suit all tastes.

Comprising 7,107 islands, the Philippines is Asia's second largest archipelago, after Indonesia. The diversity of the country is astonishing: from powdery white sand beaches framed by limestone formations to 2,000-year-old UNESCO-listed rice terraces, there is plenty to keep visitors occupied for months on end. Given the time involved in traveling from island to island, the best way to explore the archipelago is by air.

Most trips to the Philippines start in the chaotic capital of Manila, a major transport hub and gateway to the country's innumerable islands. There are plenty of sights outside the city, including the gorgeous Lake Taal, a crater lake with Taal Volcano sitting right at its center. To the north of Manila is northern Luzon, home to spectacular mountain scenery and

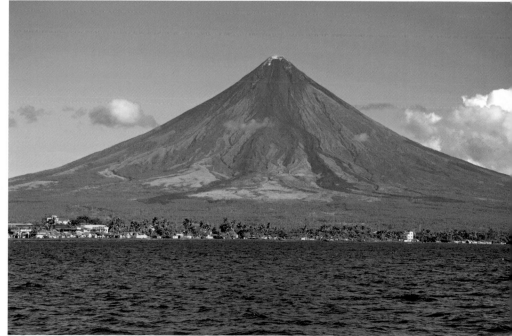

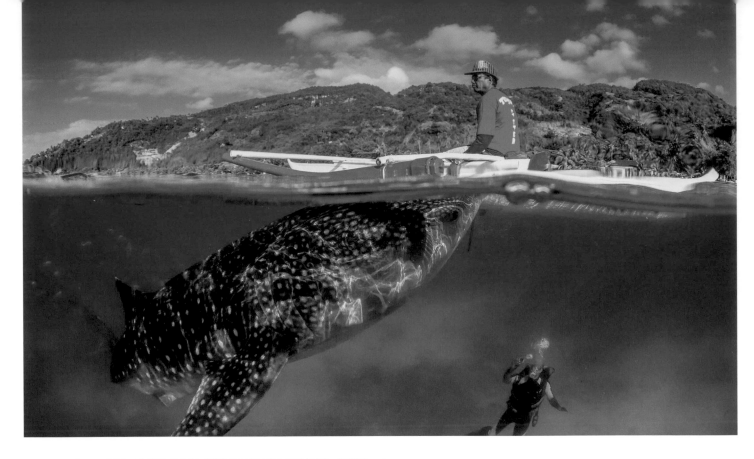

cooler climes than in the lowlands. In Banaue it is possible to trek through awe-inspiring rice terraces, while the UNESCO-listed town of Vigan offers a glimpse of life during Spanish colonial times.

To the south of the capital is the Bicol region, home to the country's best known volcano, Mount Mayon, which is said to have the world's most symmetrical cone. The town of Donsol is one of the few places in the world where you can swim with whale sharks. Many visitors opt for the spectacular white-sand beaches and crystal-clear waters of the Visayas, at the heart of the archipelago. Boracay is probably the region's best-known island, although there are hundreds more, providing a wealth of activities, including snorkeling and diving. The rugged island of Mindoro, just a few hours south of the capital, offers some of the country's best diving.

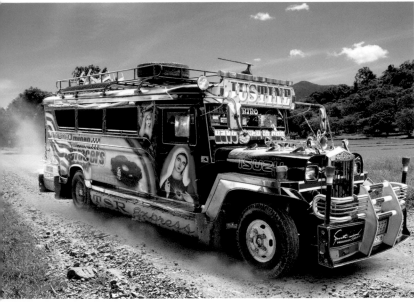

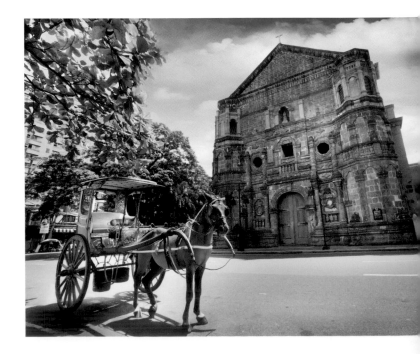

TOP The Philippines is one of the few countries in the world where it's possible to swim with whale sharks.

ABOVE The country's much-loved mode of transport, jeepneys are decorated with splashes of brightly colored paint.
RIGHT A horse-drawn carriage waits for customers outside Manila's Malate Church.

Resilient Roots

Named after King Philip II of Spain, the Philippines is the only country in Asia that was colonized by the Spanish, and is today a blend of Malay, Chinese, Spanish and American influences. The first humans are thought to have migrated from Borneo to Palawan in southwestern Philippines during the Ice Age; the Aeta, also known as Negritos, are said to have descended from these migrants. Tribal groups in the Cordilleras settled in northern Luzon around 500 BC, while Malay peoples from nearby Indonesia and Malaysia put down roots in the Visayas and southwestern Luzon. Recently discovered Chinese shipwrecks suggest that ties with China were extensive by the 10th century.

During contact with Arab traders, Sufis and missionaries came to the islands to spread Islam. Following the Spaniards' arrival in 1521 and the subsequent establishment of the Spanish capital at Manila in 1564, friars commenced spreading Catholicism and building churches throughout the country. To this day 83 percent of Filipinos are devout Roman Catholics, and churches are found in even the remotest of villages. Islam continues to be practiced in Mindanao.

Following a number of revolts by intellectuals who sought independence from the Spanish crown, war broke out between the United States and Spain in 1898. Filipinos continued to fight for independence during the Philippine–American War (1899–1902), but the Americans retained control over the islands, and the Philippines became an American colony. As part of the Benevolent Assimilation Proclamation, the Americans built schools throughout the archipelago. The country soon had Southeast Asia's highest literacy rates, and Filipinos learnt to behave, eat and speak

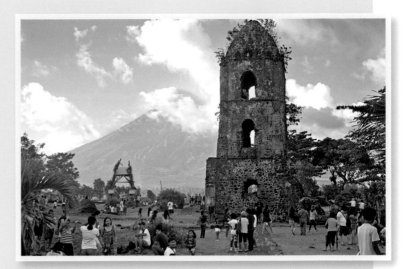

ABOVE Buried by the eruption of Mount Mayon in 1814, the Cagsawa Ruins are today a major tourist attraction offering pretty views of the surrounding rice paddies.

LEFT A statue of King Philip II of Spain that sits in the Plaza de España in Manila.
RIGHT The Heritage Monument of Cebu recounts the history of the island through a series of dramatic sculptures.

like Americans. Together with Tagalog, English is today the official language of the Philippines, making it particularly easy for Westerners to communicate with the locals.

The Philippines eventually gained independence from the United States on July 4th 1946. Since then the country has been through numerous political ups and downs. The country's most notorious politician is probably Ferdinand Marcos, who was renowned for his lavish spending and is estimated to have plundered US$10 billion from the country. Despite recent economic gains and efforts to reduce poverty, the Philippines remains one of the world's poorest nations.

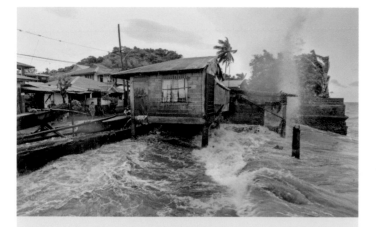

The Tyrant of the Pacific

Known in the Philippines as Typhoon Yolanda, Typhoon Haiyan was one of the strongest cyclones ever to hit the planet. With winds of up to 196mph (310km/h), it struck the southeastern Philippines in early November 2013, causing irreparable damage. Entire villages were wiped out in the Visayas, Negros, Cebu, Iloilo and Capiz. The city of Tacloban in Leyte was one of the worst hit. Over 6,000 people were killed, nearly 2,000 reported missing, and thousands displaced across the area. Boats and crops were destroyed. With coastal populations relying on fishing and coconuts as their primary sources of income, people were reluctant to move inland. Houses were rebuilt in the same areas using similar materials, which means coastal populations remain at risk. Aid agencies poured in to help rebuild the country, but the scars are still visible years later. International agencies and the local government continue to work across the typhoon-affected region to help build resilience against future disasters.

TOP AND BELOW In November 2013 Typhoon Haiyan swept through the country, razing entire villages to the ground and killing thousands.

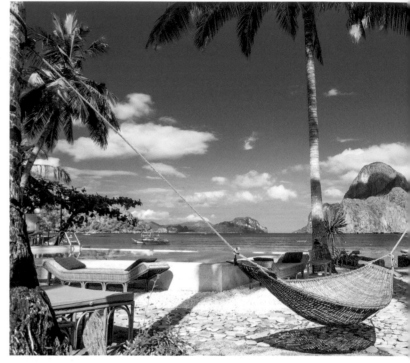

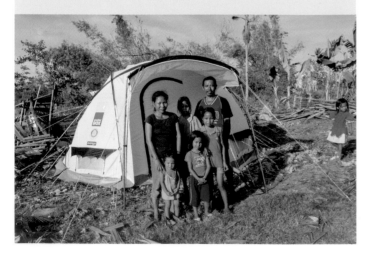

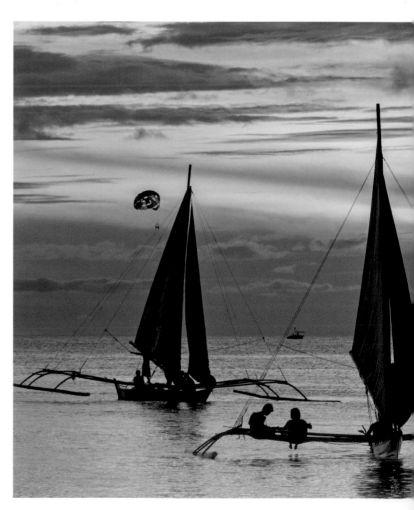

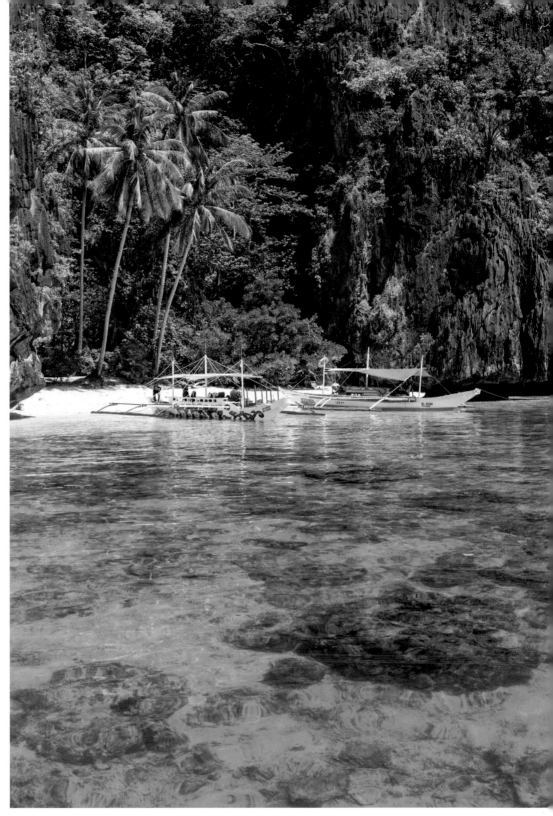

LEFT Relaxing in a hammock on a tropical beach is one of the highlights of any visit to the Philippines.
BELOW Sailing at sunset on Boracay Island, the country's premier tourist destination.
RIGHT The crystal clear waters of El Nido, Palawan, are fringed by limestone formations carpeted in thick vegetation.

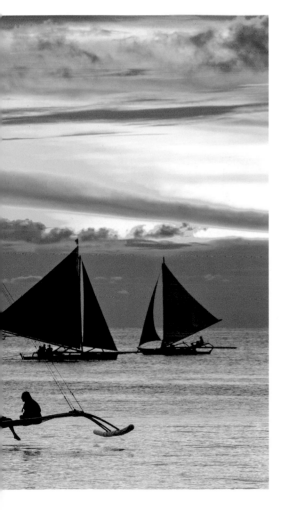

In the far south of the country, Mindanao attracts the most avid surfers for its annual Siargao Surfing Cup, although the western side of the island remains largely off-limits due to Muslim separatist unrest.

To the west of the archipelago is Palawan, a largely wild and unspoiled island. The Bacuit archipelago comprises incredible limestone formations jutting out of crystal clear waters. The best time to visit is between November and April, during the dry season. The wet season, from May to October, brings high humidity and typhoons, with flights and ferries often canceled. In a country battered by an average of twenty typhoons a year, Filipinos have the extraordinary ability to smile and remain optimistic in the face of disaster.

EXUBERANCE, HOSPITALITY AND DEFERENCE

Undoubtedly one of the world's friendliest peoples, Filipinos are renowned for their warm hospitality. The Philippines is probably Asia's most Westernized nation, largely as the result of more than three centuries of Spanish and American rule; people wear Western clothes, speak English and practice Catholicism. But underneath this Western veneer, age-old traditions are still very much alive.

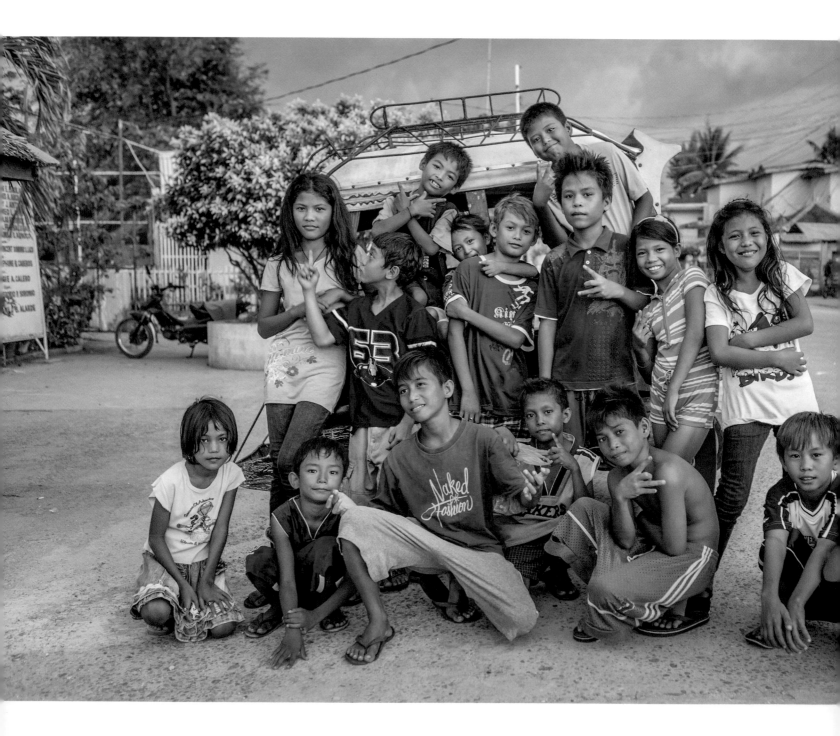

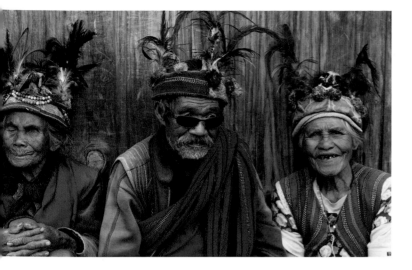

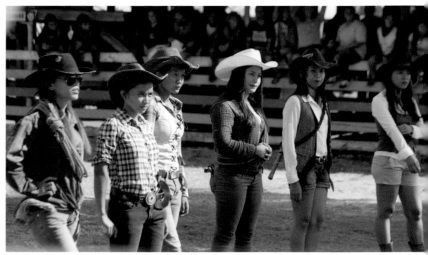

ABOVE The Ifugao people of the Cordilleras.
ABOVE RIGHT "Cowgirls" line up during a rodeo festival featuring cattle wrestling as part of the 103rd Anniversary and Alumni Homecoming of Central Mindanao University in Musuan.
LEFT A group of Filipino children pose for a photo.
BELOW Street performers pose in traditional dress at Manila's annual Aliwan Fiesta, which showcases the country's Filipino cultures and heritage.

Filipinos are known to be exceptionally friendly and approachable. Don't be intimidated or offended if a stranger quizzes you about your personal life. Filipinos are often intrigued by foreigners and don't feel shy about asking personal questions. They are a gentle, kind-hearted people who do not respond well to shouting or anger, and find it difficult to say "no". "Yes" can variously mean "yes", "no" or "maybe". This can cause much frustration among Westerners, although it is simply the result of Filipinos' innate desire to please those around them. They dislike broaching awkward subjects for fear of losing face. Failure to be sensitive, disagreeing with others and getting angry in public can cause *hiya*, or deep shame.

One of the most admirable qualities of Filipinos is their ability to always smile and be positive in the face of calamity. Filipinos show their respect by using the Tagalog honorific "*po*" ("sir" or "mam") when addressing others. "*Po*" is often added at the end of sentences when speaking to someone who is older or of higher social rank.

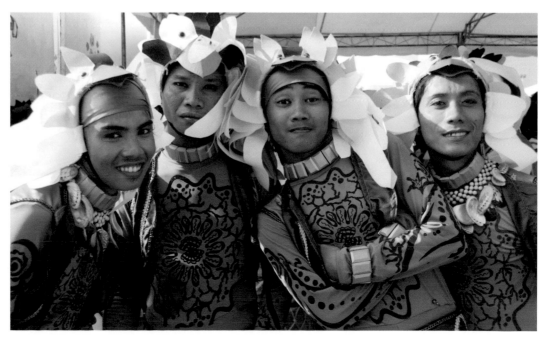

Asia's Bastion of Christianity

Home to 86 million Christians, the Philippines is the fifth largest Christian country in the world and is Asia's only Catholic nation along with East Timor. Following the Spanish conquest of the archipelago in the 16th century, Catholic missionaries spread Christianity throughout the islands. In the tribal heartland of the Cordilleras ethnic groups avoided Spanish annexation largely thanks to their remote location. Over time the faithful integrated pre-Hispanic beliefs with Catholic rites and rituals, resulting in a syncretic religion known as Folk Catholicism. A good example of this practice includes venerating saints that are not recognized by the Catholic Church, and praying to animist spirits for abundant harvests.

Processions, fiestas and Catholic rites like All Saints Day, Holy Week and Christmas are rigorously observed and are official public holidays. In recent years, new Catholic movements such as El Shaddai, along with Protestant movements, including Jesus Lord Church and Iglesia ni Cristo, have spread across the country.

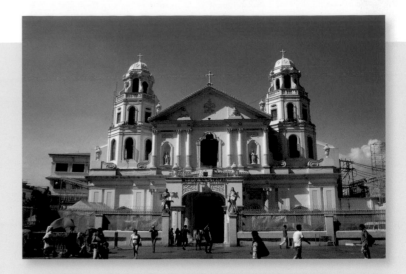

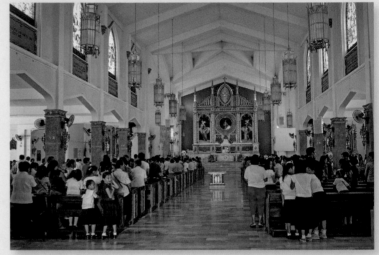

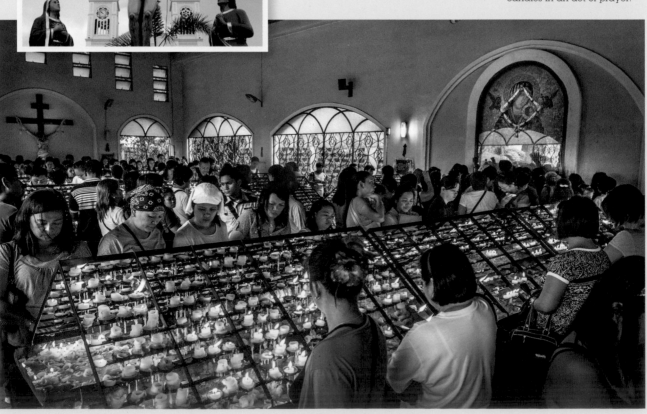

ABOVE Filipino families attend Mass at the Santo Niño Parish Church in Tacloban City, Leyte Island.
LEFT A statue of Jesus Christ outside Baguio City's rose-colored Our Lady of the Atonement Cathedral.

TOP Manila's Minor Basilica of the Black Nazarene, colloquially known as Quiapo Church, houses the Black Nazarene, an ebony statue of Jesus Christ believed to be miraculous.
BELOW Men and women light votive candles in an act of prayer.

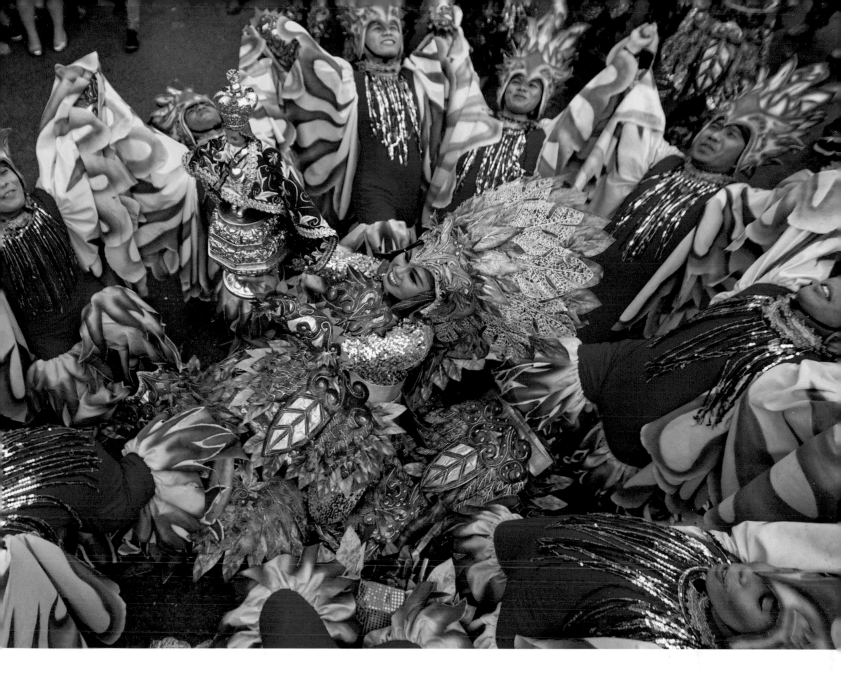

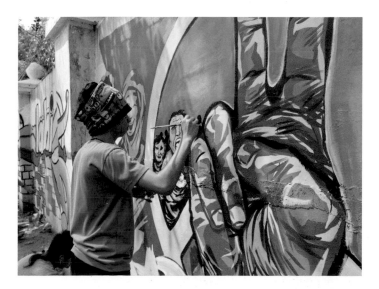

TOP Cebu's Sinulog Festival is held in honor of the Santo Niño, or Baby Jesus, with a grand parade featuring boisterous celebrations and vibrant costumes.

ABOVE A young man paints a street mural in Manila, said to be the world's longest peace mural spanning 2.35 miles (3.77km).

Customs and traditions vary widely across the archipelago. Life in the frenetic capital differs hugely from village life, where houses are traditionally constructed of *nipa* (palm tree). In Batanes, a cluster of islands to the far north that forms the remotest province of the country, houses are built of stone to withstand the destructive force of typhoons. The Spanish influence on Philippine architecture is evident in provincial areas, where colonial plazas dominated by Spanish brick churches lie at the heart of most towns. Over 80 percent of Filipinos are devout Roman Catholics, while Sunni Islam is practiced in Mindanao.

The Cordillera Mountains in northern Luzon form the tribal heartland of the country, with dozens of ethnic groups maintaining age-old traditions and beliefs. More and more youngsters are migrating from rural areas to the cities because of better job prospects and an improved quality of life, with less and less young people willing to work in agriculture.

Filipino families are close-knit, with extended families often living together. It is not unusual for single aunts, uncles and grandparents to live with other family members, and nephews and nieces are often referred to as one's own children. Families always gather together to celebrate important holidays, birthdays and anniversaries, with Sundays usually a time for extended families to meet.

The Filipino diaspora is one of the largest in the world, with around a million Filipinos leaving the country every year to work abroad as nurses, engineers, teachers and domestic helpers. Remittances pour in, helping keep the country afloat, with many families relying on their relatives abroad to support them.

The country has two official languages: Filipino and English. The former, based on the Tagalog dialect from Luzon, is used to communicate among ethnic groups. Foreign words have been adapted into Filipino over time, and it's not uncommon to hear English or Spanish words sprinkled in everyday speech. There are seven other languages that are widely used in the archipelago, including Cebuano and Bicolano, along with over 176 local dialects. As a result of American colonization, American English is taught in schools and is the preferred language for print and broadcast media, business, movies, courts and government administration. The majority of Filipinos are bilingual, and can read, write and speak fluently in English.

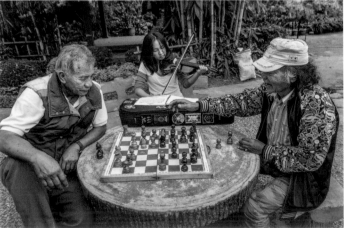

ABOVE MIDDLE, RIGHT Miss Philippines 2013 joins the annual Santacruzan, also known as Flores de Mayo, a religious festival and beauty pageant.
RIGHT Two men enjoy a game of chess as a young woman plays the violin in Burnham Park, Baguio City.

TOP A dancer at Cebu's Sinulog Festival carries a figurine of the Santo Niño, or Baby Jesus.

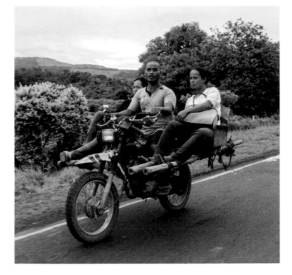

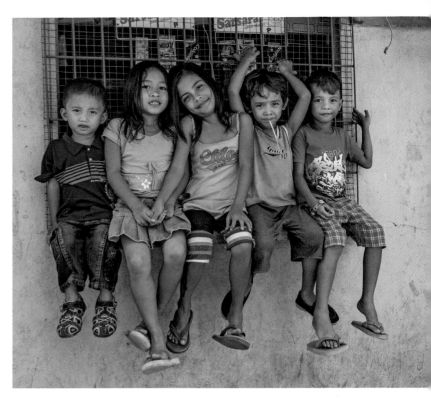

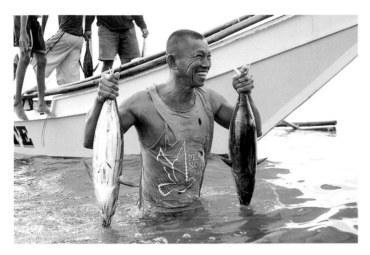

TOP LEFT A driver and his passengers on a *habal habal*, a motorbike with seats extended sideways, often used as a taxi service in areas with steep, narrow roads.

LEFT A fisherman returns from a successful early-morning fishing trip.

ABOVE Filipino children pose for a photo outside a *sari-sari* convenience store.

Blood Sport

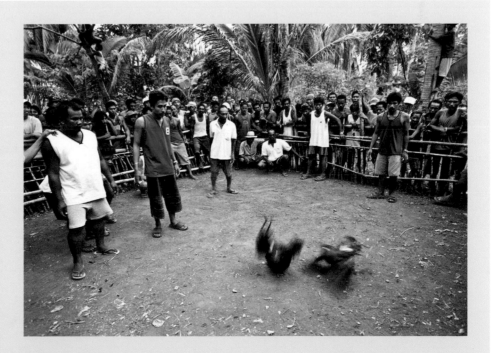

Sabong, or cockfighting, has a long history in the country. It had been a part of daily life long before the Spaniards arrived in the Philippines in 1521. It is today a favorite national pastime, and is commercially one of the biggest industries in the country. With over 2,500 cockfighting pits in the Philippines, the sport kills 30 million roosters every year. Birds are bred to fight from a young age, with trainers helping develop and strengthen the muscles on their wings. During fights roosters wear sharp, dagger-like knives on their limbs in order to maim and kill their opponent. In the arena all are equal: millionaires mingle with common folk, and losing is not taken lightly—seeing one's rooster die in battle is seen as a loss of one's manhood.

ABOVE Cockfights are the country's most popular sport, drawing in huge crowds.

A NATION-WIDE OBSESSION

Food has tremendous importance for Filipinos. Eating fewer than three meals a day (plus snacks in between) is seen as unnatural. Filipino food is not well-known outside the country, but is actually one of Asia's most exciting cuisines—with plenty of variety, from simple grilled dishes to complex stews and delicious desserts. Trade and colonialization have resulted in Malay, Chinese, Spanish and American influences.

Filipinos will assume you're unwell if you don't partake in all five daily repasts. In between the three daily meals *merienda* (a snack) is eaten. Nearly a meal in itself, it consists of rice and other staples, along with a selection of sweet courses. There are no knives—spoons are used instead.

Steamed rice forms the basis of each dish, often accompanied by grilled fish and vinegar sauce. Seafood, including squid, crab and prawn, is particularly good, and readily available in most coastal areas. *Sinigang*, a delicious tamarind-based soup, features on most menus, while *pancit* (Chinese noodles) are also very common. Fried or barbecued chicken is another key staple, along with the ubiquitous pork. *Adobo* is the country's national dish: a dish of pork or chicken stewed in soy sauce, garlic, bay leaf and black pepper. *Lechón*, roasted suckling pig, is enjoyed on special occasions.

One of the delicacies in Mountain Province in northern Luzon is *pinikpikan*, a chicken dish whose name translates as "killing me softly". The chicken is beaten slowly with a stick until it dies; the blood rises to the surface, allegedly making the meat more tender.

The Bicol region in southern Luzon is famed for having some of the best cuisine in the country, with chili peppers and coconut milk featuring heavily in most dishes. The popular Bicol Express, named after a passenger train service from Manila to Bicol, consists of pork cooked in coconut milk, soy and vinegar with chilies. Another popular *bicolano* dish is *laing*, made with taro leaves simmered in coconut cream and served with chili peppers.

Vegetables do not feature as part of the main meal, and are often served as a side dish. Tropical fruits are available year-round, including durian, jackfruit, mangosteen, pineapple, bananas, sugar apple, watermelon and juicy mangoes, said to be the sweetest in the world.

Today, fast-food restaurants are ubiquitous (Jollibee is one of the most popular chains), and Coca-Cola is now consumed widely, a legacy of the American occupation.

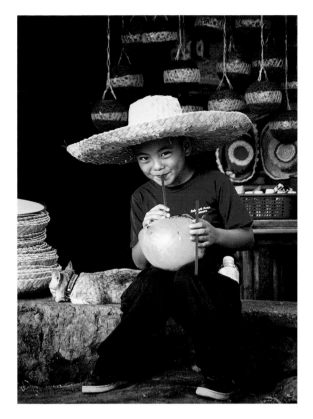

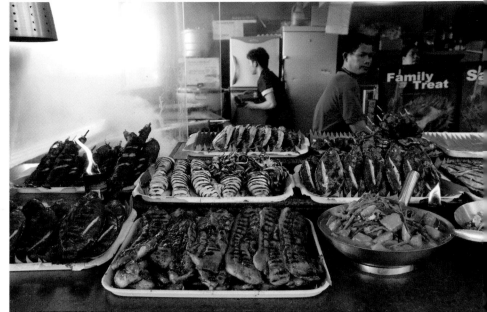

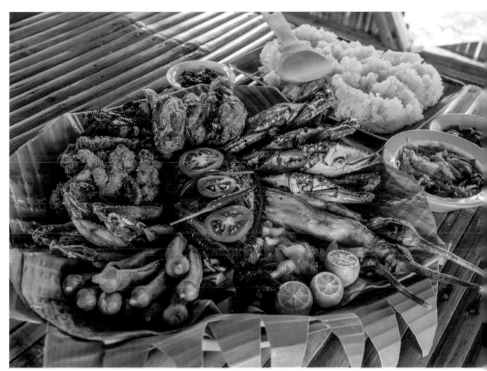

ABOVE A young boy wearing a *sombrero* enjoys a refreshing coconut drink.

ABOVE RIGHT An assortment of foodstuffs at a street market in Taguig City, Manila.

RIGHT In coastal areas seafood is often served on a banana leaf platter accompanied by a side of rice.

BELOW Children inspect *lechón*, roasted suckling pig that is a national delicacy.

BELOW RIGHT A street food vendor lovingly prepares steamed corn on the cob at Mines View Park in Baguio.

OPPOSITE BOTTOM, LEFT Street food is popular among Filipinos at all times of day.

OPPOSITE BOTTOM, RIGHT A woman sells an assortment of foodstuffs at a stall in Antipolo in Rizal province.

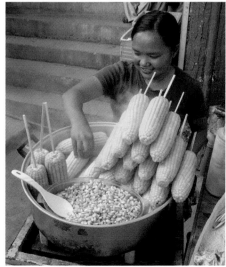

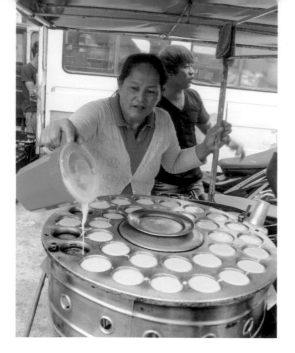

LEFT A woman pours batter into individual cups as she prepares pastries.
BELOW Sundays see extended families gather together to enjoy one another's company and feast on all manner of local dishes.

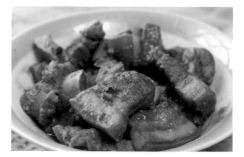

ADOBO PORK
Considered to be the country's national dish, *adobo* is made with pork (as above) or chicken.

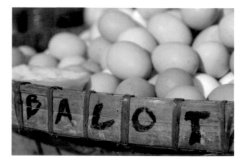

BALUT
Balut, a national delicacy, is traditionally sold as street food.

HALO-HALO
Made of shaved ice, evaporated milk and a motley of toppings, *halo-halo* is often enjoyed as a refreshing mid-afternoon snack.

Filipino breakfast consists of *longganisa* (sausage), *tocino* (cured pork), and corned beef, while fruits, eggs and toast are also available in most hotels and restaurants. Street food typically includes deep fried or grilled meats or fish, often served on sticks—chicken feet and pig intestine are among the highlights.

The most popular snack is undoubtedly *balut*, partially boiled duck embryo. Typically sold by roadside vendors, it is allegedly an aphrodisiac—and not for the faint-hearted. The egg is cracked open and the salty broth (embryonic fluid) enjoyed before munching through the semi-developed egg. The veins, partially compressed beak and little wings are often visible, and it's not uncommon to feel a brush of soft feathers as it slides down your throat. The egg is sometimes seasoned with salt, chili, garlic and vinegar. Rich in protein and cysteine, an amino acid that protects and breaks down toxins in the liver, it is said to be the ultimate hangover cure.

The nation's most-loved dessert is the colorful *halo-halo*, a refreshing blend of shaved ice, evaporated milk and various toppings, including sweet beans, fruits and jello. Ice cream is very popular too, along with *leche flan* (caramel custard) and *polvorón*, a shortbread made with flour, sugar and milk.

CHICKEN AFRITADA
This popular dish is made of chicken cooked in tomato sauce with carrots, peppers and potatoes.

SWEET AND SOUR FISH
This local classic is served on a bed of lettuce with cucumbers, carrots and tomato sauce.

LUMPIA
Also enjoyed in nearby Indonesia, *lumpia semarang* is a savory dish of thin pastry stuffed with vegetables and, at times, minced meat.

PANDESAL
An airy bread roll commonly dipped in hot coffee at breakfast time.

GINATAANG ALIMANGO
A deliciously creamy dish of crabs cooked in coconut milk.

PANCIT
Asian noodles were originally introduced by the Chinese and are now available in a number of variations.

LEEG NG MANOK
Grilled or deep-fried chicken neck is a popular type of street food sold on a skewer.

LECHE FLAN
Made of eggs, milk and soft caramel, *leche flan* is typically served at festive occasions throughout the year.

BIBINGKA
Traditionally enjoyed during the Christmas season, *bibingka* is a type of rice cake cooked in clay pots and paired with a variety of toppings, from cheese to grated coconut.

ISAW
A popular street food dish, *isaw* is made from barbequed chicken or pig intestines.

A RICH TRADITION OF CRAFTSMANSHIP

Traditional Filipino arts and crafts including weaving, woodcarving and pottery have a long history that dates back to pre-colonial times. Each region specializes in its own arts and crafts, from woodcarving in the tribal heartlands of the Cordilleras to batik prints and ornate carvings in Muslim Mindanao.

ABOVE A traditional Ifugao mask from the Cordilleras region of northern Luzon.

ABOVE A wooden tribal mask embellished with white motifs. **BELOW** Catholic statuettes and relics are on display outside an antiques shop in the colonial-era city of Vigan.

Before the arrival of the Spanish in the 16th century, the inhabitants of the islands weaved using local fibers such as abaca, cotton and pineapple. Baskets were made to transport and store goods, while grass-woven trays were used to sift rice. Tribal and religious artifacts are sold as souvenirs in the Cordilleras in northern Luzon, while rattan baskets are on display in markets and stores across the country. In Mountain Province, wooden rice gods—small figurines that are placed in rice paddies to encourage abundant harvests and fend off evil spirits—continue to be produced and utilized, along with wooden bowls, wall carvings and wall hangings. Brooms, bowls, baskets and other household products are often made with coconuts and coconut leaves.

The Spanish introduced artistic paintings to the islands, largely in order to spread Catholicism, and it wasn't until the 19th century that secular art first appeared. The university town of Baguio in the Cordilleras has a thriving arts scene, and in recent years has established itself as a magnet for artists. One of its most popular sites is the BenCab Museum, one of the country's best art galleries housing the collection of painter Ben Cabrera, along with permanent displays of Ifugao artifacts and sculptures by contemporary Filipino artists.

The small town of Paete in Luzon is dubbed the "woodcarving capital of the Philippines", with a centuries-old tradition of woodcarving and painting. Skilled artisans produce wooden *bakya*

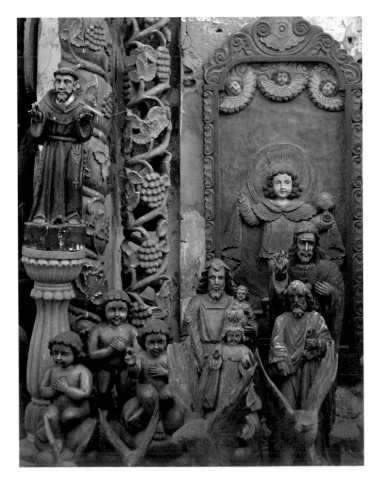

RIGHT Some of the Philippines' finest designers like Kenneth Cobonpue (all except chair) and A. Garcia Crafts (Andres Side Chair) have expanded their collections overseas.

BELOW A skilled craftsman works hard forging knives.

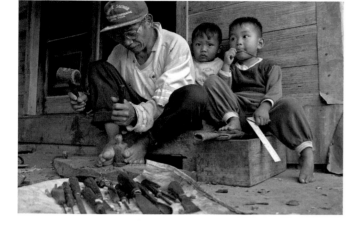

The BenCab Gallery in Baguio

Awarded National Artist of the Philippines for Visual Arts in 2006, Benjamin Cabrera, popularly known as BenCab, is one of the country's foremost contemporary artists. Born in 1942 during the Japanese occupation, BenCab started drawing on pavements and walls at the age of seven. As a schoolboy, he sold illustrations and portraits to his peers, and later went on to study Fine Arts at the University of the Philippines. His artistic career kicked off in 1968, and he spent long spells living in London over the following two decades. His work took on a political angle in response to the repressive regime of President Marcos. In 1986 BenCab settled in the mountain city of Baguio. His state-of-the-art gallery with attached farm and oriental garden on the outskirts of the city is arguably one of the best in the country, housing a collection of primitive wooden sculptures from the Cordillera region along with paintings and sculptures by up-and-coming Filipino artists. In the 1990s BenCab helped found Baguio's Tam-awan Village, a replica tribal village with a small gallery housing temporary exhibitions that attracts local artists.

ABOVE "Dancing at Rock Session" by Benedicto Reyes Cabrera, hailed as a master of contemporary Philippine art.
ABOVE MIDDLE, LEFT A *bulul*, a carved wooden figure traditionally placed in rice granaries to bring a plentiful harvest.
LEFT The modernist BenCab Museum houses temporary exhibitions along with permanent displays showcasing Ifugao artifacts and works by contemporary artists.

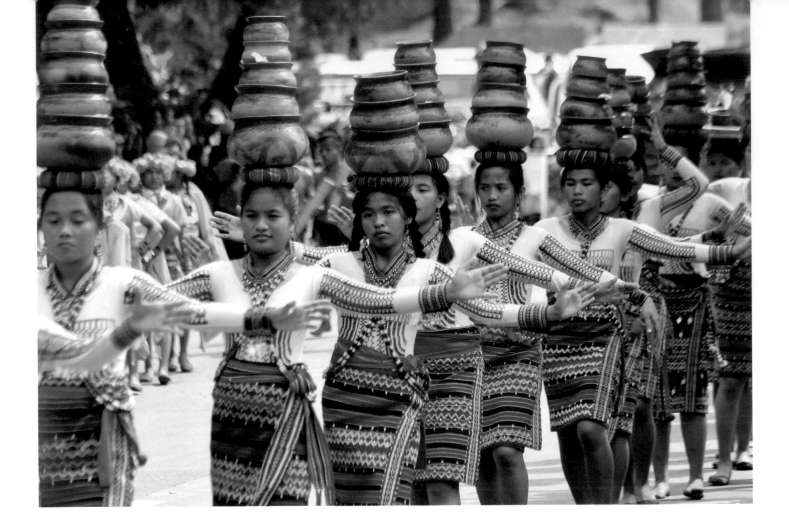

(clogs), religious art and papier-mâché masks that are used during the town's Salibanda Festival that honors the Santo Niño, or Baby Jesus, every January. Handcrafted musical instruments such as guitars, mandolins and ukuleles, can be found in Cebu, while drums and gongs come from Mindanao.

Since the arrival of Muslim traders and missionaries in Mindanao in the 13th century, Islamic art has flourished. Batik clothing rich in geometric and floral patterns was introduced from Indonesia, and textiles are woven using the *ikat* technique. Muslim women wear *malong*, a skirt made of pineapple fiber with two hand-woven silk pieces. Remote tribes on the island produce beautiful accessories and furniture, such as brass jars and wooden chests inlaid with mother of pearl. White, pink and gray pearls are cultivated on farms in Mindanao and Palawan and made into earrings, necklaces and bracelets.

Pottery has long been produced in the Philippines. Centuries ago ceramic jars were used to hold the deceased. Thanks to the favorable qualities of the clay in the Chico river valley, the Kalinga people in the Cordilleras region have for centuries made a living from pottery. To this day households continue to make their own pottery, including cooking vessels, water transport and storage containers for *basi* (sugarcane wine).

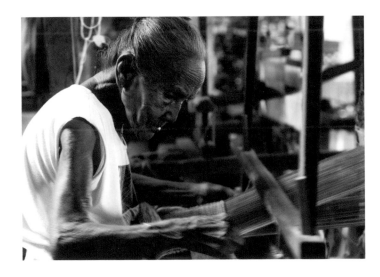

ABOVE MIDDLE, LEFT An elderly woman in northern Luzon concentrates intently as she weaves highland textiles.
LEFT Traditional cloth weaves are made with abaca fiber using natural dyes and threads.

TOP A street parade during Baguio's month-long Panagbenga Festival celebrates the blooming of flowers.

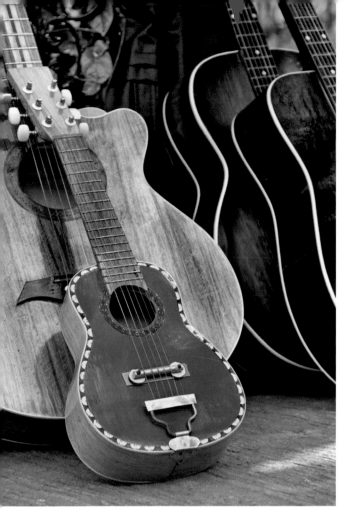

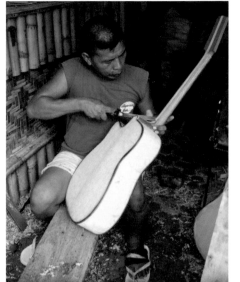

FAR LEFT Guitars from Cebu are traditionally handcrafted.
LEFT An artisan carves out a guitar at the Alegre Guitars Factory in Lapu-Lapu City.
BELOW Handmade clay pots on display at a workshop.
BOTTOM Wooden plates, trays and other tableware are displayed for sale in a shop.

RIGHT AND BELOW A collection of hair accessories, earrings, necklaces and rings designed by Tambourine Jewelry, where the materials are sourced mostly from the Philippines.

LAVISH CELEBRATIONS FILLED WITH SONG, DANCE AND FOOD

As a result of three centuries of Spanish colonial rule and nearly five decades of American colonization, Filipino culture is heavily influenced by Hispanic and American traditions. Hundreds of exuberant Catholic celebrations feature colorful spectacles that embrace traditional songs, dances and lavish feasts.

Fiestas lie at the heart of Philippine culture. There are hundreds of ebullient festivals and raucous celebrations year-round, mostly rooted in Christianity. Often held to commemorate patron saints, they were largely introduced by the Spanish and became a vital means of spreading Christianity to all corners of the country. Today they can be both religious and cultural, with parades, street performers, re-enactments, plays, pageants and contests. Holy Week and Christmas are celebrated with unbridled enthusiasm, with extended families coming together from across the country.

An important day for families is Todos Los Santos, or All Saints' Day, which is celebrated to honor the dead. The entire country comes to a standstill, with Filipinos traveling far and wide to spend the day with their relatives and pay tribute to the deceased. Family members prepare abundant feasts and travel to the cemeteries, gathering around graves and memorials.

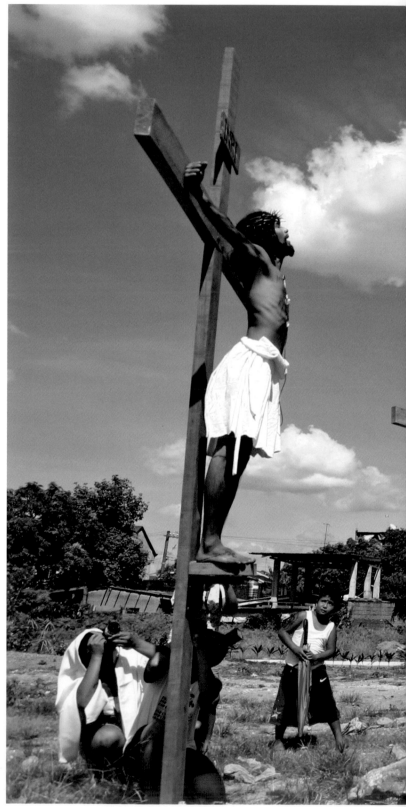

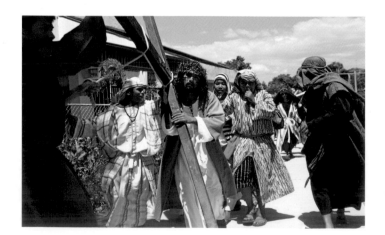

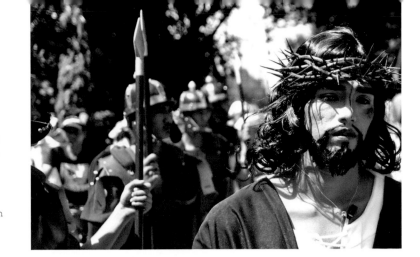

RIGHT A man in Cainta, Rizal, plays the role of Jesus at the Senakulo, a play depicting events from the Old and New Testament.
BELOW Filipinos re-enact the crucifixion of Jesus Christ during Easter celebrations.
OPPOSITE, BOTTOM LEFT Participants at the Senakulo watch a re-enactment of Christ carrying his cross to Golgotha.

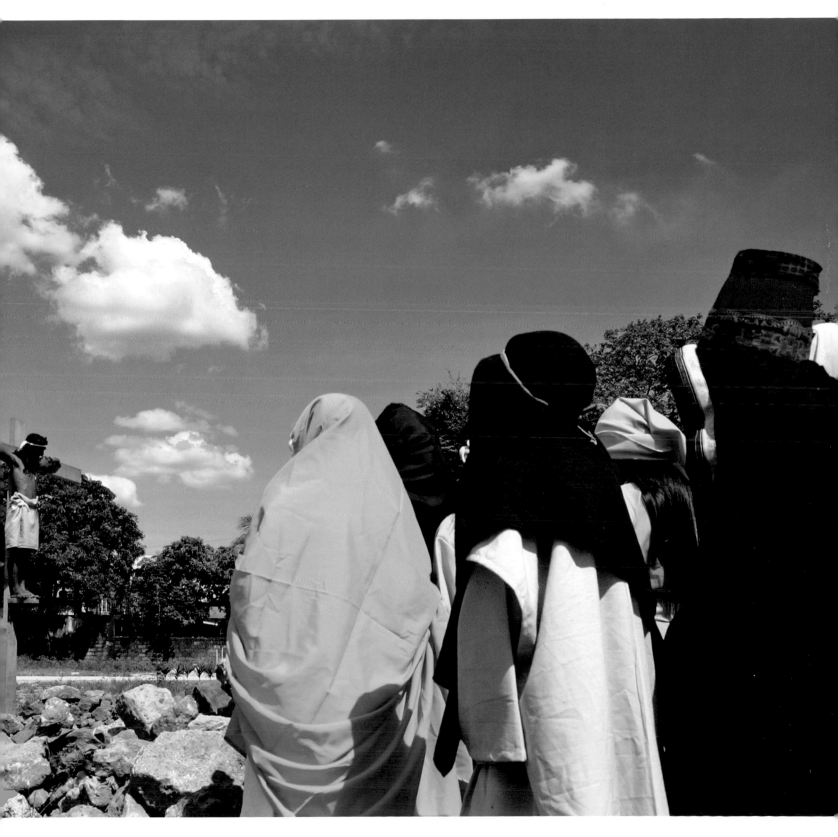

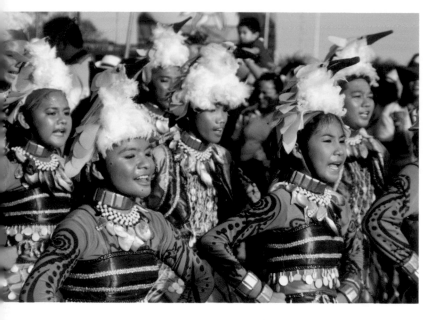

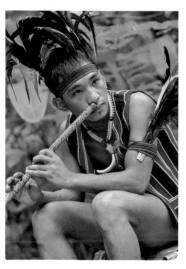

Flowers are arranged and candles lit, and picnic hampers and alcoholic drinks are opened to celebrate and pay respect to those who have passed.

Feast days are sometimes held for two or three consecutive days, with *lechón* gracing the tables, and street parades featuring dancers clad in colorful costumes. Most fiestas are held between January and May, although all *barangays* (districts) in the Philippines put on at least a couple of celebrations a year to commemorate their patron saint. Held in honor of the Virgin Mary, the Flores de Mayo Festival in May is one of the country's largest, along with Kalibo's Ati-Atihan Festival that features street dancing and wild costumes.

Filipinos' friendly disposition is captured in the numerous cultural dances that originate from all corners of the archipelago. Ethnic tribal dances in the Cordilleras feature wooden instruments such as bamboo flutes, while dances in the highlands of Mindanao and the Sulu archipelago embrace Muslim Filipino culture and echo the islands' Arabian and Indo-Malayan influences.

While the country had a rich musical tradition long before the arrival of the Spanish, Catholicism strongly impacted Philippine musical traditions. In the 19th century the piano and European string instruments were introduced. Bands of musicians were formed and began playing at town celebrations. Groups often gathered to form a *rondalla*, a band of stringed instruments played with a plectrum, such as the double bass and twelve-string guitar. During US rule there was a shift to American tunes and songs, and it was only in the 1970s that OPM (original Pilipino music) took off.

ABOVE Participants at the annual Aliwan Festival showcase their culture and traditions.
RIGHT Ifugao man playing a bamboo nose flute locally known as "*kaleleng*". The Ifugao tribe mainly resides in the Cordilleras in Luzon.
BELOW A band of young musicians plays at the Philippine Independence Day Parade in Kawit, Cavite.
BELOW RIGHT A street dancer at the Dinagyang Festival, a religious and cultural event held in Iloilo both to honor the Santo Niño and to celebrate the arrival of Malay settlers.

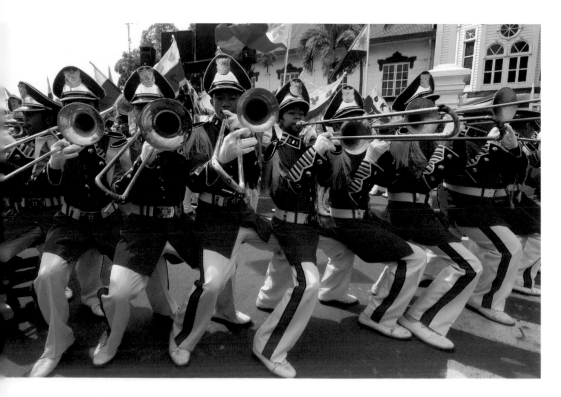

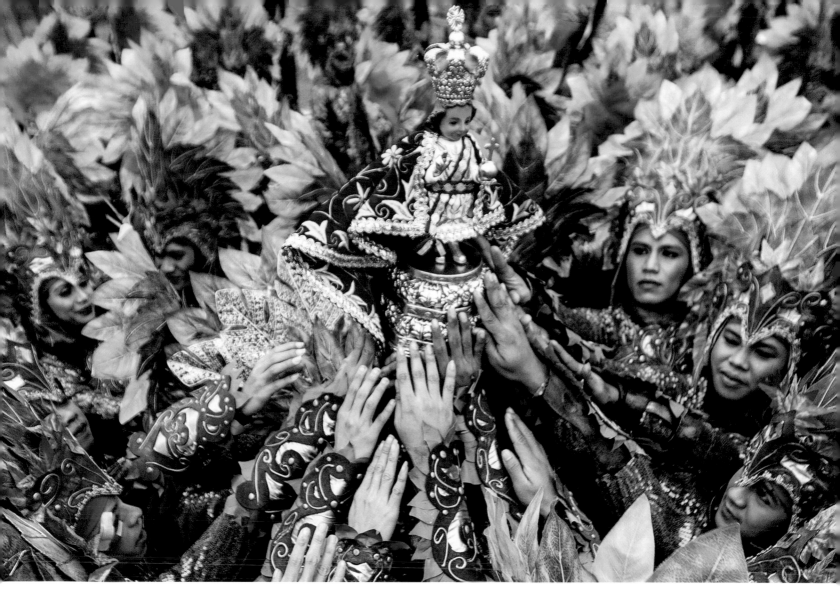

BELOW A marching band carrying percussion instruments sports colorful dress at the annual Ati-Atihan Festival on Boracay Island.

ABOVE Participants at the Sinulog Festival reach out to a statuette of the Santo Niño, or Baby Jesus.
RIGHT A man stands on a large float atop two model lions at the Aliwan Festival, which celebrates the country's diverse cultures.

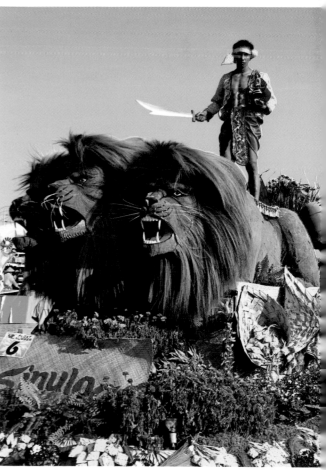

A SPECTACULAR NATURAL DIVERSITY, NOW UNDER THREAT

Comprising over 7,000 islands with a complex geological history, the Philippines is home to some of the world's most spectacular wonders of nature. The diversity of the country is astounding: active volcanoes, limestone formations, white-sand beaches, coral reefs teeming with marine life, jungle-clad peaks, age-old rice terraces—the list goes on.

The Philippines has a plethora of unique biodiversity, with hundreds of endemic species of plants, mammals and birds such as the Philippine Eagle. Once carpeted in lush rainforest, the archipelago is today one of the world's most threatened hotspots, with less than 10 percent of original forest remaining. Lying between the South China Sea and the Pacific Ocean, the country is located on the volcanic Ring of Fire. With over 20 active volcanoes, Mount Mayon in southern Luzon is the most active of all. The Cordillera highlands in northern Luzon rise to about 9,020 feet (2,750m) and, along with the province of Mindanao in the south, have rainforests that are home to dozens of tribal groups.

Constructed over 2,000 years ago, the rice terraces of the Ifugao tribe spread around the Cordillera highlands. Passed down from generation to generation, the terraces are the result of elaborate farming and irrigation systems that use water harvested

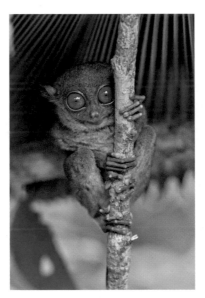

LEFT Tarsiers are strange-looking primates with exceptionally wide eyes that are only found in the islands of Southeast Asia.
OPPOSITE PAGE Clouds envelop the summit of Mount Mayon, while whale sharks are attracted to the waters of nearby Donsol Bay that are rich in plankton and krill.

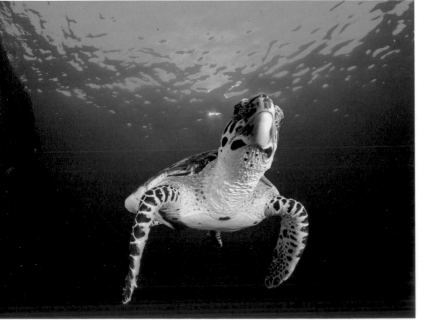

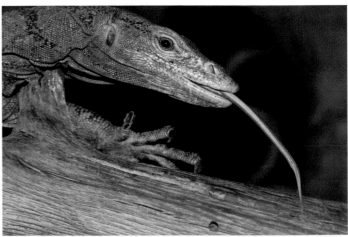

LEFT A hawksbill sea turtle swimming through clear waters; today, these beautiful creatures are critically endangered.

ABOVE Monitor lizards in the Sierra Madre mountain range feed on fruit and can grow to more than 6.5 feet (2m) in length.

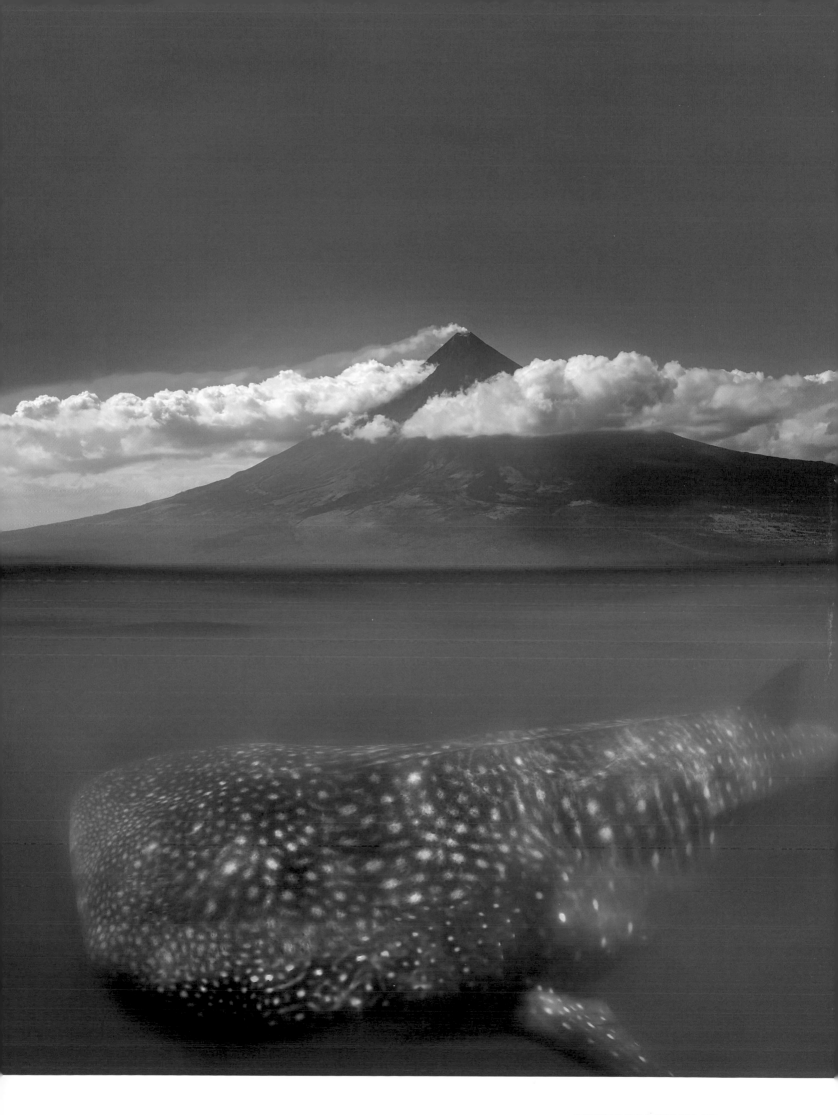

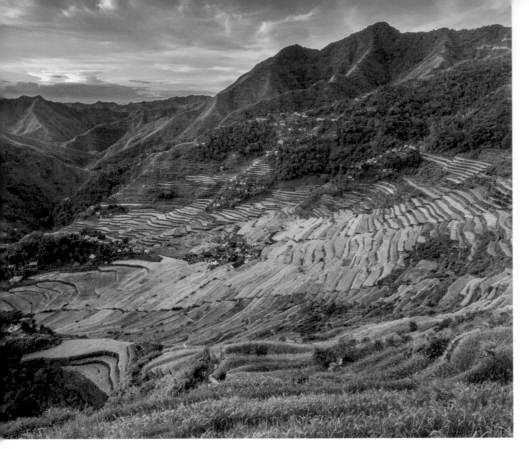

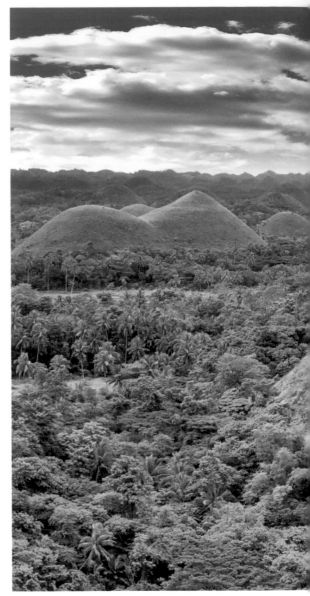

from mountain forests. With their stone and mud walls, they showcase a perfect balance between man and nature.

Batanes, the country's remotest island province, has very little in common with the rest of the country. The topography, language, food and traditions here differ greatly from the mainland. With rugged cliffs and verdant pastureland home to rolling hills and green meadows where horses, buffalo and cattle graze, the islands are reminiscent of Ireland's lush green landscape and jagged coastline.

Among the country's main attractions are the conical-shaped Chocolate Hills of Bohol in the Visayas. Blanketed in green grass that turns brown during the dry season (hence their name), there are between 1,260 and 1,776 dome-shaped limestone hills. West of the Visayas is the island province of Palawan, with

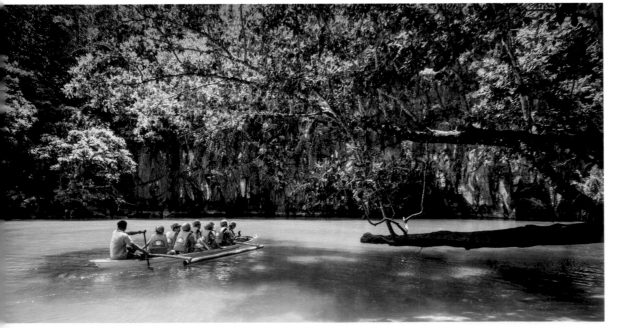

TOP LEFT Designated a UNESCO World Heritage Site, the Banaue Rice Terraces wrap around the mountains of the Cordilleras.
LEFT A group of tourists enter the Puerto Princesa Underground River in Palawan.
ABOVE The dome-shaped Chocolate Hills of Bohol are a remarkable sight.
OPPOSITE PAGE, TOP Tarsiers are so small they can comfortably sit on one's hand.
OPPOSITE PAGE, BOTTOM The entrance to the Tarsier Conservation Area in Loboc, Bohol Island.

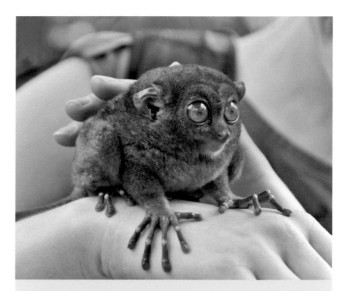

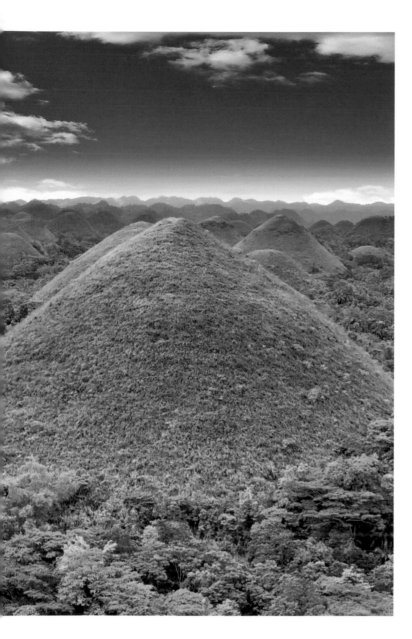

The Tarsier—Man's Smallest Living Relative

No bigger than a human hand, the wide-eyed Philippine tarsier weighs less than 5.3 ounces (150g). It is one of the world's smallest primates, and has the largest eyes of any mammal relative to its body size; each is the size of its brain. It is thought to have existed for 45 million years, leaping and clinging on to trees in the country's forests. It can rotate its head 180 degrees to find its prey and keep an eye out for predators. It feasts on insects and small vertebrates, including bush crickets, lizards and frogs. A nocturnal creature, it is a monogamous animal, keeping in contact with its partner during the night and defending its territory by calling out with high-pitched, bat-like squeals. Tarsiers have an exceptional sense of hearing and are thought to sometimes communicate in ultrasound, allowing them to warn other tarsiers of potential predators, who are unable to detect such frequencies.

awe-inspiring limestone cliffs, underground rivers and caves. The Puerto Princesa Subterranean River National Park comprises an impressive cave system with karst landscapes, home to what is allegedly the world's longest navigable underground river. El Nido in northern Palawan and the nearby island of Coron feature awe-inspiring, 250 million year-old limestone cliffs that jut out of crystal-clear waters. In northern Luzon the Hundred Islands National Park features 124 islands, also formed of limestone.

Underwater lies one of the world's most biodiverse reef systems, with over 1,200 marine life species. Spectacular coral gardens have gorgonian and sponges covering the walls and teem with prolific fish life, including scorpion fish, turtles and sea snakes. Deeper down there are eagle rays, tuna, and white-tip and gray reef sharks. The waters around the sleepy town of Donsol in southern Luzon house one of the world's greatest concentrations of whale sharks. Weighing up to 40 tons, they are harmless creatures despite their size, feeding on plankton and krill.

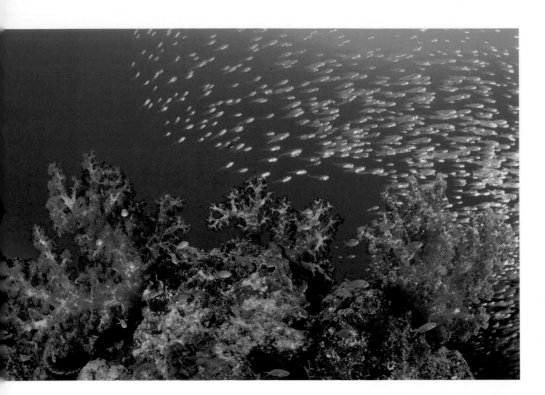

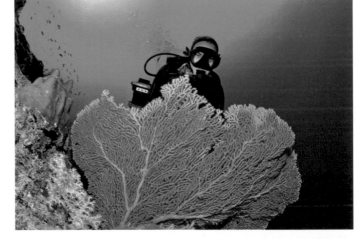

OPPOSITE PAGE, TOP A boat sits off the shores of Maniwaya Island in Marinduque, a heart-shaped island in the province of Luzon.
OPPOSITE PAGE, BOTTOM A waterfall nestles in the forest of Siquijor Island.

ABOVE The Philippines is part of the Coral Triangle, home to over 600 species of coral and 2,000 species of reef fish.
RIGHT A scuba diver poses for a photo while exploring the underwater world.
BELOW A woman diver swims alongside a whale shark, the world's largest fish.

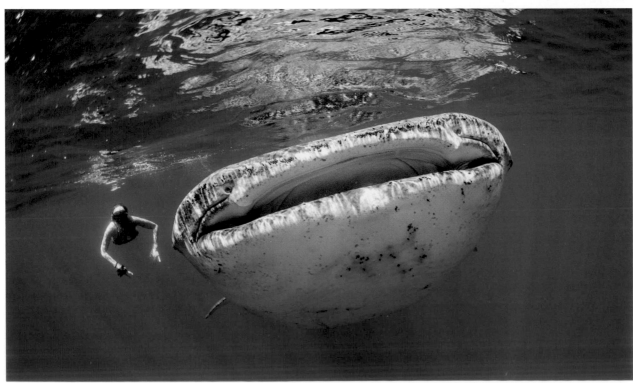

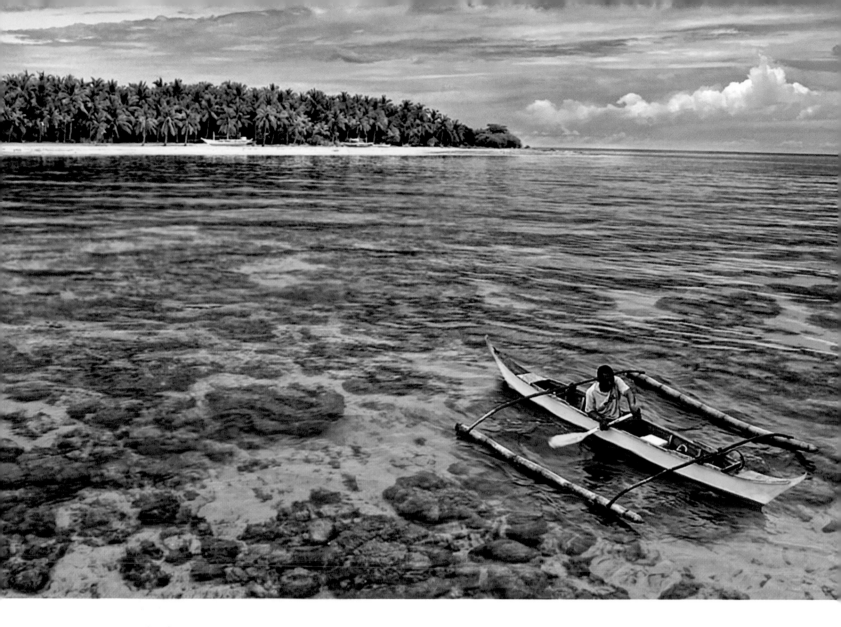

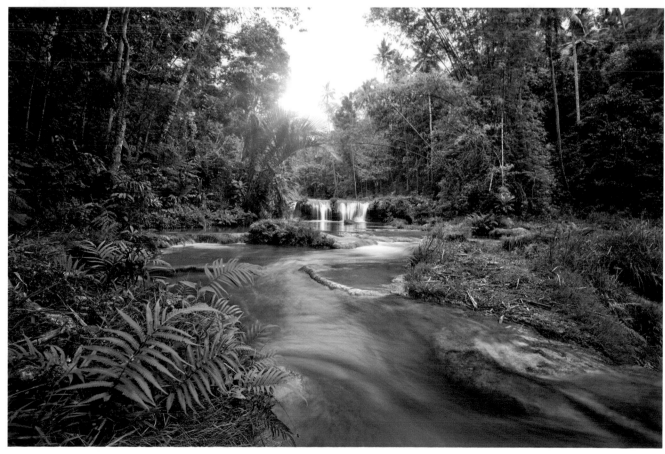

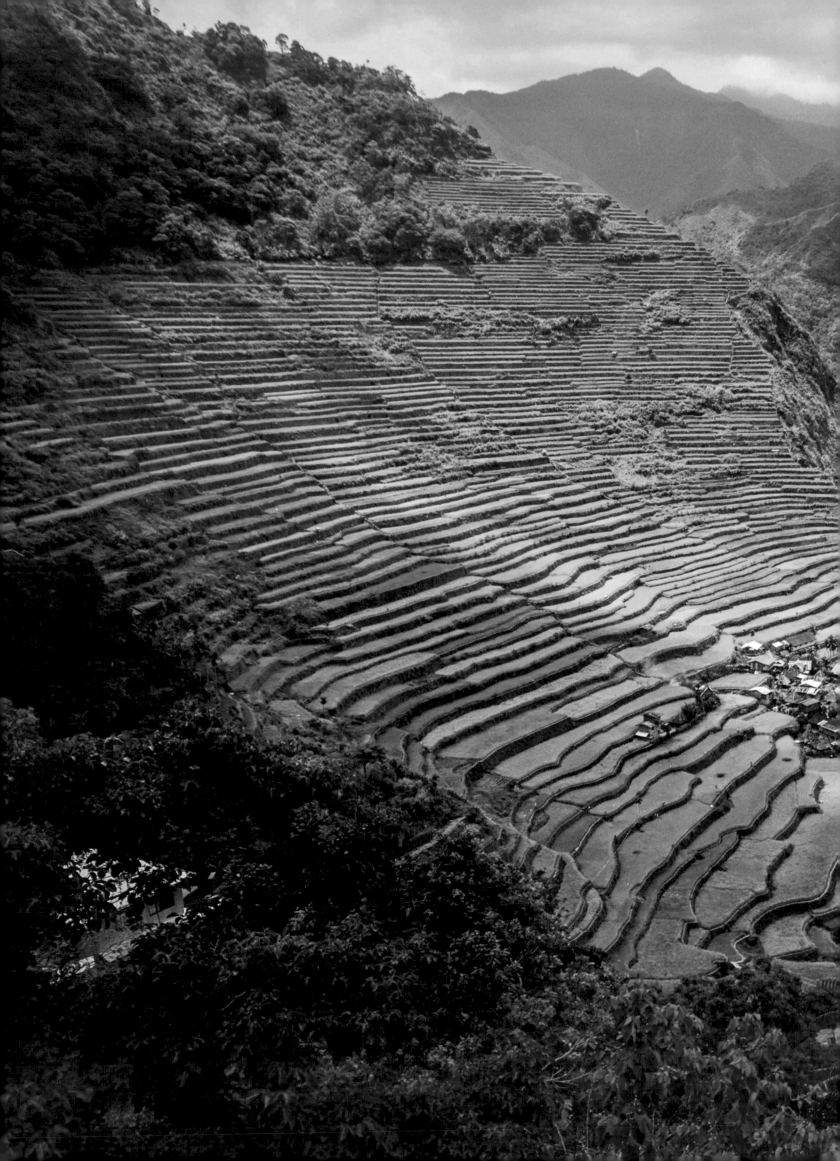

THE BUSTLING, RAUCOUS MOTHER CITY

Once dubbed the "Pearl of the Orient" thanks to its strategic location on major Pacific sea trade routes, Manila is still something of a rare gem, rich in history and charm. It is one of Southeast Asia's liveliest cities, with a thriving creative arts and music scene, world-class restaurants, round-the-clock nightlife and some of the country's most engaging museums.

Comprising 17 cities and municipalities with a combined population of over 12 million, the Philippine capital may at first seem overwhelming. The world's most densely populated city is an exciting mélange of Spanish colonial architecture and modern high-rise buildings. But it is also exceptionally poor. Shantytowns stretch out for miles, congestion is atrocious, with cars, pedicabs, buses and jeepneys chugging along the streets day and night, and pollution is terrible, with a thin layer of haze enveloping the city rooftops. But strolling around Manila's snazzy Makati district is no different from walking around an affluent neighborhood in the West: smart shopping malls are lined with international brands, stylish restaurants serve some of the best cuisine in the country, and affluent *Manileños* know how to party in style.

A major port for centuries, the village of Manila was converted to Islam when it fell under the control of the Sultanate of Brunei during an invasion in the 15th century. In the 16th century the city was soon Christianized by the incoming Spanish, who renamed the area Nuevo Reino de Castilla. Under Spanish rule, the Philippines was administered from the Spanish colony of Mexico, and the Catholic Church and its representatives exercised power over the archipelago. City residents grew wealthy largely as a result of the galleon trade, whereby Chinese goods were exported through Manila to Acapulco in exchange for Mexican silver. The city was largely destroyed by an earthquake in 1863. In the 20th century, it lay in ruins following the 1945 Battle of Manila, when American troops liberated the Philippines from the Japanese.

PREVIOUS SPREAD The spectacular Batad rice terraces weave around the mountainside in the Cordilleras region of northern Luzon.

RIGHT Three prominent Filipino priests collectively known as GomBurZa revolted against the Spanish government and were executed by garrotting in 1872.

BELOW Towering skyscrapers and modern apartment blocks fill Manila's swanky business district.

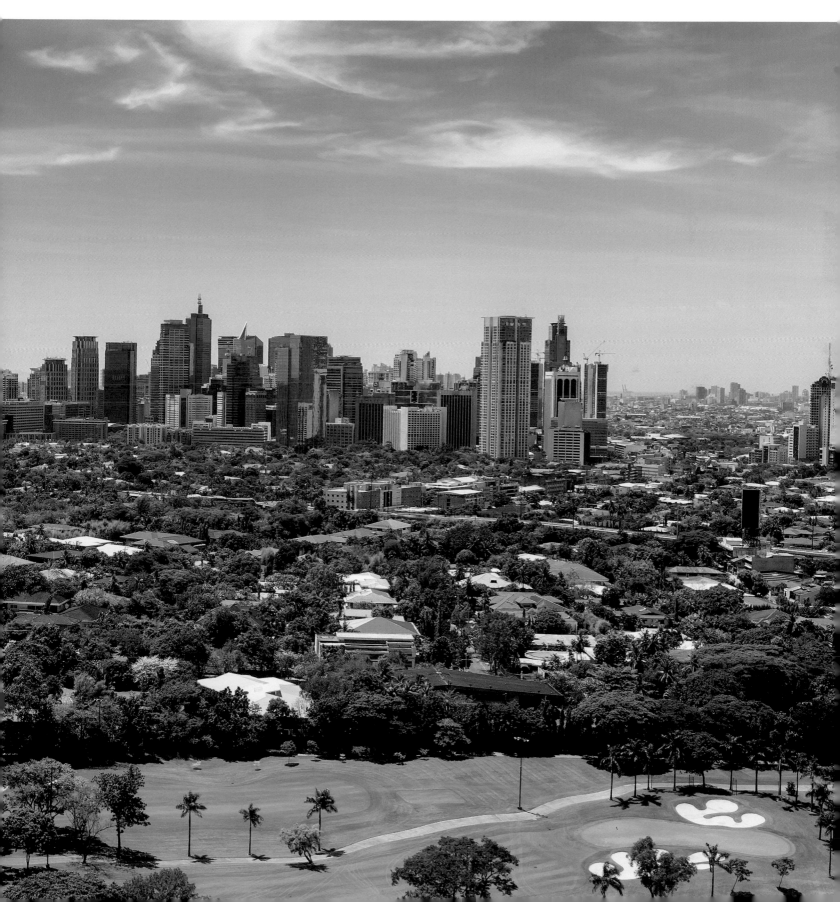

Intramuros: The Old Walled City

The historic core of Manila and the seat of the government during Spanish colonial rule, Intramuros ("area between the walls" in Spanish) is one of the city's main tourist attractions. Thanks to its strategic location, Manila was declared capital of the Spanish territory in 1571, with Intramuros becoming the center of the Spanish empire in Asia. As the city was prone to natural disasters and attacks by invaders, Chinese and Filipino laborers were called to build defensive walls. Construction of the walls and a surrounding moat continued into the 20th century. Within the walls were the City Hall, the Governor's Palace, Roman Catholic churches, convents and church-run schools. During WWII Intramuros was heavily damaged, with only 5 percent of the original city structure still standing. It has since been rebuilt, and strolling around the walled city's quaint little streets provides an insight into life under Spanish colonial rule.

Lying on the western side of Intramuros is San Agustin Church, the oldest stone church of the Philippines with a sumptuous baroque interior. It houses the tomb of Miguel López de Legazpi (1502–72), the Spanish founder of Manila. A stone's throw away is Casa Manila, a replica of an 1850s

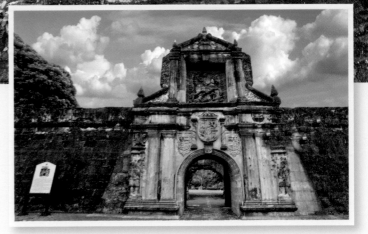

BELOW A popular means of exploring the walled city, horse-drawn carriages carry tourists along the narrow streets of Intramuros.

ABOVE Near the mouth of the Pasig River lies Fort Santiago, a citadel built by Spanish conquistador Miguel López de Legazpi.

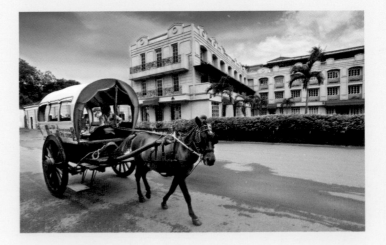

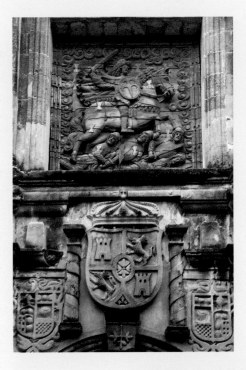

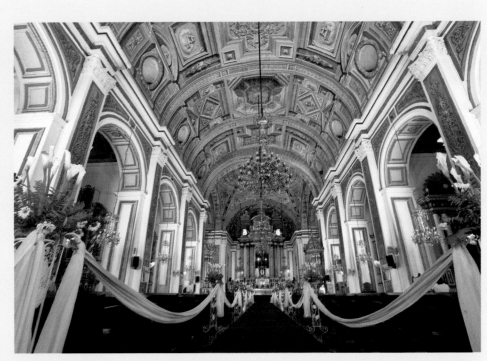

ABOVE The façade of Fort Santiago is adorned with the arms of the monarch of Spain and, above, a relief depicting Santiago, the patron saint of Spain.

RIGHT An ancient cannon at the Baluarte de San Francisco de Dilao faces the clock tower of Manila City Hall in the Ermita district.

OPPOSITE PAGE, TOP The Baluarte de San Diego is a bastion that was part of the fortifications of the walled city of Intramuros, Manila's oldest district.

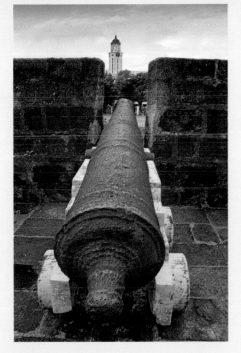

ABOVE The oldest stone church in the country, San Agustin has a beautiful baroque interior with vaulted ceilings and *trompe l'oeil* murals.

BELOW The ornately carved wooden door of San Agustin Church is decorated with floral motifs and religious imagery.

BOTTOM The Casa Manila Museum, a reproduction of a Spanish colonial house displaying original antique furniture and artwork, provides a glimpse of the opulent life of the Spanish gentry during the colonial period.

colonial mansion that provides an insight into the lives of a wealthy family during Spanish rule. Packed with beautiful antiques, the house itself is not original; it was built by First Lady Imelda Marcos in the 1980s to showcase the architecture of the late Spanish colonial period. A short walk north is Manila Cathedral, originally built in 1581 and destroyed several times as a result of typhoons; the eighth and current cathedral dates back to 1958. At the northwestern end of Intramuros is Fort Santiago, a citadel that was also a prison and torture chamber during Spanish times. This is where José Rizal (1861–96), the country's national hero, was imprisoned as he awaited execution in nearby Rizal Park, the city's main green space today.

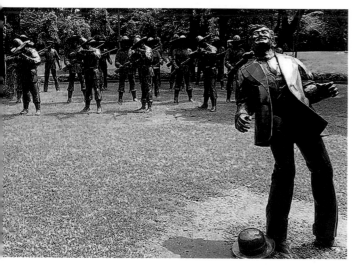

ABOVE Often referred to by its Spanish name of Luneta, Rizal Park attracts early morning joggers, couples and families who seek to escape the hubbub of the city.
LEFT The Diorama of the Martyrdom of Rizal contains life-size sculptures depicting the execution of Filipino nationalist José Rizal.
BELOW Here is one of the eight wall sculptures at Rizal Park dramatizing Rizal's final days, particularly evocative during an open-air light and sound presentation.

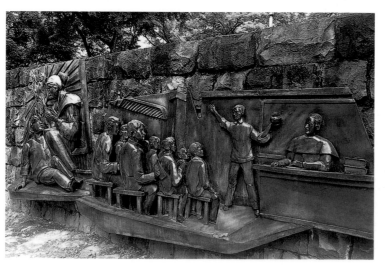

Intramuros is the historic core of the city and was the seat of the government during Spanish colonial rule. Originally built to protect the city from invaders, the walled city is today one of the city's major tourist attractions. Nearby Rizal Park features the Rizal Monument, a bronze sculpture of national hero Jóse Rizal with a stone base where his body is interred.

Near Rizal Park are two of the city's most engaging museums. Originally designed as a public library in 1918 during the American occupation, the National Art Gallery was completed eight years later to accommodate the legislature. Its galleries display works by Filipino artists that span the 17th to the 21st centuries. The museum's most notable work of art is painter and political activist Juan Luna's Spoliarium, a monumental oil-on-canvas depicting dying Roman gladiators, a clear allusion to the atrocities committed during the Spanish occupation. A component part of the National Art Gallery, the National Museum of the Filipino People is located in a neoclassical building that was once the Department of Finance. It houses a superb collection of anthropological and archeological artifacts, with a section of the museum dedicated to objects salvaged from the *San Diego*, a Spanish galleon that sunk off the coast of Luzon. Among the treasures on display are Chinese porcelain, coins and jewelry. The anthropology section features displays on the country's numerous tribal groups, providing an insight into the lives and traditions of the many peoples of the Philippines.

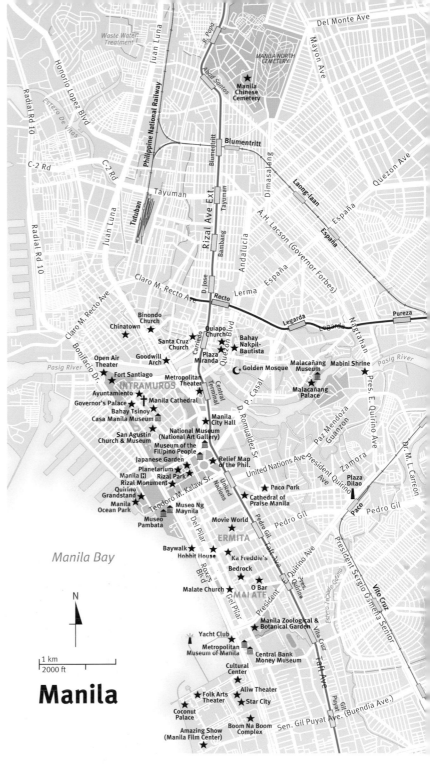

LEFT The Little Theatre of the Cultural Center of the Philippines features a stage curtain tapestry made in Kyoto, Japan.

BELOW The National Museum of the Philippines contains ethnographic, archaeological and anthropological displays.

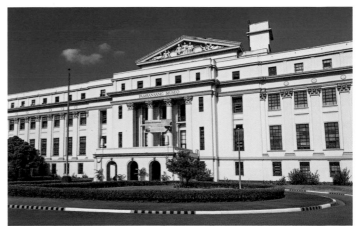

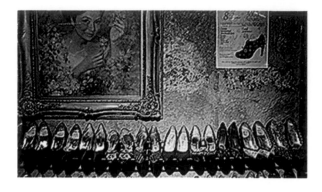

The neighborhoods of Ermita and Malate, both popular with backpackers thanks to their affordable accommodation and lively local food scene, house another of the country's top attractions: the Metropolitan Museum. It houses pre-colonial, modern and contemporary art, with a particularly impressive collection of pre-colonial gold and pottery artifacts, indicating that the country was engaged in a flourishing international trade long before the Spanish conquest.

South of the museum is the Cultural Center of the Philippines, one of First Lady Imelda Marcos's creations that aimed to beautify and modernize the capital. Founded in 1969, it hosts ballet productions, musicals and theater performances from both the Philippines and beyond. Productions, workshops and performances take place year-round. A short walk from here is the octagonal-shaped Coconut Palace, also built under Imelda's orders. It's a bizarre structure, with 70 percent of the building constructed from coconut materials. Commissioned in 1978, it was offered to Pope John Paul II when he visited the city three years later, although he declined to stay in such an opulent palace while people begged for food on the city's poverty-ridden streets.

As Minister of Human Settlements, Imelda Marcos commissioned other buildings around the city. The most controversial of all is probably the Manila Film Center. Built in the 1970s with the idea of staging an annual film festival that would rival France's Cannes Festival, the building's scaffolding collapsed in 1981, causing the death of over 150 workers. Despite the deaths,

ABOVE Manila is a city of contrasts. Here, modern skyscrapers are lit up at sunset.
TOP LEFT Ferdinand Marcos's wife Imelda was renowned for her extensive shoe collection. Manila's Marikina Shoe Museum displays over 700 pairs.
LEFT Constructed under Imelda Marcos's orders, the controversial Coconut Palace was built using 70 percent coconut products, costing the country millions while the populace lived in abject poverty.
OPPOSITE PAGE, RIGHT At rush hour the traffic-choked streets of Manila come to a complete standstill, with jeepneys, buses, taxis and pedicabs competing for space.

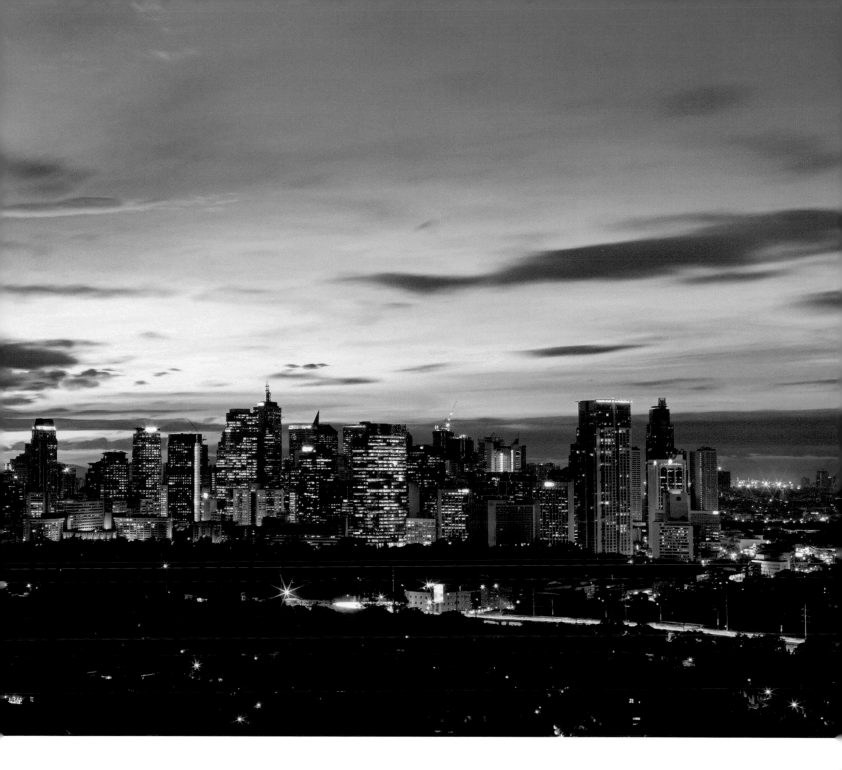

construction continued and the building was eventually completed just in time for the opening night of the 1982 International Film Festival. Abandoned in 1990 following an earthquake that struck the city, it was later re-used in 2012 to host occasional performances, although it was damaged by fire the following year. The building is said to be haunted by the ghosts of the construction workers.

Nicknamed "the Steel Butterfly", First Lady Imelda Marcos is probably best known for her shoe collection: "I did not have 3,000 pairs of shoes, I had 1,060", she famously claimed. Whatever the number, it was an ostentatious show of wealth while ordinary Filipinos suffered terrible poverty. Part of her shoe collection (749 pairs) is on display at the Marikina Shoe Museum in the capital's eastern suburbs.

One of the city's most bustling districts is Binondo, or Chinatown, thought to be the oldest Chinatown in the world. Here, street peddlers and vendors sell anything and everything,

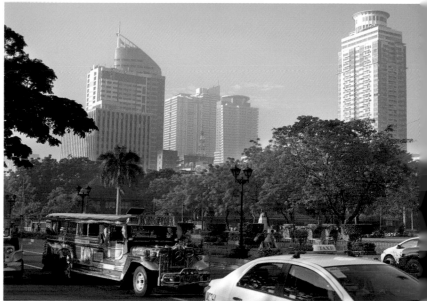

ABOVE LEFT Established by the Spanish at the end of the 16th century, Manila's Chinatown is said to be the oldest in the world.
LEFT The Chinese-Filipino community welcome the Chinese New Year with boisterous celebrations featuring dragon dances and fireworks.

ABOVE A street vendor lovingly prepares a display of colorful fruits ahead of Chinese New Year in the district of Binondo.
BELOW A cheerful tricycle driver at Divisoria Market, a large flea market known for its wide assortment of goods, from electronics to crafts.

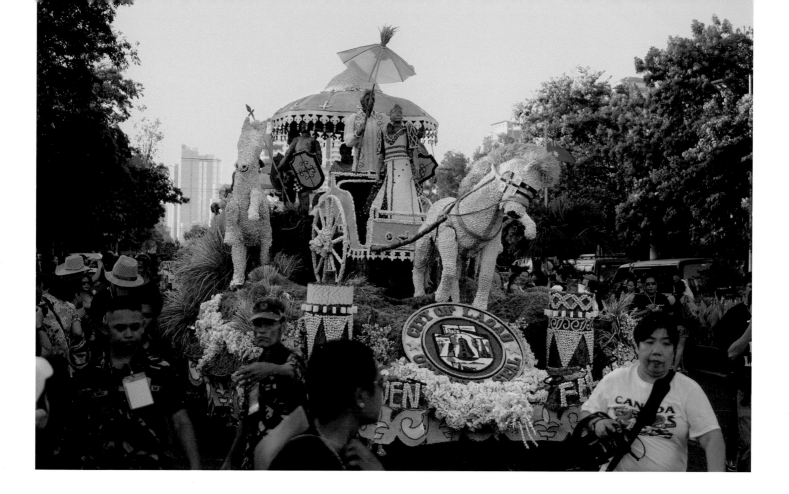

from fake watches to herbal remedies. The Spanish established Chinatown in 1594 as a settlement for Chinese immigrants. During the American occupation it became a center for commerce, and was largely destroyed during World War II, causing most companies to move to Makati, today the financial center of the country. Chinatown's most notable site is probably the Chinese Cemetery, established in the mid 19th century because the Spanish would not allow the Chinese to bury their dead in Catholic cemeteries. It is an extraordinary sight, with the streets lined with opulent mausoleums, of which some are embellished with marble pillars and fountains. One even has a small swimming pool.

On the banks of the Pasig River is the Malacañang Palace, the official residence of the President of the Philippines. It was originally purchased as the summer residence of the governor-general; following the destruction of the Palacio del Gobernador in Intramuros during the 1863 earthquake, it became the president's official residence. Most of the palace is closed to the general public, although it's possible to visit the Malacañang Museum, which sheds light on the palace's history.

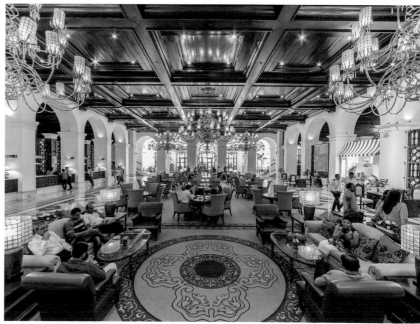

TOP An elaborate Laoag City float made of garlic for the annual Aliwan Fiesta, where representatives from all over the country compete in dance parades and float competitions.

ABOVE RIGHT Built during the Spanish colonial era, the Malacañang Palace has been the official residence of the President of the Philippines since the second half of the 19th century.
RIGHT The lobby of Manila Hotel, which served as the home of General Douglas MacArthur during his tenure as Military Advisor to the Commonwealth Government of the Philippines during the 1930s.

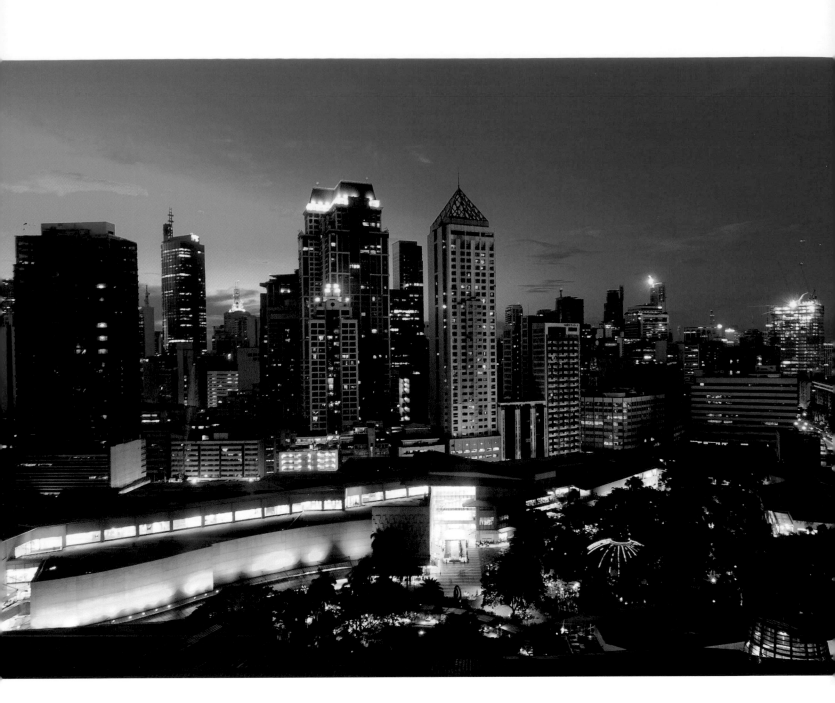

ABOVE At twilight the business district of Makati comes to life, with stylish bars and restaurants attracting the capital's moneyed elite.

LEFT Spread over seven floors, Robinsons Place mall houses thousands of retail shops, restaurants and entertainment outlets.

RIGHT Graffiti culture and street art is on the rise in the capital, livening up the city's backstreets.

LEFT The bars and restaurants of Eastwood City shopping mall in Quezon City attract their share of locals and expats alike.
BELOW Filipino TV and movie actress Ai-Ai delas Alas performs alongside singer-songwriter and guitarist Aiza Seguerra to a jubilant crowd at The Big Dome, one of Asia's largest sports arenas.

RIGHT Renowned for its bustling restaurants and bars, Adriatico Street in the district of Ermita attracts plenty of youngsters because of its lively bohemian nightlife.

East of Manila Bay is the city's exclusive business and financial district of Makati, home to glossy air-conditioned shopping malls, upmarket hotels, and some of the country's best restaurants. It's worth visiting the excellent Ayala Museum, showcasing an incredible collection of pre-colonial gold ware, porcelain and ceramics, along with paintings by Filipino Realists, Impressionists and abstract artists. Displays highlight key events in the country's history, from pre-history up to independence.

Once the sun sets, Manila morphs into one of Asia's most exciting cities, with round-the-clock nightlife catering to all tastes, from chic wine bars in Makati to edgy live music gigs in bars and clubs around town. Manila's nightlife easily rivals, if not exceeds, that of other Southeast Asian capitals.

SCENIC EXCURSIONS WITHIN A DAY FROM THE CAPITAL

The provinces around Manila are rich in historical and natural attractions, making the capital an ideal base from which to explore the area.

The town of Tagaytay, about 41 miles (60km) away from Manila, is the jumping off point for visiting stunning Lake Taal, a volcanic lake with an island in the center. Fifteen miles south of here is Taal, one of the country's most beautifully preserved Spanish colonial towns founded by Augustinian friars in 1572; it was moved to its present location two centuries later, following the eruption of Taal volcano. One of the most popular sites is the Basilica de San Martin de Tours (or Taal Basilica), probably the biggest church in Southeast Asia, and today a major pilgrimage site. Its small pinewood image of the Virgin Mary, only eight inches (20cm) high, attracts scores of visitors throughout the year. It is worth visiting one of the town's Spanish-era houses that have been converted to museums, with their polished narra hardwood floors, colonial furniture and spiral staircases. On the southeastern side of Lake Taal is the small town of Cuenca, from where it is possible to climb Mount Maculot, which boasts superb views of the lake. Near the summit is an area of steep rock known as the Rockies, with a platform offering clear views of the lake.

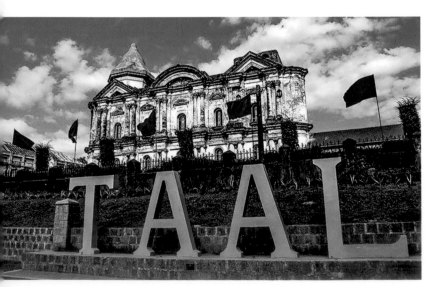

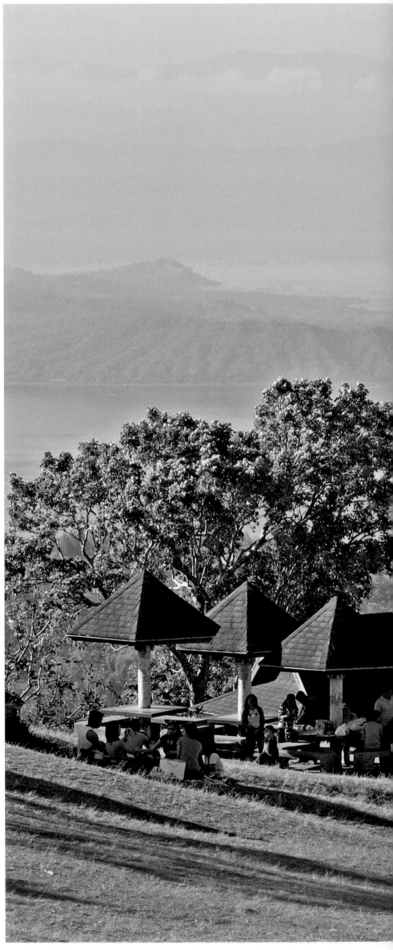

OPPOSITE PAGE, BOTTOM LEFT
Said to be Asia's largest Catholic church, Taal Basilica sits atop a hill in the beautifully preserved Spanish colonial town of Taal.

BELOW Filipinos enjoy the spectacular views of Taal Volcano from the Tagaytay Picnic Grove, a popular mountain resort south of Manila.

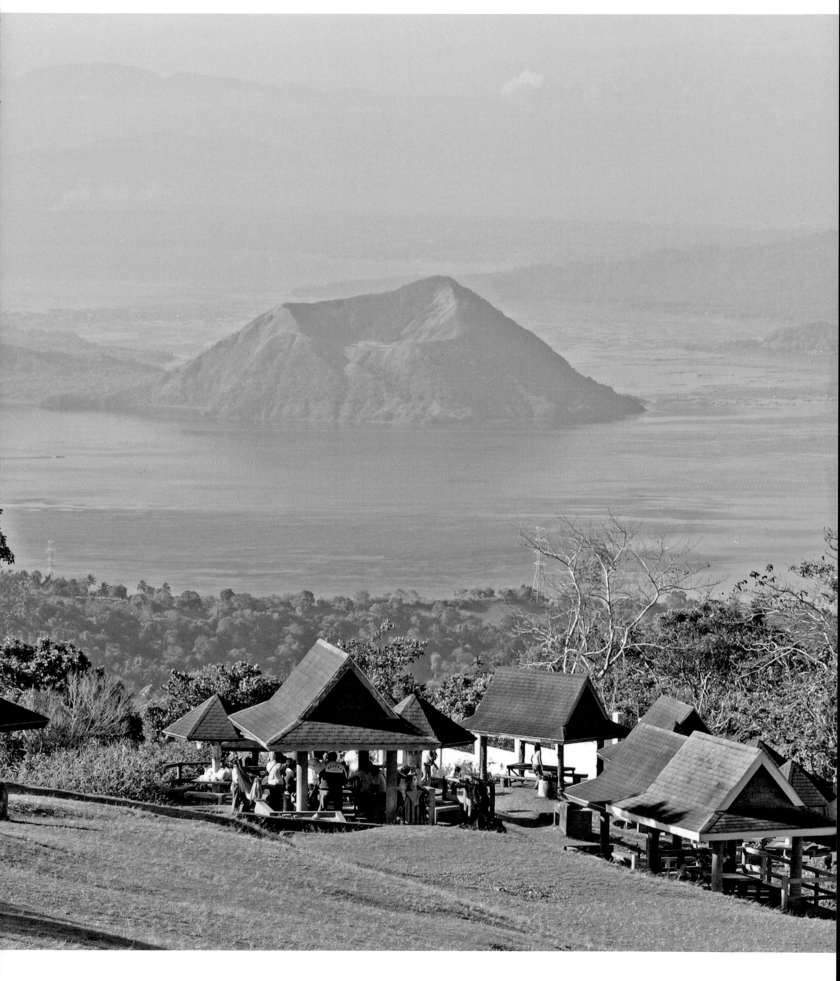

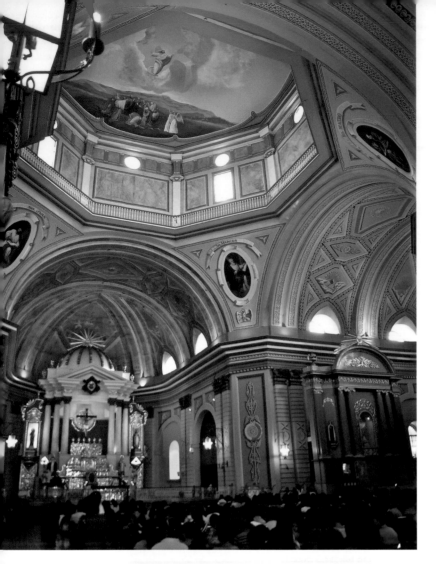

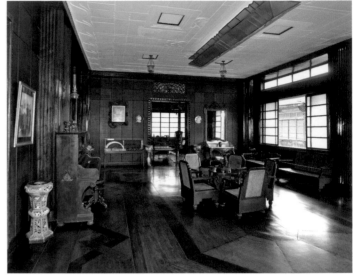

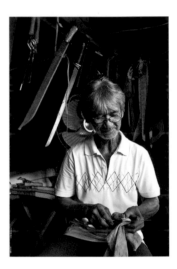

TOP LEFT The magnificent interior of Taal Basilica houses an eight-inch (20cm) high pinewood image of the Virgin Mary that attracts scores of pilgrims year-round.
TOP RIGHT Built in the 18th century, the ancestral home of lawyer and revolutionary Leon Apacible has beautiful narra wood floorboards and original features.
RIGHT Experienced knife maker Diosdado Ona is one of a handful of artisans that to this day forges blades by hand.
LEFT Locally known as the *balisong*, a butterfly knife is a folding pocketknife that originated in the province of Batangas.

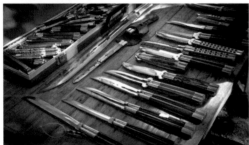

Taal Volcano

Lake Taal sits in a caldera formed by eruptions that occurred 500,000–100,000 years ago. Sitting in the center of the lake on Volcano Island is Taal Volcano (1,020ft/311m), the world's smallest active volcano. The volcano's first recorded eruption was in 1754 when thousands were killed and the old town of Taal destroyed (it was later moved to its present location).

A number of small eruptions have been recorded since. Its unique feature as a volcano on an island within a lake attracts thousands of tourists and geologists alike. As well as harboring a rare species of venomous sea snake, the lake is home to the world's only freshwater sardine,

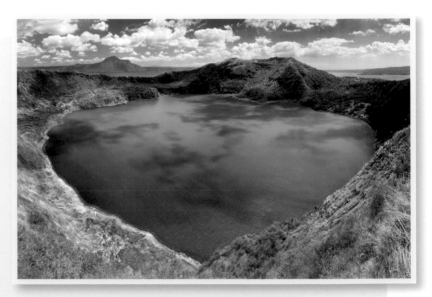

Sardinella tawilis. Eruptions sealed off the lake from the sea, trapping the fish, which evolved into a freshwater species. Widely consumed around the Philippines, the sardine is enjoyed raw, dried or salted, although high demand means it is threatened by overfishing.

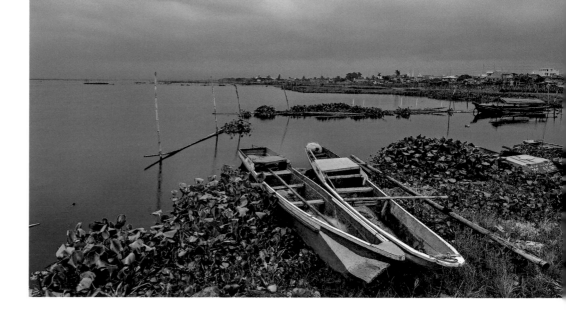

The province of Laguna is home to Laguna de Bay, the largest lake in the country. Hikers can head up to the summit of Mount Makiling (3,576ft/1,090m), a dormant volcano that is named after Mariang Makiling, a woman whose spirit is said to watch over the mountain. The volcano is the source of numerous natural hot springs, which attract visitors who come to seek out the water's curative properties throughout the year. The area is also famous for its delectable *buko* pies, traditional coconut custard pies that were created in the lakeside town of Los Baños in the 1960s.

East of Mount Makiling is Lake Sampaloc, whose perimeter can be walked in a few hours. A short drive east is Pagsanjan, sight of the spectacular Pagsanjan Falls where the final scenes of Francis Ford Coppola's 1975 movie *Apocalypse Now* were filmed. Most visitors head here to take a thrilling ride down the Bumbungan River to the falls and back, best experienced in the wet season (June–September) when the water level is at its highest. North of here is the town of Paete, famous for its woodcarving, which comes to life every January during the Salibanda Festival, the feast of the Holy Child. The town's stores sell a variety of woodcarvings, masks and *bakya*, traditional wooden clogs.

ABOVE Laguna de Bay, the country's largest lake, is one of the Philippines' most important fishing areas.
ABOVE LEFT Local fishermen examine their catch at Laguna de Bay.
RIGHT The small town of Paete is renowned for its woodcarving industry, with skilled artisans crafting all manner of ornamental objects, from religious icons to souvenirs.
BELOW The San Pedro de Alcantara Church in Pakil, Laguna, enshrines *Our Lady of Turumba*, an oil painting depicting the Virgin Mary that attracts pilgrims from far and wide.

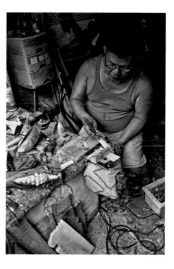

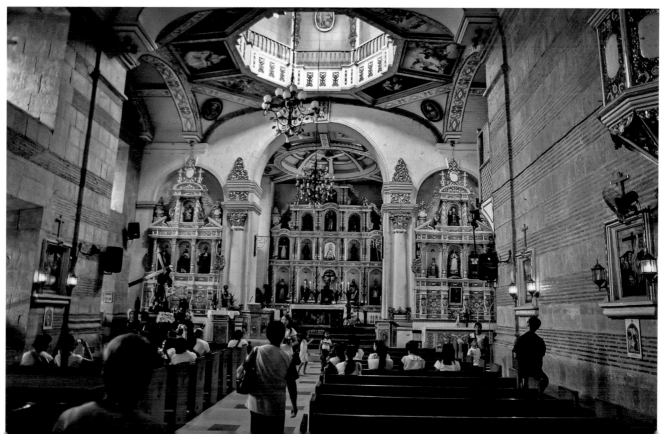

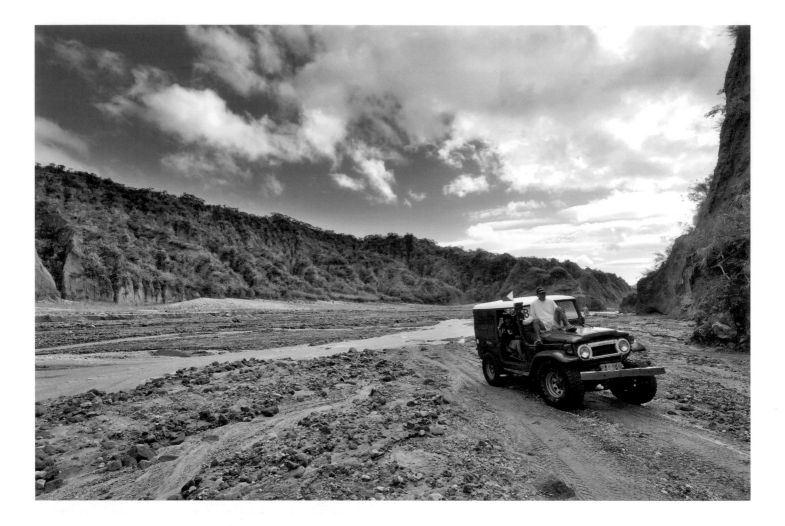

The provinces north of Manila, namely Pampanga, Bulacan and Bataan, are worth visiting for their historic attractions and stunning scenery. About 50 miles (80km) north of the capital are the sleazy cities of Clark and the adjacent Angeles City, both popular sex tourist destinations and home to dozens of strip bars and nightclubs. There's no reason to linger here, and travelers are better off heading east towards Mount Pinatubo, one of the area's main sights. The eruption on April 2, 1991 was one of the largest in the 20th century, leading to the formation of a shallow crater. The Aeta people from the lower slopes of Mount Pinatubo were forced to relocate, with some living in temporary accommodation to this day. The lake is a beautiful sight, with emerald-green waters and gorgeous surrounding views. South of Lake Pinatubo is Lake Mapanuepe, which was formed after the eruption of Mount Pinatubo. Debris blocked the drainage of the Mapanuepe River, and the eponymous valley and the *barangays* of Aglao, Buhawen and Pili were flooded. To this day homes lie underwater, and the steeple of a church protrudes from the water's surface. It is possible to rent a *bangka* to visit the submerged church and head across the river to an Aeta village. Just over 25 miles (40km) east of Mount Pinatubo is Mount Arayat, a dormant volcano that travelers can climb in a few hours.

LEFT Trekking to Mount Pinatubo's emerald-green crater lake is a popular activity for Filipino and foreign tourists alike.

TOP Organized trips to Mount Pinatubo involve taking a 4x4 vehicle for an hour or more through dusty foothills.

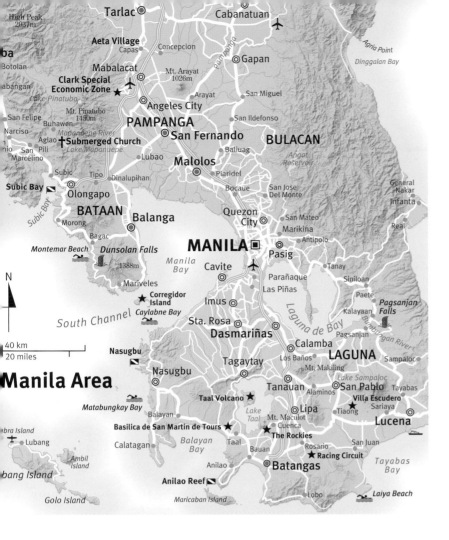

Manila Area

Manila Area map labels:

High Peak 2037m
Tarlac
Cabanatuan
Aeta Village
Capas
Concepcion
Gapan
Agria Point
Dinggalan Bay
Botolan
Mabalacat
Mt. Arayat 1026m
abangan
Clark Special Economic Zone ★
Angeles City
Arayat
San Miguel
San Felipe
Buhawen
Mt. Pinatubo 1450m
PAMPANGA
San Ildefonso
Narciso
San Pili
Aglao † Submerged Church
Mapanuepe River
Lake Mapanuepe
San Fernando
BULACAN
Marcelino
Lubao
Balluag
Malolos
Angat Reservoir
Subic
Tipo
Dinalupihan
Plaridel
Bocaue
San Jose Del Monte
General Nakar
Subic Bay
Olongapo
BATAAN
Balanga
Quezon City
San Mateo
Marikina
Antipolo
Infanta
Real
Morong
Bagac
Montemar Beach
Dunsolan Falls
1388m
MANILA
Pasig
Tanay
Manila Bay
Cavite
Parañaque
Las Piñas
Sipiloan
Mariveles
Corregidor Island
Caylabne Bay
Imus
Paete
Kalayaan
Pagsanjan Falls
South Channel
Sta. Rosa
Dasmariñas
Laguna de Bay
Pagsanjan
Bumbungan River
40 km
20 miles
Nasugbu
Calamba
Los Baños
Mt. Makiling
LAGUNA
Sampaloc
Nasugbu
Tagaytay
Lake Sampaloc
San Pablo
Tayabas
Alaminos
Matabungkay Bay
Taal Volcano ★
Tanauan
Villa Escudero
Sariaya
Balayan
Lake Taal
Lipa
Mt. Maculot
Cuenca
Tiaong
Lucena
Basilica de San Martin de Tours ★
The Rockies ★
Taal
Bauan
Rosario
San Juan
Racing Circuit ★
Tayabas Bay
bra Island
Lubang
Calatagan
Balayan Bay
Anilao
Batangas
Anilao Reef
Lobo
Laiya Beach
Ambil Island
bang Island
Golo Island
Maricaban Island
N

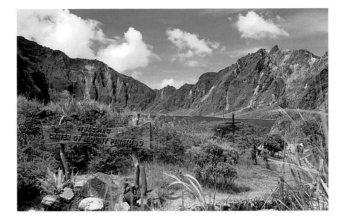

ABOVE Stony paths lead to the crater of Mount Pinatubo.
BELOW It's not possible to swim in the clear waters of Lake Pinatubo, although boats can be rented out for a small fee.

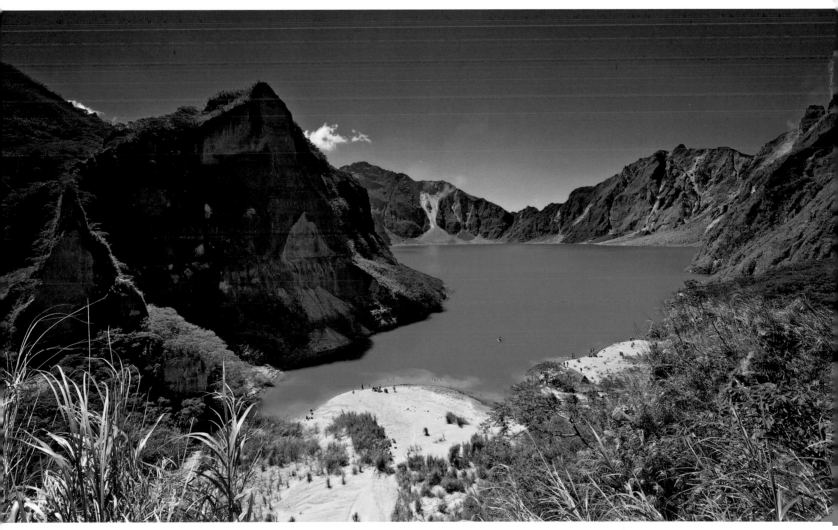

Corregidor: The Island of Remembrance

Thanks to its strategic location at the entrance of Manila Bay, 25 miles (40km) west of Manila, Corregidor Island served as a harbor defence outpost. During World War II, Japanese guns and aircraft continually bombarded the island, which was defended by American and Filipino soldiers. Hundreds died in the fighting, and when the Americans regained control of the island in 1945, they annihilated the Japanese garrison. After the war the island was abandoned and was covered in thick vegetation, until the 1980s when it became a national shrine. Today a major historic site, the ruins serve as a memorial to the American, Filipino and Japanese soldiers who lost their lives during the war.

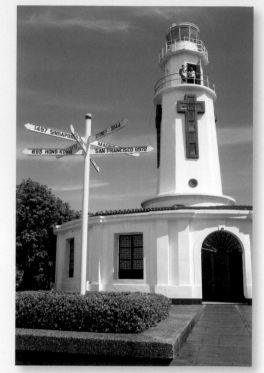

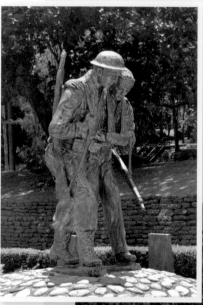

LEFT The bronze Brothers in Arms statue depicts an American soldier supporting an injured Filipino comrade.
BELOW Heavily bombarded during World War II, Corregidor's Mile-Long Barracks was used to house American soldiers.

RIGHT Tourists soak in the gorgeous views of Bataan and Mount Mariveles from the top of the 19th century Spanish lighthouse on the island of Corregidor.
BOTTOM RIGHT The small island of Corregidor features abandoned gun emplacements that the Americans used to defend the country from the invading Japanese.

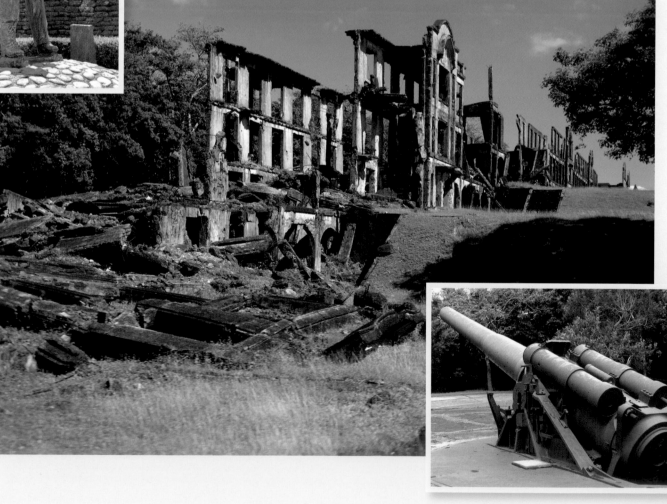

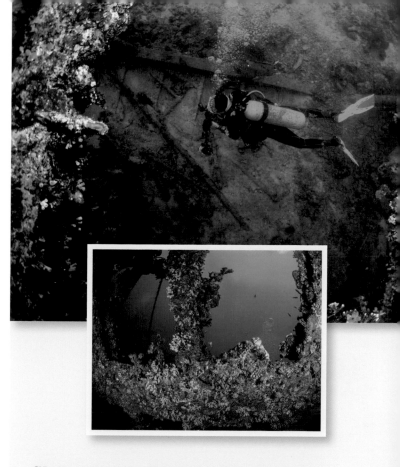

Largely covered by jungle, the Bataan peninsula forming the western side of Manila Bay was the scene of bloody fighting during World War II. Following the Japanese invasion of the Philippines in December 1941, thousands of Filipino and American soldiers were forced to withdraw here. A number of soldiers escaped to neighboring Corregidor Island, while numerous captured troops died during the Bataan Death March in April 1942. US forces eventually recaptured Manila Bay in 1945.

On the northwestern coast of the peninsula is Subic Bay, home to a US Naval Base until 1992 and today an upmarket resort with golf courses, casinos and expensive hotels. The bay attracts large numbers of travelers thanks to its excellent wreck diving sites, with fifteen shipwrecks close to shore.

Shipwreck Diving in Anilao

About 87 miles (140km) south of Manila is Anilao, home to some of the country's best diving. It gets particularly busy at the weekends, when crowds descend from Manila to dive in one of the many dive spots (there are around 40). With sandy slopes, drop-offs and great visibility, there are sites to suit all abilities. The Anilao reef is a protected marine sanctuary and perfect for underwater photographers. Its clear waters teem with macro critters, nudibranchs, shrimp, crab, squid and cuttlefish, seahorses and pipefish, along with blue-ringed octopuses and bobbit worms. The area abounds in coral, forming underwater forests in a rainbow of colors.

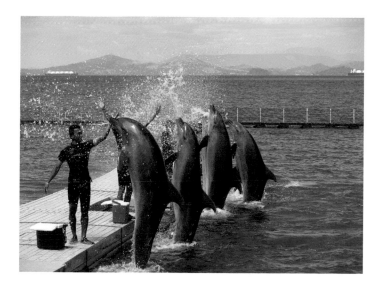

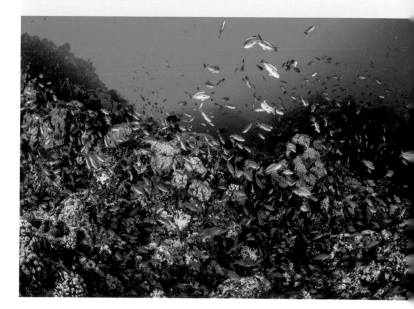

TOP RIGHT, TOP RIGHT INSET
A diver in Anilao—one of the country's best diving spots—explores a decaying shipwreck covered in coral.
RIGHT The reef at Anilao is a protected marine sanctuary, harboring a spectacular range of marine life including cuttlefish, squid, reef fish, sea slugs and soft and hard coral.

ABOVE Dolphin shows attract scores of families at Ocean Adventure, an open-water marine park in Subic Bay.
TOP Famed for wreck diving, Subic Bay also has a lively nightlife scene, and plenty of bars and restaurants.

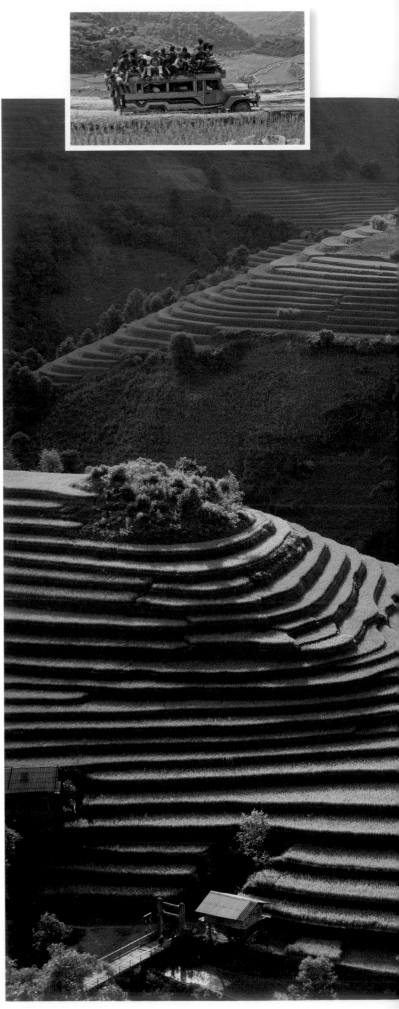

NORTHERN LUZON

STUNNING RICE TERRACES AND COLONIAL ARCHITECTURE

Home to some of the country's most spectacular natural attractions, northern Luzon is a paradise for outdoor enthusiasts, offering thrilling activities from whitewater rafting to spelunking.

Visitors heading north from Manila will drive along the Zambales Coast, famed for its juicy mangoes and sprinkled with laidback beach resorts. One of the region's main attractions, the Hundred Islands National Park, situated in the Lingayen Gulf, can easily be visited as a weekend trip from the capital. Occupying an area of 1,844 hectares, the park is actually home to 123 islands, some no more than small, mushroom-shaped rocky outposts. Island-hopping trips take visitors out to numerous islets, stopping off at small sandy coves where it's possible to have a picnic, a snorkel and a swim. While the nearest point to the islands is Lucap, travelers are better off staying at one of the resorts in nearby Bolinao, an area of gorgeous rugged beaches, underground pools and emerald waterfalls.

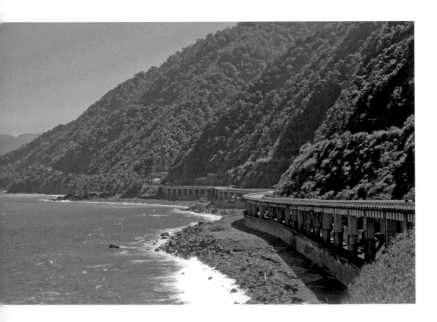

OPPOSITE PAGE, TOP Jeepneys are a popular mode of transport and are often seen overflowing with passengers; the vehicles were left by the Americans following their departure after World War II.

OPPOSITE PAGE, BOTTOM A large elevated coastal highway hugs the coast in northern Luzon.

BELOW Commonly referred to as the "eighth wonder of the world", the Banaue Rice Terraces were first developed by the Ifugao people over 2,000 years ago. Today they are a popular tourist site.

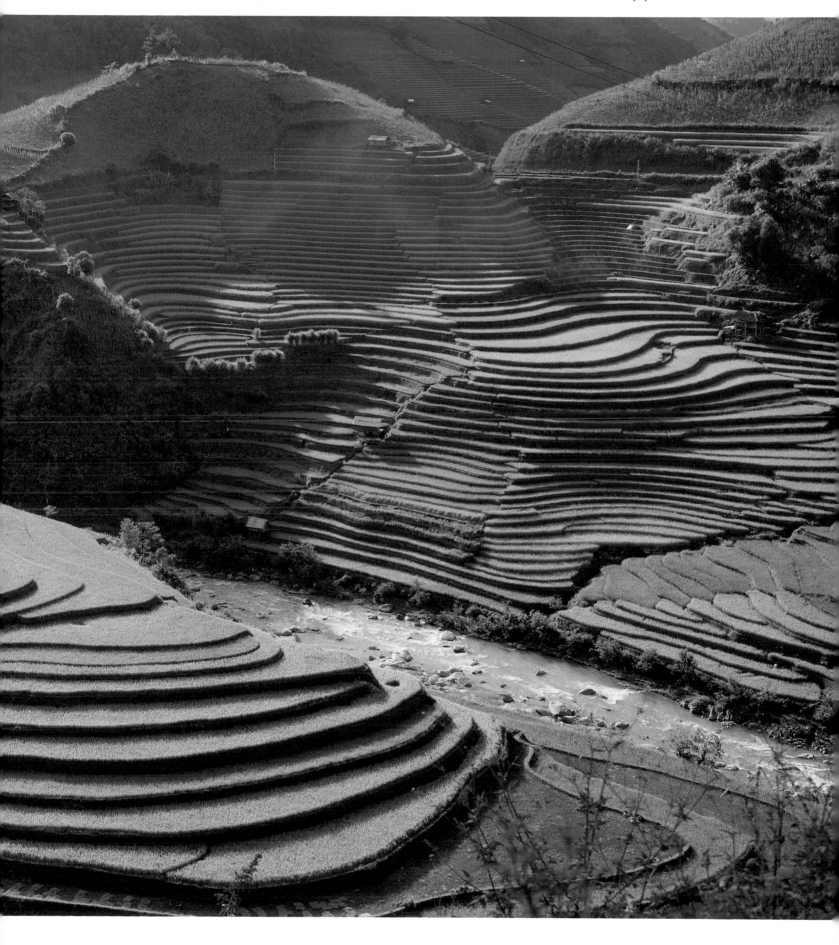

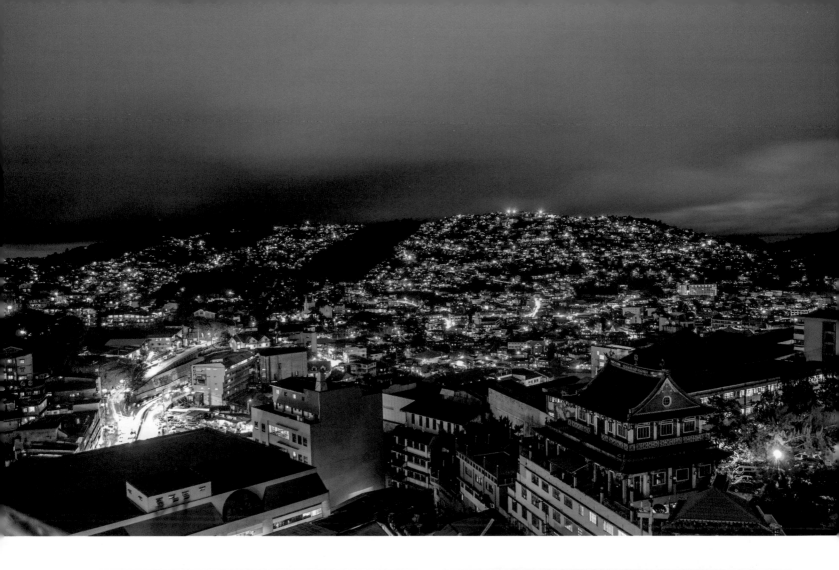

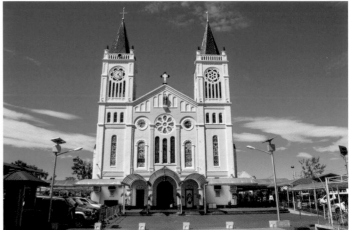

TOP With its traffic-choked streets, the university city of Baguio is no longer the rural mountain retreat it once was; today it is a bustling place with great restaurants and a busy nightlife.

ABOVE LEFT Street dancers at the month-long Panagbenga, an annual flower festival held in February featuring flower-clad floats and street dancing.

ABOVE RIGHT Built and consecrated in 1936, the Our Lady of the Atonement Cathedral, or Baguio Cathedral, is the center of religious activities during Holy Week.

RIGHT Locals and tourists gather around the shops in Mines View Park, Baguio, which overlooks the mining town of Itogon.

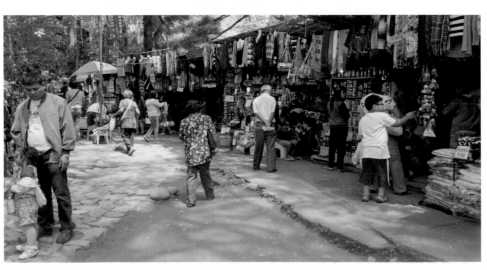

Further up the coast is San Juan, the area's most famous surfing beach. Laidback surfer hangouts line the beachfront, where surfboards can be rented and lessons organized. Travelers usually roll in between September to March, while during the rest of the year the beach is pretty quiet. It is worth exploring Northern Luzon's east coast, which offers some of the country's best surfing at Baler. Scenes from Francis Ford Coppola's movie *Apocalypse Now* were filmed at Charlie's Point, the town's most famous surf spot. It's ideal for both beginners and experienced surfers, with waves averaging about six feet (2m).

North of Baler is one of the region's remotest wildernesses, the Northern Sierra Madre Natural Park. The largest protected area in the country, it is also the richest in terms of species and habitat diversity, harboring rare fauna such as the Philippine eagle, the golden crowned flying fox and the dugong. Small aircraft connect the park's two towns of Palanan and Maconacon to the rest of the province; boats also travel here from San Vicente near Santa Ana on Luzon's northern coast, although services are weather dependent.

The main hub of the Cordilleras is Baguio, an arty university city home to excellent restaurants and one of the country's best art galleries, the BenCab Museum. The city was developed during the American occupation, when it became an administrative center. Camp John Hay, named after US President Theodore Roosevelt's secretary of war, was once a rest and recreation facility for US soldiers, and is today a major tourist attraction. About 53 miles (85km) north of Baguio is Kabayan, an isolated mountain village home to one of the area's most extraordinary sights: a group of mummies in mountaintop caves thought to date as far back as 2000 BC. The town also offers some excellent trekking: from here it's possible to ascend Mount Pulag, Luzon's highest mountain at 9,586 feet (2,922m).

TOP With its cool climate, Baguio is a haven for Filipino artists like Benedicto Reyes Cabrera, and is often visited by local artists during the annual Baguio Arts Festival in November and December.

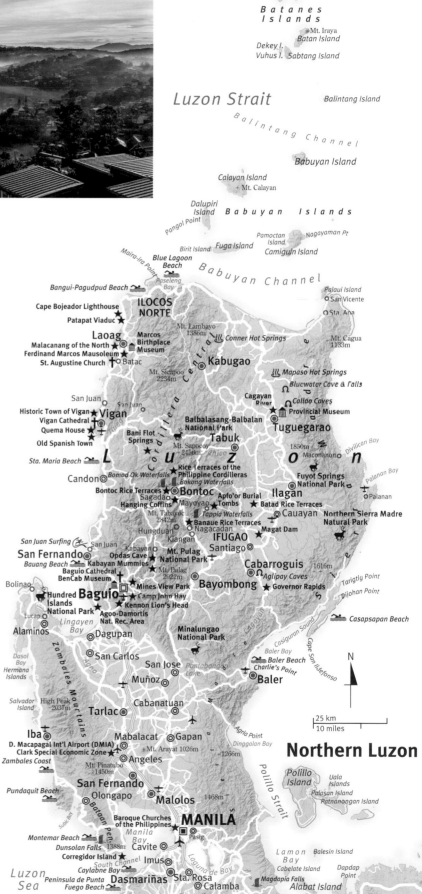

Further north is one of the region's main attractions, the hanging coffins of Sagada. Nailed to the cliff face, the coffins measure about three feet (1m) in length, as corpses are buried in the fetal position. The tradition of burying the dead in hanging coffins dates back about two millennia.

Sagada became a laidback bohemian retreat in the 1970s when intellectuals and artists flocked here to write and paint. It is today an attractive mountain town lined with cosy restaurants that serve some of the country's best dishes, lovingly prepared with locally-grown greens. This is also a great spot to partake in exciting outdoor activities, including trekking, mountain biking, rafting and caving in the area's web of limestone caverns. The area around Tabuk in Kalinga province also offers some exciting whitewater rafting opportunities down the Chico River, passing through superb rice terrace scenery.

The area's tribal heartland is undoubtedly Ifugao province, which hosts some of the country's most awe-inspiring scenery: spectacular rice terraces that weave around the mountainsides. Designated a UNESCO World Heritage Site, the rice terraces were hewn out of the mountainside 2,000 years ago by the Ifugao people. Trekking through the rice terraces and overnighting in traditional Ifugao huts is a highlight of any trip to the Cordillera mountains.

The town of Banaue serves as the most popular base to explore the surrounding terraces, and hiking to the small town of Batad has become one of the area's most popular tourist activities—although there are plenty of other designated World Heritage Sites offering stunning scenery that easily rival that of Banaue and Batad.

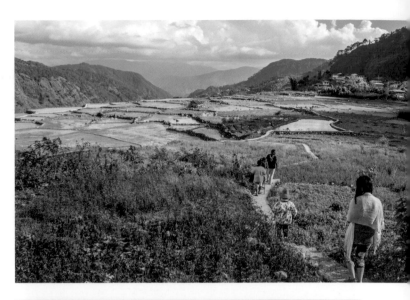

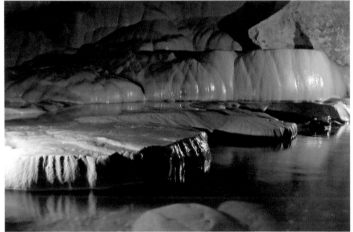

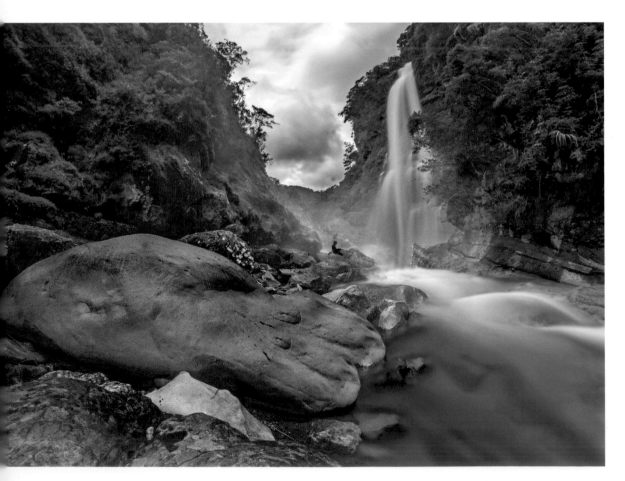

TOP Albeit smaller and less impressive than Banaue's, the rice terraces of Sagada offer trekking opportunities and scenic views.
ABOVE The landscape around Sagada is characterized by limestone caves with impressive chambers and rock formations.
LEFT A pleasant trek through lush, verdant scenery leads to the magnificent Bomod-ok Falls, which tumble down into a cool pool of water.

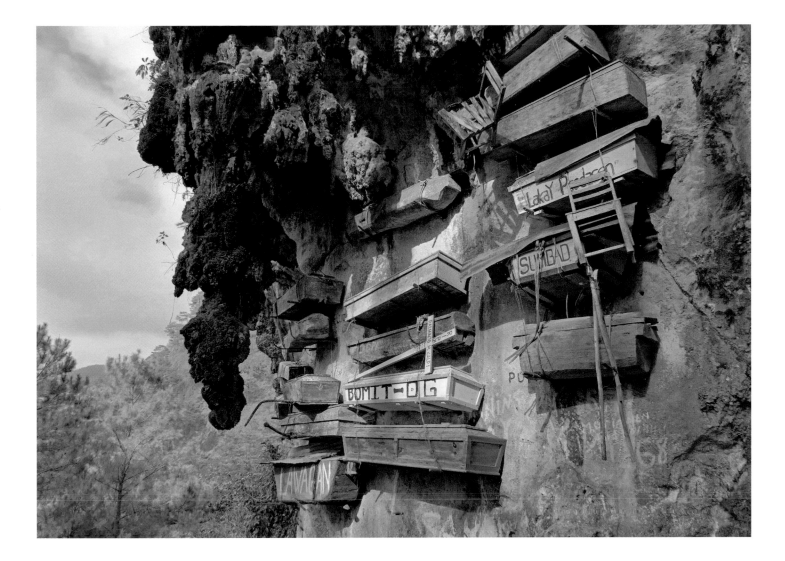

ABOVE The Igorot people's tradition of burying the dead in hanging coffins continues to be practiced to this day, although it is slowly dying out.

RIGHT Comprising seven gargantuan chambers, Callao Cave's main chamber has a skylight and a chapel used for mass on special occasions.

BELOW Opdas Cave in Kabayan contains around 200 skulls and bones that are thought to date back about a thousand years.

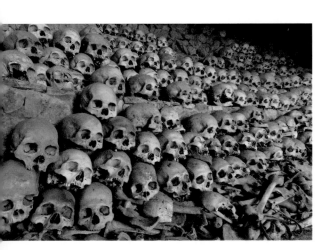

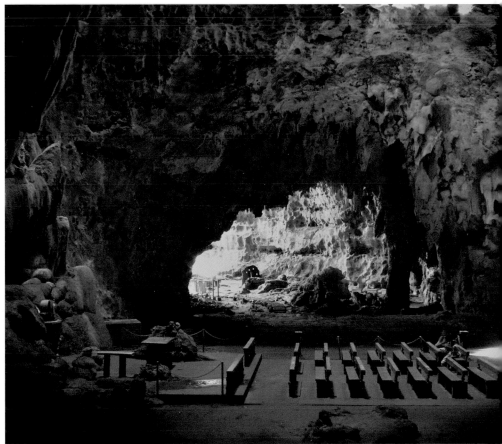

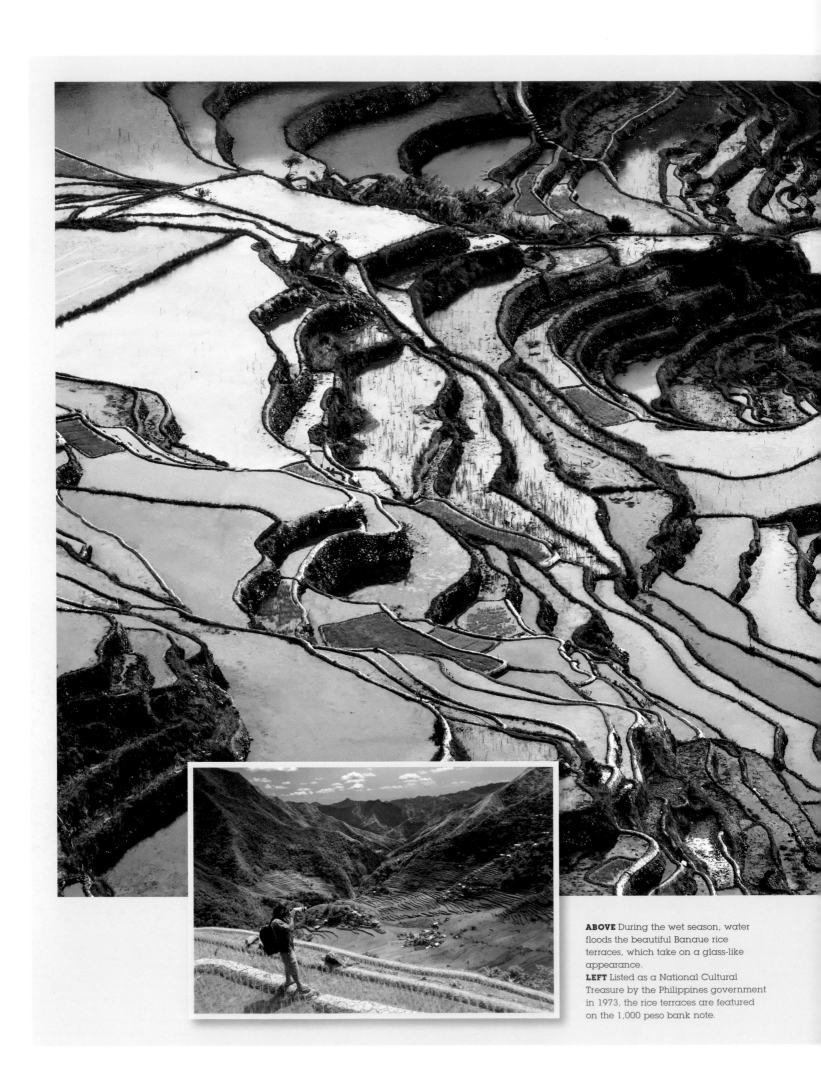

ABOVE During the wet season, water floods the beautiful Banaue rice terraces, which take on a glass-like appearance.

LEFT Listed as a National Cultural Treasure by the Philippines government in 1973, the rice terraces are featured on the 1,000 peso bank note.

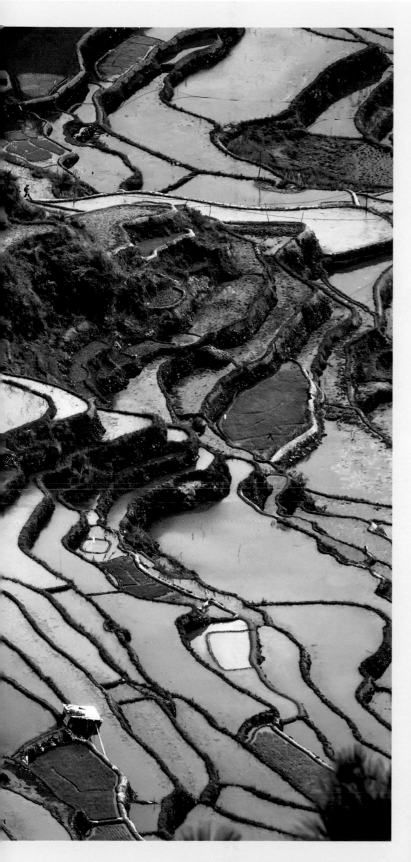

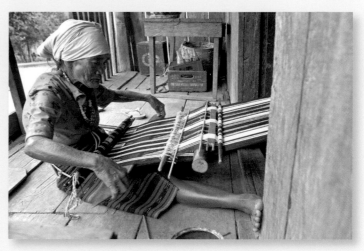

Banaue's Famous Rice Terraces

Designated a UNESCO World Heritage Site in 1995, the magnificent rice terraces of the Cordilleras were built by the Ifugao ethnic group over 2,000 years ago. Nicknamed the "Stairways to Heaven", the stone and mud wall terraces weave around the mountainsides in an awe-inspiring spectacle. It is said that if laid out flat, the narrow terraces would stretch halfway round the Earth. Complex farming and ingenious irrigation systems that use water harvested from the nearby mountaintops indicate a mastery in engineering that has been passed on down the centuries. The terraces have been vital for the survival of the Ifugao people since long before the arrival of the Spanish. To this day *bulol*, or rice deities, are placed in the terraced pond fields and granaries to bring plentiful harvests and protect against malignant spirits.

TOP The traditional art of weaving is still practiced by the local Ifugao people, with schools set up to preserve this local craft.
RIGHT A number of Banaue's buildings offer gorgeous views of the surrounding countryside.

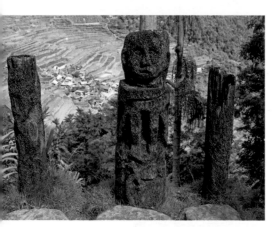

ABOVE The trail to the remote village of Batad is popular among tourists.
LEFT Ifugao totems are placed in the rice terraces. They are believed to fend off evil spirits, prevent catastrophe and encourage a good harvest.
BELOW The spectacular Tappia Waterfall near Batad plunges 130 feet (40m) and has a deep pool of water that is ideal for a refreshing dip.

A gorgeous patchwork of rice terraces can be found in Hungduan, while in Mayoyao the terraces are dotted with pyramid-shaped homes and old burial mounds (called *Apfo'or*). The use of the mounds declined as a result of the Christian influence of the Spanish and American colonizers, soon leading to their abandonment. Sadly, a number of them have since been looted for their artifacts. The oldest town of the Ifugao people is Kiangan, where a river bisects the Nagacadan cluster of terraces. It was here that the Japanese Imperial Army surrendered in 1945 to American and Filipino troops, an event that is commemorated with a large shrine.

Further north, in the province of Ilocos Norte, is one of the country's best-preserved Spanish colonial towns and undoubtedly a major highlight of the region. During the Spanish era Vigan was an important political and military center, although it was already a major trading port long before the Spanish arrived. Chinese sailing vessels laden with silk and porcelain left with beeswax, gold and other products brought to the coast from the Cordilleras. To this day horse-drawn carriages clippity-clop along the cobbled streets of the old town, which are lined with picture-perfect colonial buildings, many of which have been converted into guesthouses and museums. The wooden houses reflect Chinese or Mexican influences, embellished with ventilated walls and elegant features made by local artisans. Built in the 1820s, Quema House was once the home of one of Vigan's wealthiest merchants. It is today a

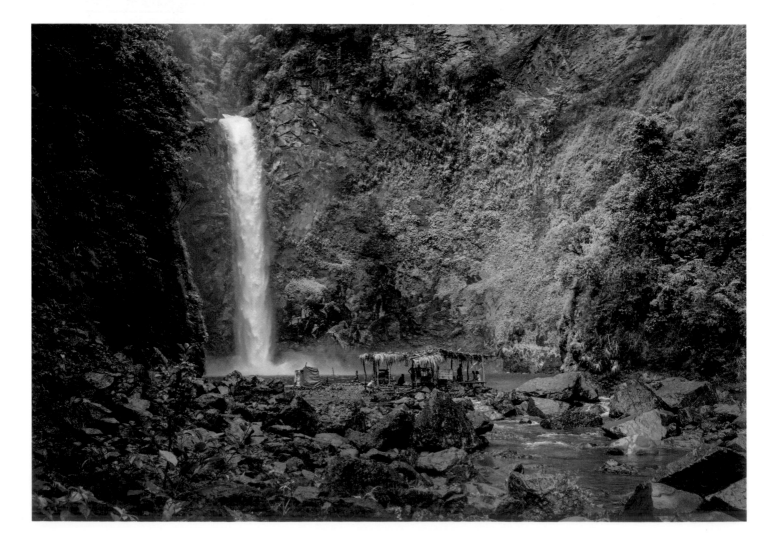

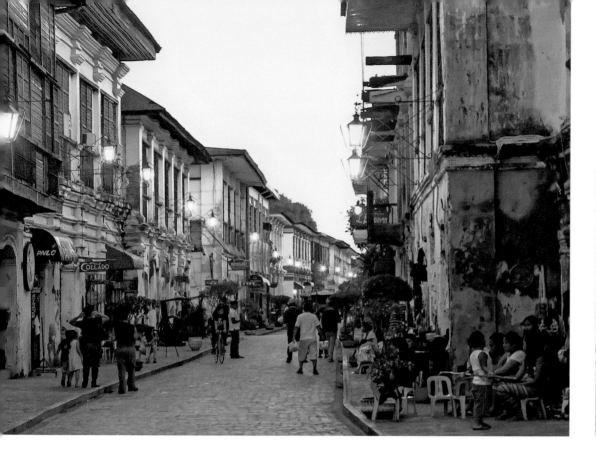

ABOVE The historic town of Vigan is characterized by fine colonial architecture that reflects Chinese, Filipino, Mexican and European influences.

BELOW The UNESCO-listed St. Augustine Church features immense buttresses and walls made of large coral stones and brick.

ABOVE RIGHT The Vigan *longganisa* sausage is a culinary specialty of the city; the Longganisa Festival is celebrated every January 22nd, during the feast of St. Paul.

RIGHT Souvenir shops, along with furniture and antique stores, line the cobbled streets of Vigan's historic center.

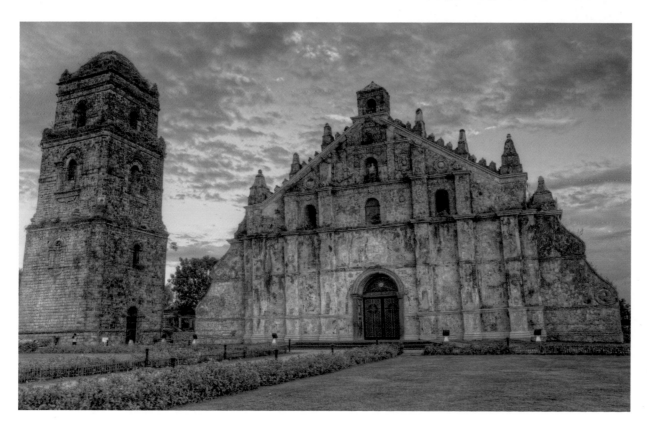

ABOVE The best place to find the famous Vigan burnay earthenware jars is Pagburnayan in Baranggay VII, in the southwest of the city.
RIGHT A reception room in the Malacañang of the North, the former holiday residence of the Marcoses in the town of Paoay.

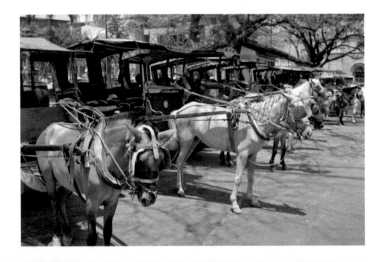

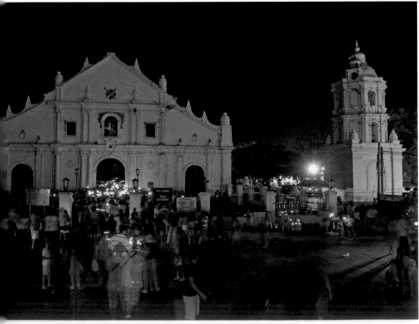

museum housing beautiful original furniture and décor, including ornate hand-painted vines on the ceiling. One of the most atmospheric times to visit Vigan is during Holy Week at Easter, when candlelit processions pass through the quaint streets and devotees flock to churches around town.

The provincial capital of Ilocos Norte, Laoag, is most associated with former President of the Philippines Ferdinand Marcos. Born in Sarrat in 1917, the Philippine dictator's old home is today the Marcos Birthplace Museum. It is really for Marcos aficionados only, displaying a set of his baby clothes, along with other family memorabilia. Marcos was brought up in the nearby town of Batac, where his refrigerated corpse is preserved at the Ferdinand Marcos Mausoleum. The site's museum includes displays tracing Marcos's political career and sheds light on his love affair with First Lady Imelda Marcos.

West of Batac in the town of Paoay is the Malacañang of the North, the sumptuous palace where Marcos spent his presidential holidays. Located on a beautiful five-hectare estate, it is today open to visitors. Part of the building showcases Marcos's major reforms, including irrigation and infrastructure programs—although nothing is said about the corruption, racketeering and embezzlement that plagued his presidency.

LEFT MIDDLE The best way to explore Vigan is by *kalesa*, a traditional horse-drawn carriage.
LEFT The Vigan Cathedral, or the Metropolitan Cathedral of the Conversion of St. Paul the Apostle, was designed in the Earthquake Baroque style and features a silver-paneled main altar.

OPPOSITE PAGE, TOP Rainbows hug the lush rolling hills and rugged coast of Batanes, the remotest of the country's provinces.
OPPOSITE PAGE, BOTTOM The Basco lighthouse has a viewing deck offering views of Batan Island and Mount Iraya, an active volcano that last erupted in the 15th century.

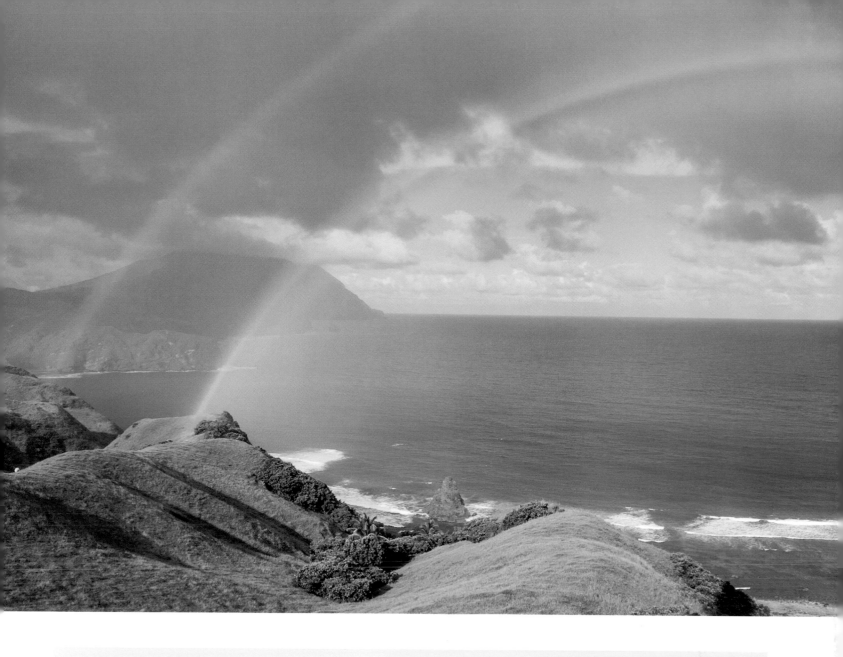

The Rolling Hills of Batanes

Located between the choppy waters of the Bashi Channel and Balintang Channel, where the Pacific Ocean merges with the China Sea, Batanes is the smallest and most isolated province of the country. Comprising just three inhabited islands (there are ten in total)—namely Batan, Sabtang and Itbayat—the language, customs and traditions here vary greatly from the mainland. Even the topography of the islands is different: the scenery will remind visitors more of the jagged coasts of northern Europe than a tropical Asian paradise.

Characterized by a rugged coastline, Batan features verdant rolling hills where cattle and horses graze in elevated pasturelands dubbed "Marlboro Country". A 30-minute boat ride takes

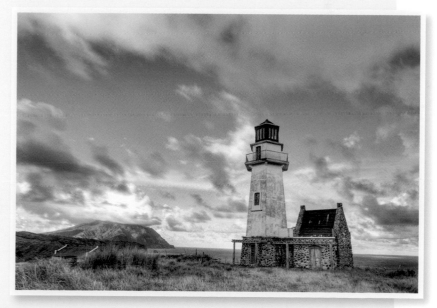

visitors across to Sabtang Island, a quiet little place with traditional villages where houses are built out of stone to withstand the destructive force of typhoons that often hit the area. The inhabitants of the islands, the Ivatan, subsist on livestock and growing yams and garlic. Some women wear rain capes made of stripped palm called *vakul* to protect themselves from the hot sun and pounding rain. The best time to visit is between February and June; during the rest of the year the islands are frequently hit by typhoons, making access almost impossible.

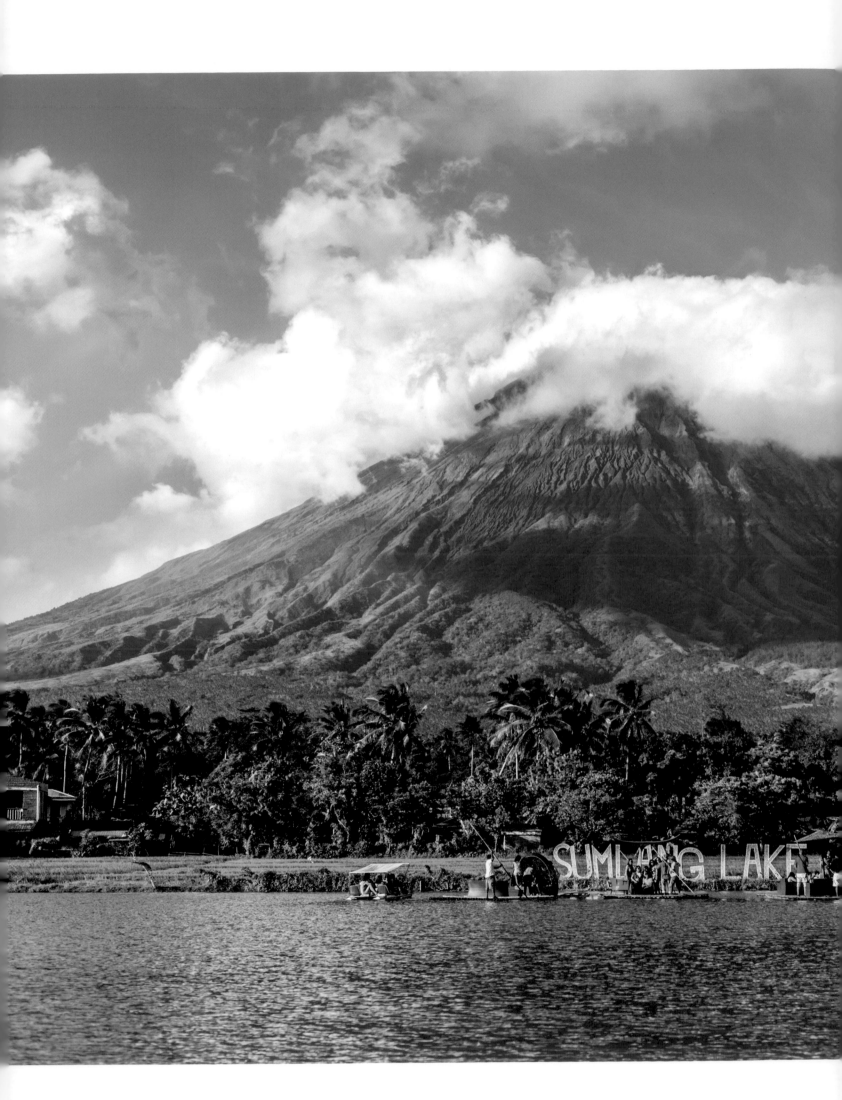

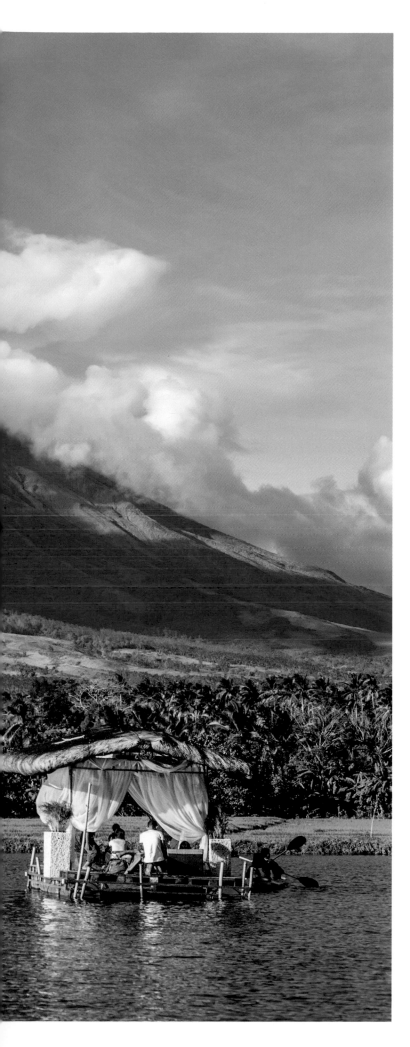

UNDER THE VOLCANO

With their powdery white beaches, hot springs, limestone cliffs and active volcanoes, the provinces south of Manila are among the most visited in the country. The region's main attraction is smoking Mount Mayon, said to have the world's most symmetrical cone. This is also one of the few places in the world where it's possible to swim with whale sharks.

Traveling from Manila, the first province visitors come across is Quezon, home to Mount Banahaw, considered by many to be a holy mountain. The dormant volcano attracts its fair share of pilgrims, and offers one of the most rewarding climbs in the country. Regular ferries connect Quezon to Marinduque, a friendly island that comes to life during the annual Moriones Festival during Holy Week. Men and women don elaborate costumes and masks that depict Roman soldiers and Syrian mercenaries, celebrating the life of Roman centurion Saint Longinus.

Further east from Quezon is the Bicol region, which occupies the rest of southern Luzon, renowned for its delicious cuisine characterized by the use of chilies and coconut. The area's most famous dish is Bicol Express, a stew made with chilies, coconut milk, shrimp paste, onion, garlic and pork.

The university city of Naga is one of the liveliest spots in the country, offering fun nightlife and an excellent dining scene. East of here is Mount Isarog National Park, an area of outstanding beauty and home to the second highest peak in southern Luzon, Mount Isarog. The wild and rugged Caramoan Peninsula is one of southern Luzon's main draws, with its awe-inspiring limestone formations and white sand beaches that served as the setting for the 2008 French reality-TV series *Survivor*. Today, the area's beautiful rugged scenery attracts its share of visitors, although

LEFT The wonderfully symmetrical cone of Mount Mayon is deceptive —this is one of the country's most active volcanoes.

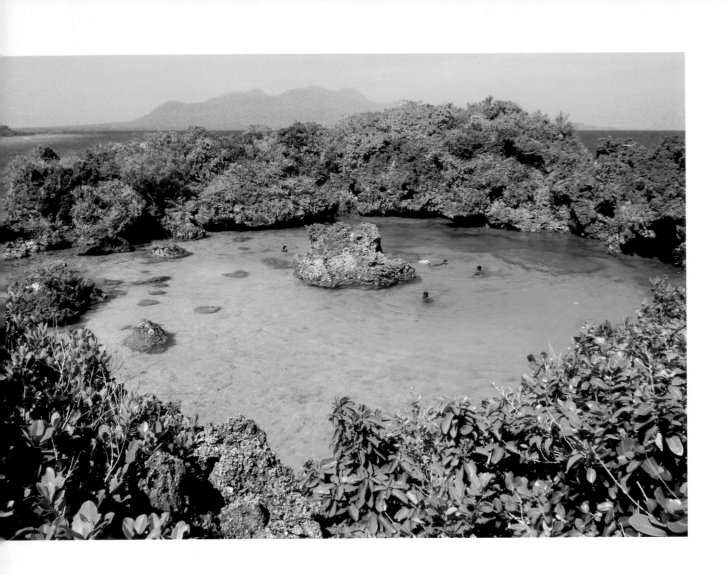

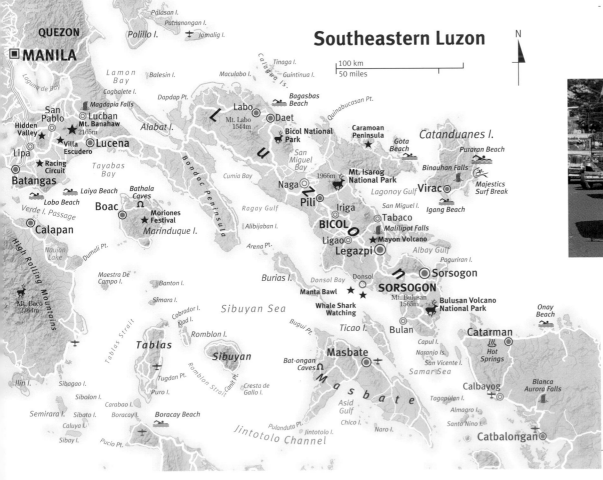

Southeastern Luzon

N

100 km
50 miles

QUEZON
■ MANILA

Pálasan I.
Patnanongan I.
Polillo I.
Jomalig I.

Lamon Bay
Balesin I.
Cagbalete I.
Laguna de Bay

San Pablo
○ Lucban
★ Magdapia Falls
○ Mt. Banahaw
2165m
Villa Escudero
○ Lucena

Hidden Valley
Lipa
★ Racing Circuit
Batangas

Tayabas Bay

Lobo Beach
Laiya Beach
Verde I. Passage
Boac

Calapan

Nuujan Lake

High Rolling Mountains

Maestra De Campo I.
Mt. Baco 2464m

Ilin I.
Sibagao I.
Sibolon I.
Semirara I.
Sibato I.
Caluya I.
Sibay I.
Pucio Pt.

Carabao I.
Boracay I.
Boracay Beach

Dapdap Pt.
Maculabo I.
Labo
○
Mt. Labo 1544m
○ Daet

Bondoc Peninsula

Bathala Caves
Ω
Moriones Festival
★
Marinduque I.

Banton I.
Simara I.
Cobrador I.
Alad I.
Romblon I.
Tablas
Sibuyan
Tugdan Pt.
Puro I.
Cresta de Gallo I.

Tablas Strait
Romblon Strait
Canit Pt.

Sibuyan Sea

Tinaga I.
Guintinua I.
Catanduag Is.

Bagasbas Beach
Quinabucasan Pt.

Bicol National Park
Caramoan Peninsula
Gota Beach

San Miguel Bay

Cumia Bay
1966m
Mt. Isarog National Park
Naga ○
Pili

Ragay Gulf

Lagonoy Gulf

Alibijaban I.
Iriga
Arena Pt.

BICOL
Ligao
Legazpi

Burias I.

Manta Bawl
★
Whale Shark Watching

Ticao I.

Bat-ongan Caves
Ω
Masbate
○

Asid Gulf

Pulanduta Pt.
Jintotolo I.
Jintotolo Channel

Bugui Pt.

Naro I.

Puraran Beach
Catanduanes I.

Binauhan Falls
Virac ○
Majestics Surf Break

San Miguel I.
Igang Beach

Tabaco
Malilipot Falls
★ Mayon Volcano

Albay Gulf

Paguriran I.
Sorsogon ○
Donsol
SORSOGON ○
Mt. Bulusan 1565m
Bulusan Volcano National Park

Bulan

Capul I.
Naranjo Is.
San Vicente I.
Samar Sea

Calbayog

Tagapulan I.
Almagro I.

Santo Nino I.

Catbalongan ○

Catarman
Hot Springs

Onay Beach

Blanca Aurora Falls

ABOVE The country's most popular means of transport, jeepneys are painted in bright showy hues, adding a blast of color to the streets.

TOP Lying just off the coast of Sorsogon, Paguriran Island comprises an emerald-green rocky lagoon with coral formations.

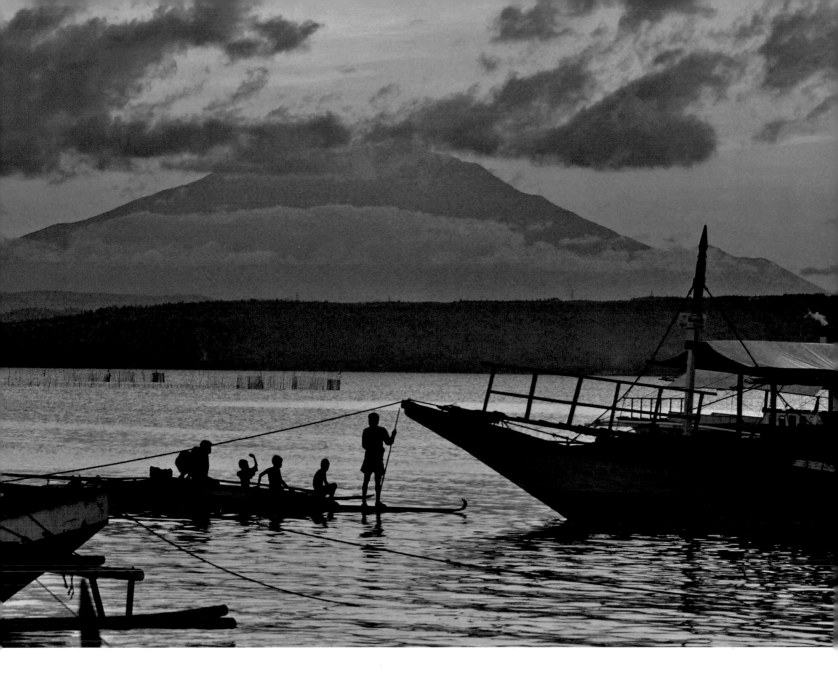

it largely remains off the tourist radar. Bangkas connect the Caramoan Peninsula to Catanduanes, a wild craggy island with a smattering of surfable beaches. The most popular is the laidback Puraran Beach, known as "Majestic" after its renowned surf break, which attracts surfers between July and October when swells come in from the Pacific.

The largest city of the Bicol region is Legazpi, which serves as a major transport hub. Looming over the city is Mount Mayon, said to have the world's most symmetrical cone. Its beauty is deceptive: it has erupted over 40 times, and is one of the country's most active volcanoes.

Offering a wide range of accommodation, the provincial capital of Sorsogon City, in Sorsogon Province, west of Legazpi, serves as a base to explore the area. The Kasanggayahan Festival in the city sees crowds descend onto the streets to celebrate Sorsogon's foundation as a province, with dancers in traditional dress, parades and beauty pageants.

South of Sorsogon City is Bulusan Volcano National Park, dominated by one of Bicol's three active volcanoes. It is possible to ascend the volcano, although it's vital to check the current situation; in late 2010 a series of ash explosions halted all trekking activities.

ABOVE The sun sets at Cagbalete Island, bathing Mount Banahaw in an orange hue.
BELOW Street dancing at the yearly Magayon Festival in Legazpi City, which celebrates the region's beauty.

Swimming with Whale Sharks and Manta Rays

Known as *butanding* in the Philippines, whale sharks are the world's largest fish. They gather in the warm waters of Donsol Bay during the northern monsoon season (December–May), thanks to the area's abundant concentration of plankton and krill. Their mouths, which spread open to a whopping five feet (1.6m) wide, gulp down gargantuan quantities of plankton that are filtered through the sharks' gills. They measure about 40 feet (12m) in length and weigh around 14 tons. Normally solitary creatures, the whales of Donsol can be found in schools of up to 100 creatures. Unfortunately, whale sharks are currently endangered. In recent years efforts to preserve these gentle giants have increased and restrictions put in place. Before heading out to sea, snorkelers are briefed on how to behave in the water when swimming with these gracious titans.

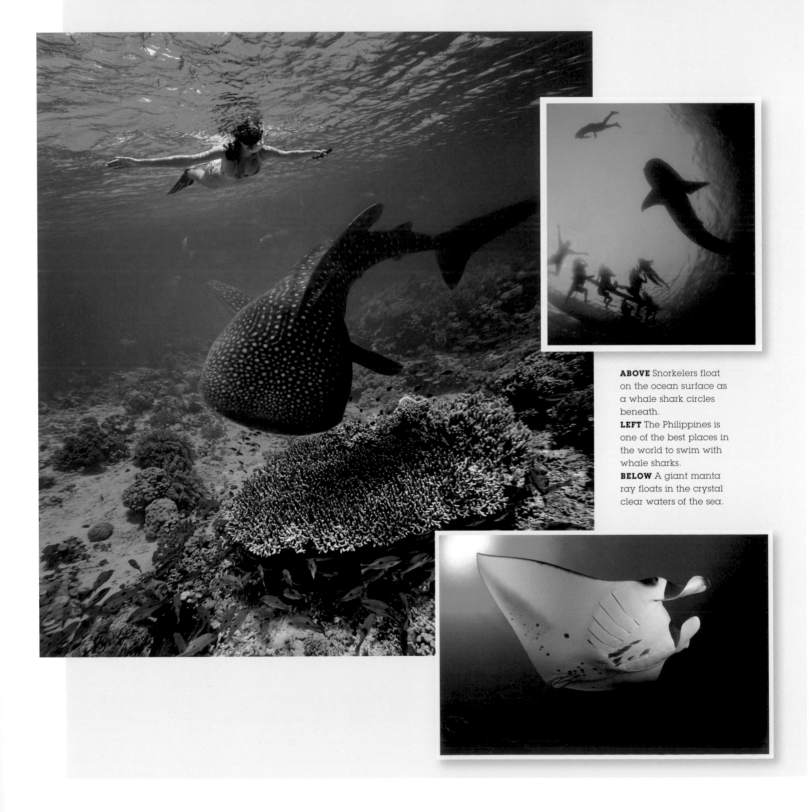

ABOVE Snorkelers float on the ocean surface as a whale shark circles beneath.
LEFT The Philippines is one of the best places in the world to swim with whale sharks.
BELOW A giant manta ray floats in the crystal clear waters of the sea.

Said to attract the largest concentration of whale sharks in the world, Donsol serves as a jump-off point not only for snorkelers, but also for experienced divers keen to visit Manta Bowl near Ticao Island, an underwater atoll where sightings of manta rays and whale sharks are common, along with hammerhead sharks and thresher sharks.

The southernmost province of southern Luzon is Masbate, which lies at the center of the archipelago. It comprises three islands, the largest of which is Masbate, the country's ranch capital. Cattle rearing and farming can be traced back to the galleon trade, when cattle was imported from Mexico. Second only to Bukidnon in Mindanao for cattle farming, the island's main source of livelihood is agriculture, while fishing is a major industry along the coast. Masbate is also one of the country's leading exporters of crabs; the tourist office in Masbate City can help organize a visit to a crab production plant in the small town of Placer on Masbate's southwest coast. Among the island's major events and festivities is the annual Masbate Rodeo Festival in May, when cowboys and cowgirls sport Western-style clothes and compete in a series of events that include cattle wrestling, bull riding and lassoing.

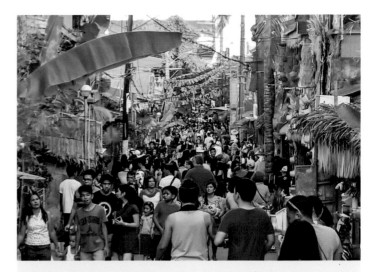

Lucban's Pahiyas Festival

The small town of Lucban bursts with color during the annual Pahiyas Festival held in May, when houses are decorated with all manner of fruits, vegetables and other produce. Held in honor of San Isidro de Labrador, the patron saint of farmers, celebrations are an expression of gratitude for bountiful harvests. Farmers decorate their houses with grains of rice, radish and other produce, while craftsmen display bags, placemats and other handcrafted products. Butchers often place the heads of *lechon* (suckling pig) in the windows. The most traditional décor is undoubtedly *kiping* (rice paper), tied together in beautiful displays that form a range of shapes, from cascading chandeliers to bouquets. Made from ground rice, *kiping* is colored in a kaleidoscope of vibrant tones, including red, yellow and green. Each household tries to outdo the next in a friendly competition. The winner of the best-decorated house is blessed by San Isidro for the coming year.

ABOVE A street parade marks the opening of a sports competition in Sorsogon.
RIGHT A one-hour *bangka* boat trip from Masbate City, Ticao Island features lush verdant forest and clear tropical waters.
TOP RIGHT Brightly colored foodstuffs, including fruits, vegetables and rice, decorate the façade of houses during Lucban's Pahiyas Festival, held in honor of the patron saint of the farmers, St. Isidore the Laborer or San Isidro Labrador in Spanish.

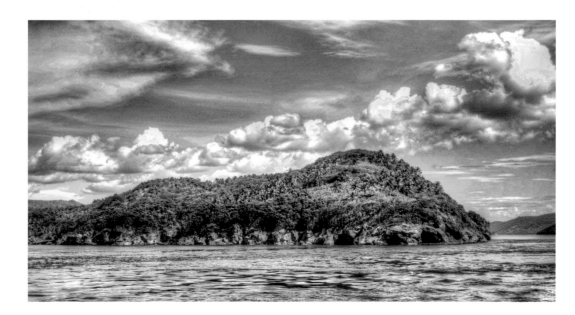

A POPULAR GETAWAY FOR DIVERS AND NATURE BUFFS

A popular weekend destination for Manileños, Mindoro is a rugged wild island with a lush verdant interior and laidback fishing villages sprinkled along the coast. It is the seventh largest island of the archipelago, offering some of the best diving in the world.

Declared a UNESCO Man and the Biosphere Reserve, Puerto Galera, in the province of Mindoro Oriental, has around 30 listed dive sites, attracting diving enthusiasts from the world over thanks to its hugely diverse coral reef that thrives with underwater species. The town was founded by the Spanish in 1574, and once served as an important port (*Puerto Galera* is Spanish for "Port of the Galleons"). Today, it is a favorite spot for yacht lovers, whose boats lie anchored in the bay, and divers, who pour into the resort throughout the year. During holidays it can get extremely crowded. While the town itself is a pleasant spot with its palm-fringed bay and green hills, most tourists base themselves in the nearby beaches of Sabang, three miles (5km) east, and White Beach, five miles (8km) west. Popular with foreign tourists, Sabang is lined with restaurants, hotels and dive schools. However, in recent years, it has seen a string of girlie bars open, catering to an international clientele. Its beach is unremarkable, although there are some more attractive spots nearby, including Small La Laguna and Big La Laguna. Popular with Filipinos and backpackers, White Beach is a lovely stretch of sand offering affordable accommodation in cottages and small resorts.

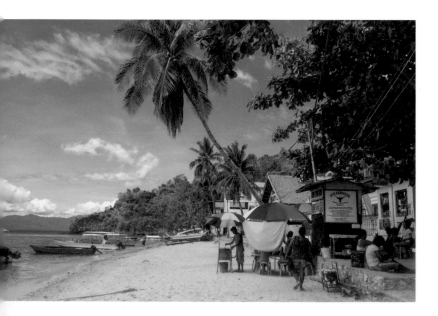

RIGHT A dive boat in Puerto Galera is moored in shallow water; the resort offers some of the country's most diverse coral reef diving, attracting scores of scuba enthusiasts.
BELOW Sabang is set in a pretty verdant cove with dive boats bobbing along the shoreline.
OPPOSITE PAGE, BELOW Sabang beach is lined with hotels and restaurants that bustle with customers at all times of the day.

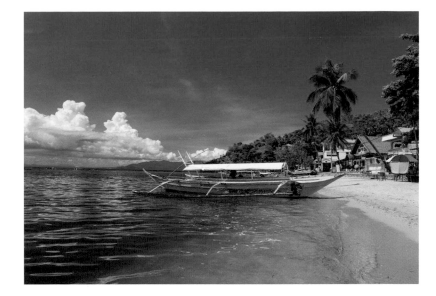

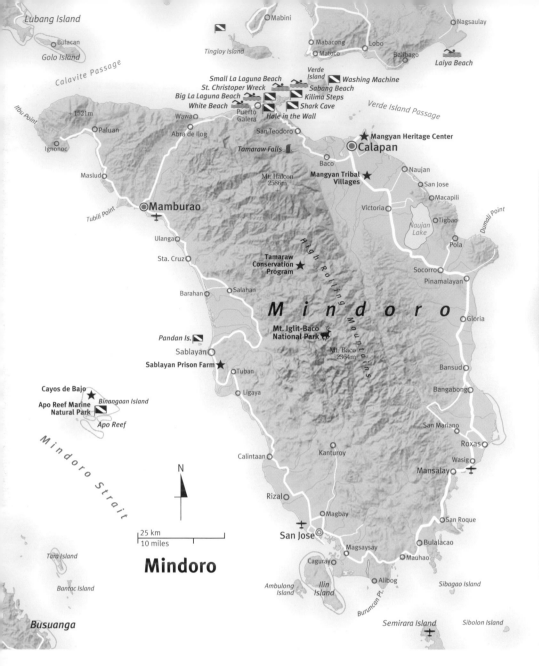

ABOVE Two Iraya-Mangyan elders watch life go by; the Iraya subsist on root crops, rice, banana and sweet potatoes.

LEFT Trekkers wade through a river on the trail to Mount Halcon, Mindoro's highest peak. The area is surrounded by thick rainforest.

TOP Mangyan tribal villages featuring traditional *nipa* houses are easily accessible from Puerto Galera town.

RIGHT An off-the-beaten-path location, San Jose in the southwest of Mindoro features three offshore islands for watersports and diving, as well as a great point to depart for Apo Reef Marine Park.
BELOW The endangered tamaraw, a dwarf buffalo endemic to the island, inhabits the foothills of Mount Iglit-Baco National Park.
BOTTOM Tourists walk through an Iraya village in Baclayan.

Traveling around the two provinces, visitors may well come across the island's original inhabitants, the Mangyan, comprising eight indigenous groups. The tribespeople practice swidden farming (shifting cultivation), subsist on rice and root crops, and are skilled in weaving. The Mangyan Heritage Center in Calapan, the city port and capital of Mindoro Oriental, is a research and education center that provides an insight into the lives of the Mangyan. Visits to Mangyan tribal villages can be organized through travel agents; guides are essential, as they can advise on cultural etiquette and serve as interpreters.

The town of Calapan is also a jumping off point for treks up Mount Halcon, considered by many to be the most challenging peak to climb in the country. Surrounded by dense rainforest, the mountain sees heavy rain most days of the year, resulting in an abundance of fauna and flora, including pitcher plants and dripping moss.

Avid climbers can also test their skills in the tropical wilderness of Mount Iglit–Baco National Park, covering the central part of the island. As well as being the habitat of deer, wild pig and endemic bird species including the Mindoro scops owl, the park is the home of the critically endangered tamaraw, or Mindoro dwarf buffalo, a hoofed mammal with distinct V-shaped horns. Over the last century, poaching, disease and deforestation have resulted in their near decimation. In recent years concerted efforts have been made to double the population. It's possible to visit the Tamaraw Conservation Program, a lab where scientists breed the animals in captivity before releasing them into the wild.

ABOVE Set among the verdant hills of Mindoro, the Malasimbo Music and Arts Festival features national and international artists playing soul, jazz and world music, along with a splash of electronic and hip-hop.
LEFT Lubang Island off the northwestern coast of Mindoro has several caves to explore.
BELOW The sun sets over the coast of Sablayan in the province of Mindoro Occidental, bathing the sea in an explosion of flaming hues.

Tours depart regularly from Sablayan to Apo Reef Marine Natural Park, one of the world's greatest dive destinations. The second largest contiguous reef in the world, its corals occupy 13 square miles (34 sq km) of reef that teem with marine life. There are two main atolls separated by channels, while three islands mark the area—Cayos de Bajo, Binangaan and Apo, the largest. The diving here is truly spectacular, with common sightings of turtles, sharks and manta rays.

Yet, Mindoro isn't only about diving. The yearly Malasimbo Music and Arts Festival, set amid tropical palm-fringed hills in a grass-terraced amphitheater overlooking the bay, is the first of its kind in the Asia-Pacific region. It showcases the country's best musical talents, with jazz, hip-hop, dub reggae, psych DJs and rock bands taking center stage. The three-day festival includes a cultural program featuring art installations, daytime workshops and wild boat parties.

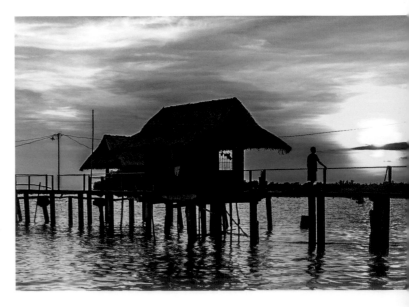

The Apo Reef Marine Park

Famous for its marine life and drop-offs, Apo Reef Marine Natural Park is one of the world's great dive destinations, harboring most of the Philippines' 450 species of coral, along with schools of trevally, tuna and barracuda. Blacktip reef sharks, turtles, manta and eagle rays are also bountiful.

The waters around Puerto Galera offer something for everyone, from sheltered coral reefs for amateurs to drift dives for the more experienced. In the daytime the small Shark Cave is a common resting site for whitetip reef sharks, while Hole in the Wall offers divers a good chance to see snappers, scorpion fish and giant trevally,

as well as soft corals such as gorgonian fans. At Kilima Steps divers will be able to spot soap fish, moray eels, lionfish and octopuses. St Christopher is an old wooden diving boat that is today home to snappers, batfish, emperor angelfish and the curious frogfish. Canyons is considered to be one of the top dive sites among experienced divers, with its strong drift dive and teeming sea life of sweetlips, groupers, turtles and octopuses. Verde Island Washing Machine provides an exhilarating thrill with its shallow gullies and strong current, tossing divers in all directions (hence the name). Sightings of frogfish and banded sea snakes are common here.

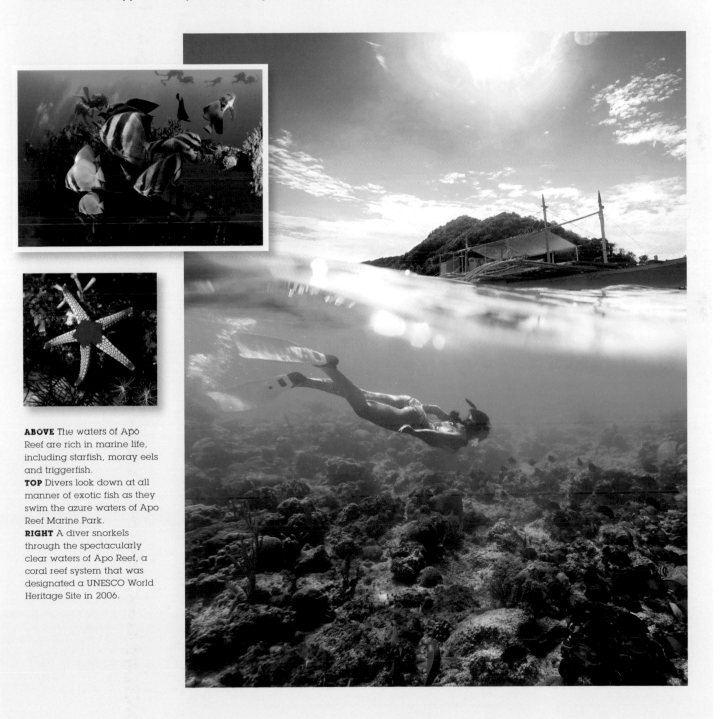

ABOVE The waters of Apo Reef are rich in marine life, including starfish, moray eels and triggerfish.
TOP Divers look down at all manner of exotic fish as they swim the azure waters of Apo Reef Marine Park.
RIGHT A diver snorkels through the spectacularly clear waters of Apo Reef, a coral reef system that was designated a UNESCO World Heritage Site in 2006.

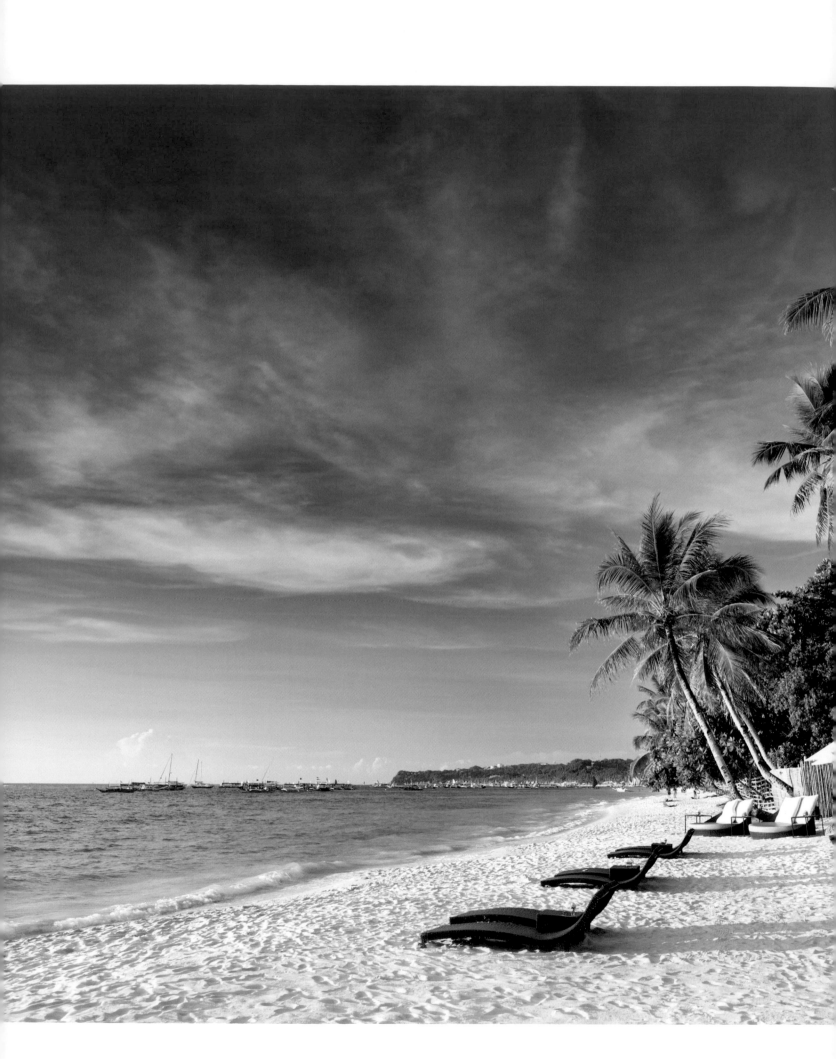

BELOW With powdery white sand beaches framed by coconut trees, Boracay is the country's ultimate beach destination.

BELOW RIGHT Boracay is a paradise for outdoor activities, including beach volleyball, fly-boarding and jet skiing.

BORACAY & THE WESTERN VISAYAS

ENDLESS SUN, SEA & SAND

The country's top tourist destination, Boracay is famed for its gorgeous White Beach—a two-and-a-half mile (4km) stretch of pristine white sand lined with hotels, cafes, restaurants and dive shops.

In recent years Boracay's explosive growth has resulted in a plethora of large resort-style hotels competing for the island's most attractive spots; touts roam the beaches and blaring music means visitors don't get to curl up in bed any time before midnight. It's still possible, however, to find authenticity and the odd quiet corner. While White Beach is the center of the action with its excellent dining scene and fun nightlife, Bulabog Beach is a popular kitesurfing destination. On the north coast is Puka Beach, named after the shiny white *puka* shells that are found in the sand. It is possible to ascend Mount Luho, an easy climb offering spectacular 360-degree views of the island. Boracay offers the largest array of activities anywhere in the country, including a variety of watersports—jet skiing, sailing, boat hire, waterskiing, kayaking, parasailing, flyboarding, banana boat rides, to name a few—and land sports such as zorbing, horse-riding, mountain biking and zip-lining. While the diving isn't as varied as that of Puerto Galera, there are plenty of dive sites around the island that can easily be accessed by *bangka*. The islands of Big and Small Laurel have some of the region's bests soft coral, with shoals of snappers, sea snakes, morays and puffers, while Yapak harbors wahoo, barracuda, tuna and grey reef sharks.

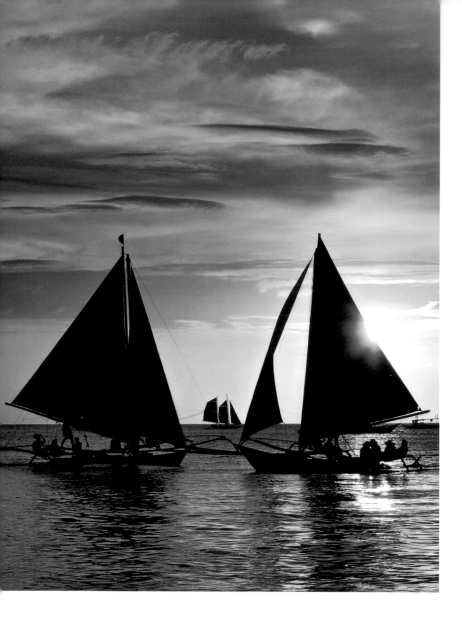

LEFT Sailing the azure waters of Boracay at sunset is one of the island's most popular activities.
BELOW White Beach, divided into Station 1, 2 and 3, has a range of restaurants, bars and coffee shops, all at very reasonable prices.
BOTTOM In recent years luxury accommodation has sprung up around the island, largely catering to moneyed foreign tourists.

Comprising three islands, the province of Romblon, north of Boracay, largely remains off the tourist trail, with its wild rugged interior, deserted beaches and coral reefs. One of the country's most unique sites for divers, the little-known Blue Hole, is found on the island of Tablas. Divers descend about 80 feet (25m) through a volcanic chimney measuring about 20 feet (6m) in diameter before reaching a giant chamber that opens up into the sloping seabed. Lobsters can be seen clinging on the ceiling of the cave, while giant moray eels, blacktip reef sharks, manta and eagle rays, and schools of tuna and barracuda are frequent sightings.

While Boracay is undoubtedly the party island of the Philippines, Panay, to the south of Boracay, hosts the country's biggest and most spectacular fiesta: the Ati-Atihan Festival. Taking place in the second week of January, the festival celebrates the original inhabitants of the area, known as the Ati, with revelers covering their faces with soot and dancing through the streets.

BELOW Motorized tricycles shuttle locals and tourists along Boracay's sand-swept roads.
BELOW RIGHT Tourists photograph Willy's Rock, a volcanic rock formation that juts out into the island's crystal clear waters.

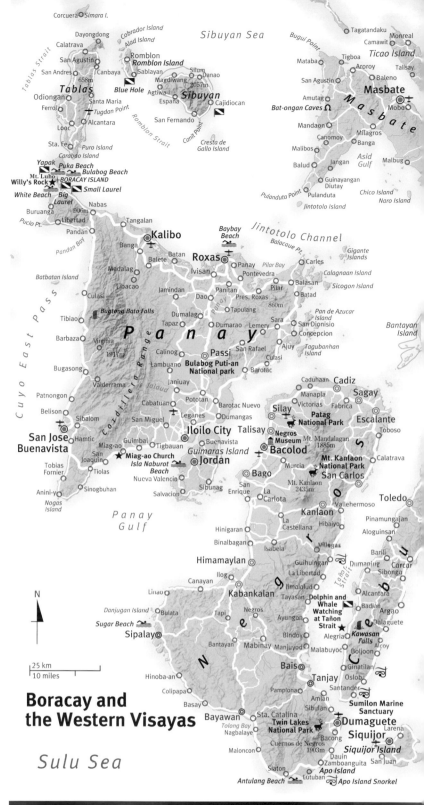

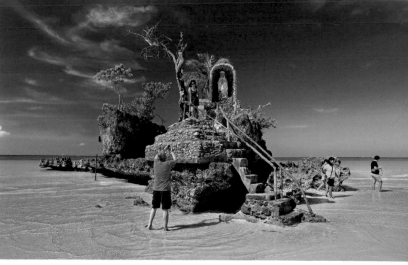

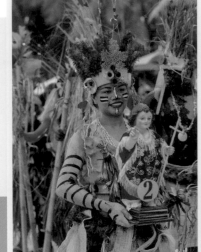

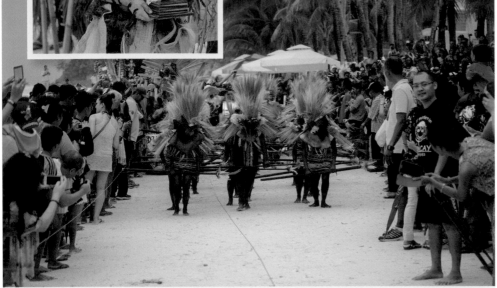

LEFT A woman parades along the streets carrying a statue of the Santo Niño, or Infant Jesus.
BELOW Celebrants cover their bodies in soot to recall the dark skin of the Atis, or Negritos, the early settlers of the island.
BOTTOM LEFT A man dons an elaborate indigenous costume representing one of the tribes of the Ati people.
BOTTOM RIGHT A young woman in traditional costume parades to the sound of music and drumming during the annual Ati-Atihan Festival.

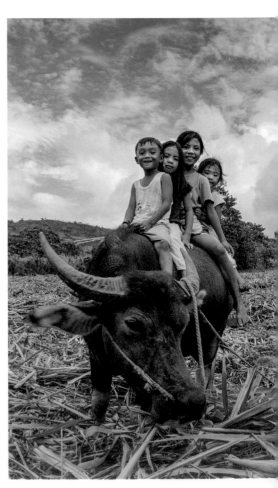

The Ati-Atihan Festival

Held annually in honor of the Santo Niño, the festival's origins can be traced back to the 13th century when Malay chieftains from Borneo settled in the area by celebrating with a ritual dance. They covered their faces in soot to mimic the dark skin of the Atis, the island's native inhabitants (*Ati-Atihan* means "to be like an Ati"). Spanish friars later adapted the festival to honor the Holy Infant Jesus. The two-week celebrations feature elaborate dresses and blackened bodies dancing through the streets to the sound of pounding drums, with the festival culminating in a procession on the third Sunday of the month.

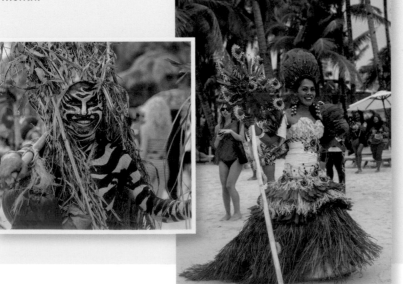

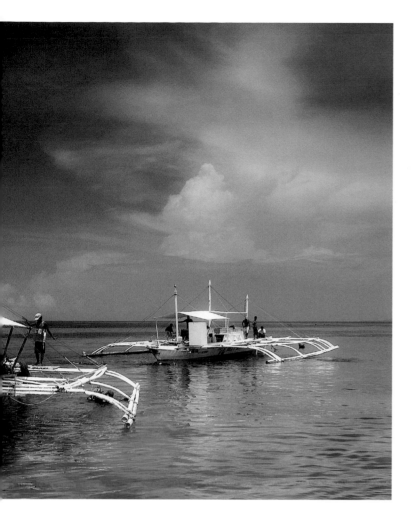

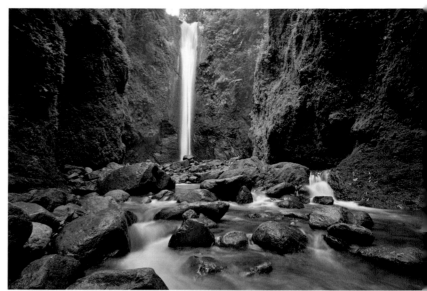

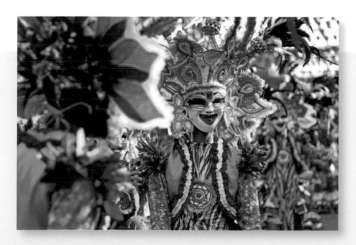

LEFT Traditional Philippine *bangkas* ply the emerald waters of Negros Island.
LEFT BELOW Boisterous costumes at the MassKara Festival feature colorful masks adorned with smiling faces.

ABOVE Water cascades into a rocky river basin from a height of over 100 feet (30m) at the narrow Casaroro Falls.
OPPOSITE PAGE, BOTTOM RIGHT Children ride a carabao, that is, a domestic water buffalo.

The MassKara Festival

Combining the word "mass", referring to a crowd, and "cara", the Spanish word for "face", MassKara both means "mask" and "many faces". Undoubtedly one of the country's most colorful festivals, it features participants in vibrant costumes with masks embellished with plastic beads and sequins, often adorned with striking feathers and flowers. The festival is characterized by beauty pageants, street parades, live music, sporting events, dance contests and even pig-catching competitions.

Lying at the heart of the Visayas, boot-shaped Negros is the country's fourth largest island and is divided in two provinces: Negros Occidental and Negros Oriental. The Spanish, who arrived here in 1565, called the island "Negros" after the dark skin of its inhabitants. The Negrito ethnic group were swiftly converted to Christianity. Dubbed "Sugarlandia", the island grows two thirds of the country's sugarcane, with farms and mills producing raw sugar from cane grown in the north and west. About 13 miles (20km) north of Bacolod, the island's largest city, Silay, is dubbed "the Paris of Negros". It is an elegant town dotted with the grand colonial homes of former sugar barons, many of which were built between 1880 and 1930. The houses are today the town's main tourist attraction, with their polished mahogany floors, elaborate furnishings and antiques that provide an insight into the opulent lives of sugar barons.

The city of Bacolod is an important sugar exporter and is famous for its version of barbeque chicken called *inasal na manok*, as well as for its delicious seafood, including steamed shrimps, grilled squid, urchin and chili crabs. Known as the "city of smiles", Bacolod is famous for its boisterous MassKara Festival, which takes place in October. When world prices for sugar plummeted in the early 1980s, the city suffered a major crisis. The festival was inaugurated as a means to lift people's spirits, and to this day it is representative of the Negrenses' staunch character and ability to put on a smile when confronted with difficulties. Revelers don flamboyant masks and colorful costumes embellished with beads and sequins, and dance through the city streets to the sound of beating drums. The Negros Museum in Bacolod houses a collection of displays spanning 5,000 years of local history, including a section dedicated to the island's sugar production that includes the early 20th century steam locomotives that were once used to transport sugar from the plantations.

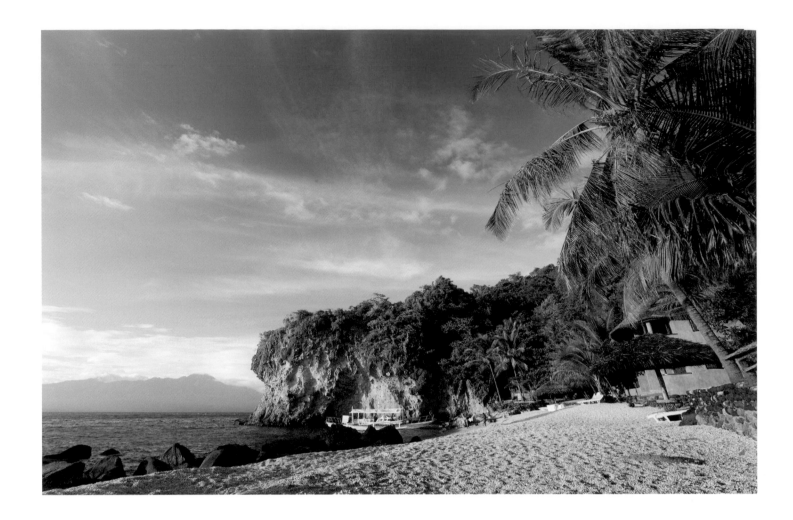

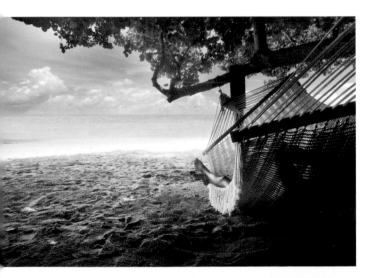

ABOVE Volcanic Apo Island's powdery golden beaches and wonderfully clear waters are a magnet for scuba divers.

LEFT A tourist soaks in the gorgeous sea view as she swings in a hammock.

BOTTOM LEFT The waters off Apo Island teem with marine life; here, a turtle swims over a coral reef.

OPPOSITE PAGE, TOP & MIDDLE A folk healer concocts a remedy of herbs and plants.

OPPOSITE PAGE, BOTTOM Multi-tiered waterfalls of natural spring water create emerald green lagoons at Cambugahay Falls.

BELOW Rich in verdant mangrove vegetation, the beautiful Apo Island is lapped by crystal-clear waters.

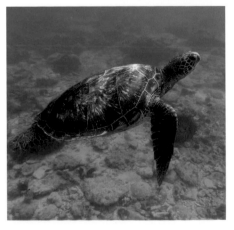

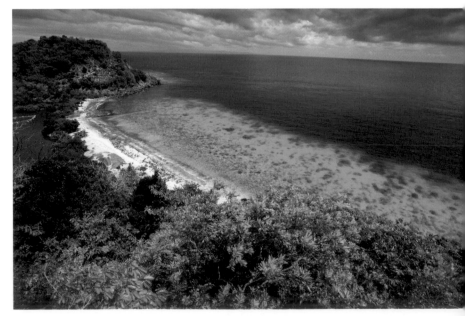

About 22 miles (36km) southeast of Bacolod is Mount Kanlaon, one of the country's most active volcanoes. It is the tallest peak of the central Philippines, and its most active, posing a dangerous challenge to climbers. It has erupted more than 20 times over the last hundred years, and was placed on high alert in November 2015 when an explosion caused a one-mile (1.5km) high plume above the summit.

Traveling south is the town of Sipalay, a jumping-off point to the surrounding islands and spectacular beaches, the most notable of which is Sugar Beach. It is an unspoilt stretch of powdery sand shaded by coconut trees, where visitors inevitably stay longer than planned, swinging in a hammock with a book in hand and swimming in the crystal-clear waters.

To the southeast of Sipalay is Dumaguete, the best departure point to get to the marine reserve at Apo Island, which offers exceptional diving. This was one of the Philippines' first marine reserves, home to some 650 species of fish and 400 species of coral (most of the country's species of coral can be seen here). With 15 dive sites featuring impressive drop-offs and sea walls, it is a prime destination for divers—although it also offers plenty to do for non-divers, including exceptional snorkeling and the possibility to walk around the volcanic Apo Island.

To the northeast of Apo Island is Siquijor, a laidback island coated in an aura of magic and mystery. The Spanish nicknamed it "Isla del Fuego", or "Island of Fire", after the glow of fireflies that cast light on the island at night. Today it remains veiled in mystery, with most Filipinos believing it to be a center of witchcraft and folk-healing practices. While visitors may well come across local faith healers and shops selling amulets, charms and potions, the island remains a peaceful picturesque spot, with gorgeous beaches and mountain trails that criss-cross the jungled interior.

A Filipino Folk Healer

Herbalists and folk healers have long called Siquijor their home, attracting Filipinos from around the country who venture to the island to seek their advice and remedies.

Mananambal (healers) gather herbs and plants from the island's mountainous interior, caves and seas, including bark, minerals and starfish, which are believed to have curative properties. Every year during Holy Week tourists and Filipinos alike flock here to witness the island's healers gather indigenous ingredients and prepare them into medicinal potions.

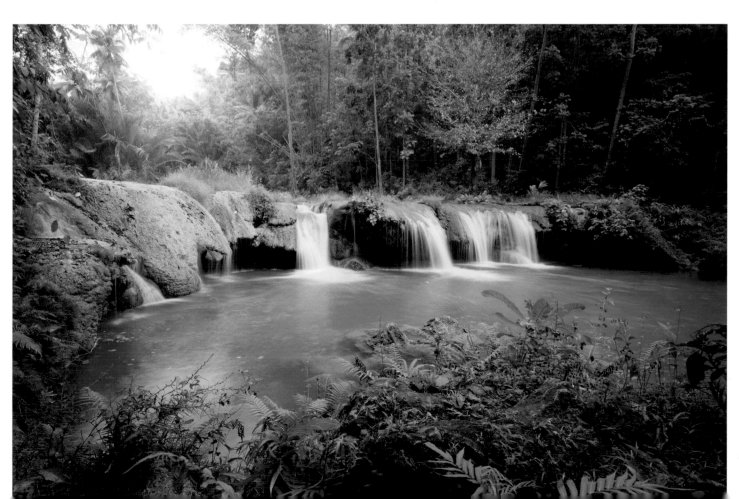

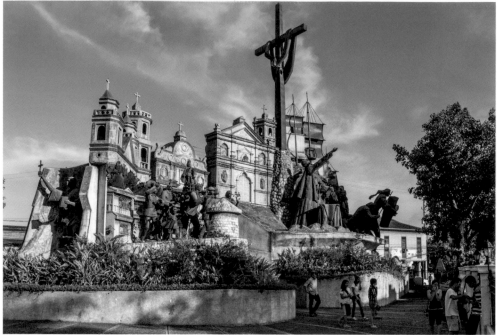

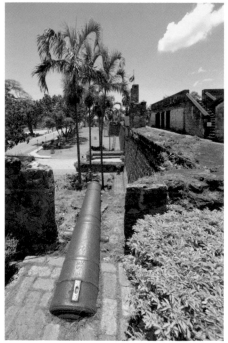

ABOVE The Heritage of Cebu Monument is a tableau of sculptures depicting key events in the history of the island.

ABOVE RIGHT Cebu is a busy metropolis and a global transport, shipping and tourism hub.

LEFT Now comprising a handful of walls and ramparts, Fort San Pedro was built by conquistador Miguel López de Legazpi when he arrived in the country in the 16th century.

RIGHT Women in colorful dress dance to the sound of drums during the cultural and religious Sinulog Festival, which takes place on the third Sunday of January.

BELOW The Spanish flag was lowered at Fort San Pedro in 1898, marking the end of three centuries of Spanish rule in Cebu.

OPPOSITE PAGE, RIGHT The beautifully painted ceiling of the circular crypt housing the Cross of Magellan depicts conquistador Ferdinand Magellan's landing in Cebu in the 16th century.

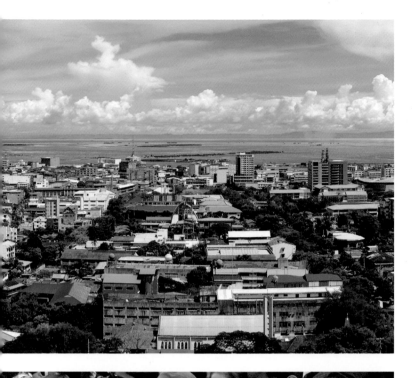

HISTORIC SECOND CITY OF THE NATION

Lying at the heart of the Visayas, the island of Cebu is a major transport hub and home to the Philippines' second largest city. Visitors will inevitably pass through here as they explore the gorgeous Visayan islands, home to palm-fringed beaches and some of the country's most impressive natural attractions.

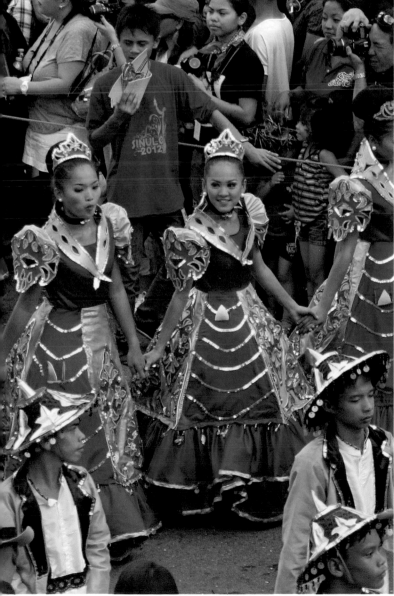

The country's second largest city, Cebu City was the birthplace of Catholicism in the Philippines. This is where Ferdinand Magellan, the first conquistador to reach the islands, set foot in the country in 1521. A circular crypt houses the Cross of Magellan, which Magellan allegedly used to baptize the chieftain of Cebu, his wife Juana and their followers. The cross visitors see today is a reproduction said to contain a few fragments of the original.

A short walk from here is Cebu Cathedral, which houses the most important religious icon of the Philippines, the statue of the Santo Niño (Child Jesus). It is believed Magellan presented it to Queen Juana following her baptism, and is said to have been the very first in Asia. Devout followers can be seen queuing for hours to take a glimpse of the statue, which is paraded through the streets during Cebu's annual Sinulog Festival held in honor of the Santo Niño.

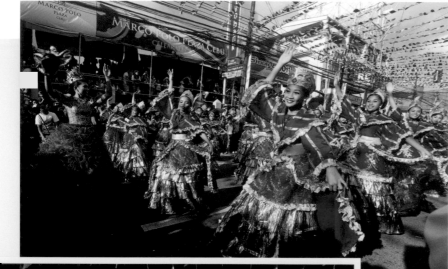

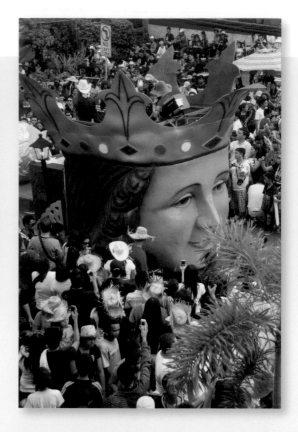

Cebu's Sinulog Festival

Culminating on the third Sunday of January in Cebu City, the Sinulog Festival is held in honor of the patron saint of Cebu, Santo Niño. The statue of the Child Jesus is brought to the island by boat, dripping with garlands and candles, and is marched through the streets in a boisterous fiesta. The festival is named after a sensual dance that moves to the sound of drums, said to resemble the current (*sinulog*) of Cebu's Pahina River. The natives danced to the *sinulog* in honor of their wooden idols and *anitos* (spirits) long before the arrival of the Spanish. When Christianity was introduced to the island, the dance acquired Catholic elements, and *cebuanos* began to dance in honor of the revered Santo Niño statue, which is currently enshrined in the city's cathedral.

ABOVE Pilgrims from around the country congregate outside the city's Basilica del Santo Niño to witness the replica image of Santo Niño being taken through the streets during a dawn procession.
TOP LEFT Spectators admire brightly dressed dancers performing the Sinulog ritual dance in honor of the Santo Niño.

RIGHT Participants at the Sinulog Festival don Filipino- and Hispanic-inspired costumes.
TOP RIGHT Onlookers watch in awe as a large float is exhibited at the annual Sinulog Festival.

LEFT *Bangkas* are widely used for fishing and can also bring travelers on island-hopping tours around Cebu.

BELOW This 65-foot (20m) bronze shrine depicts native leader Lapu-Lapu, who defeated invading Spanish soldiers at the Battle of Mactan in 1521.

ABOVE A couple enjoy kayaking at Plantation Bay and Spa Resort in southeastern Cebu.

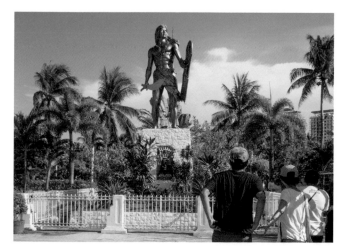

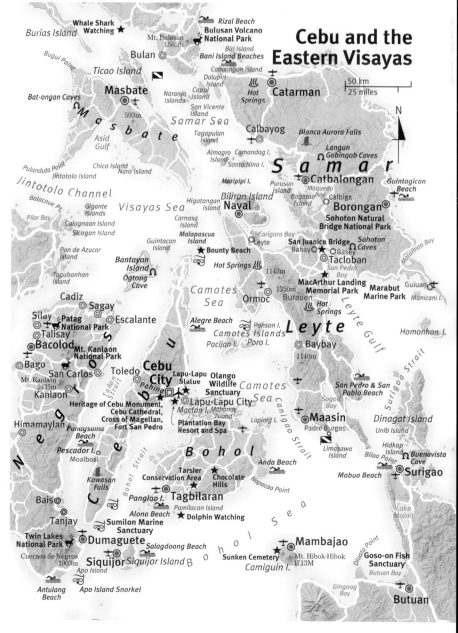

Cebu and the Eastern Visayas

Whale Shark Watching ★
Burias Island
Bugui Point
Ticao Island
Bat-ongan Caves
Masbate
M a s b a t e
593m
Asid Gulf
Pulanduta Point
Jintotolo Island
Jintotolo Channel
Balacaue Pt.
Pilar Bay
Gigante Islands
Calagnaan Island
Sicogon Island
Pan de Azucar Island
Tagubanhan Island
Cadiz
Sagay
Silay Patag National Park
Talisay
Bacolod
Bago
Mt. Kanlaon 2435m
Kanlaon
San Carlos
Himamaylan
Pescador I.
Moalboal
Bais
Tanjay
Twin Lakes National Park
Cuernos de Negros 1903m
Dumaguete
Siquijor
Antulang Beach
Apo Island
Apo Island Snorkel

Bulan
Mt. Bulusan 1565m
Naranjo Islands
Capul Island
San Vicente Island
Chico Island
Naro Island
Visayas Sea
Balacaue Pt.
Carnasa Island
Guintacan Island
Malapascua Island
Bantayan Island
Ogtong Cave

Rizal Beach
Bulusan Volcano National Park
Biri Island
Bani Island Beaches
Cabaongon Island
Dalupiri Island
Hot Springs
Catarman
50 km / 25 miles
N
Samar Sea
Tagapulan Island
Calbayog
Blanca Aurora Falls
Almagro Island
Camandag I.
Santo Nino I.
Langun Gobingob Caves
S a m a r
Maripipi I.
Purusun Island
Catbalongan
Guintagican Beach
Higatangan Island
Bagatao Island
Maqueda
Calbiga
Biliran Island
Naval
Borongan
Sohoton Natural Bridge National Park
Carigara Bay
Leyte
San Juanico Bridge
Bahay
Basey
Sohoton Caves
Bounty Beach
Hot Springs
1142m
Tacloban
San Pedro Bay
Camotes Sea
Ormoc
Burauen
1350m
MacArthur Landing Memorial Park
Marabut Marine Park
Guiuan
Manicani I.
Alegre Beach
Hot Springs
Ponson I.
Camotes Islands
Pacijan I.
Poro I.
L e y t e
Homonhon I.
Cebu City
Lapu-Lapu Olango Wildlife Sanctuary
Statue
Toledo
Pahina
Baybay
1140m
Camotes Sea
San Pedro & San Pablo Beach
Sogod Bay
Lapu-Lapu City
Mactan I. Mahanay Island
Heritage of Cebu Monument, Cebu Cathedral, Cross of Magellan, Fort San Pedro
Plantation Bay Resort and Spa
Lapinig I.
Maasin
Padre Burgos
Dinagat Island
Unib Island
Canigao Strait
Surigao Strait
Limasawa Island
Hidkop Island
Bilaa Point
Buenavista Cave
Surigao
Mabua Beach
Panagsama Beach
B o h o l
Anda Beach
Tarsier Conservation Area
Chocolate Hills
Napacao Point
Kawasan Falls
Panglao I.
Tagbilaran
Pamilacan Island
Alona Beach
Dolphin Watching
Sumilon Marine Sanctuary
Salagdoong Beach
Siquijor Island
B o h o l S e a
Sunken Cemetery
Mambajao
Mt. Hibok-Hibok 1713M
Camiguin I.
Goso-on Fish Sanctuary
Butuan Bay
Diuata Point
Gingoog Bay
Butuan

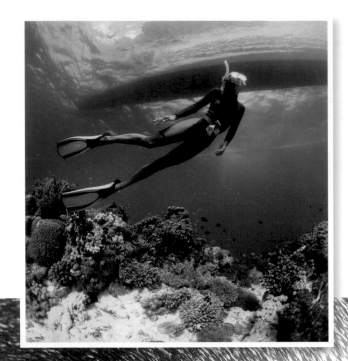

While the country's second city deserves a couple of days' exploration, the island's main attractions are its spectacular beaches and dive spots. Off the northern tip of Cebu is Malapascua Island, with a gorgeous stretch of powdery white sand at Bounty Beach along with exceptional diving. Sightings of thresher sharks here are extremely common, while manta rays and hammerheads are occasionally seen prowling the sandy depths. Close by is Bantayan Island, a laidback place with pristine beaches where it is easy to while away a few days swinging in a hammock, or trying out different water sports. Divers looking for world-class dive sites will not be disappointed: the quiet town of Moalboal serves as a jumping-off point to Panagsama Beach, a popular diver hangout. From here bangkas head to Pescador Island, one of the country's best dive spots, with a spectacular reef teeming with life and renowned for its huge sardine shoals. Batfish, sweetlips and fire gobies often roam the waters, along with hammerheads and reef sharks.

ABOVE The underground Ogtong Cavo on Bantayan Island has a clear freshwater pool for visitors to enjoy.

BELOW The island of Malapascua is fringed with unspoilt golden beaches where it is easy to while away a few hours swinging in a hammock.

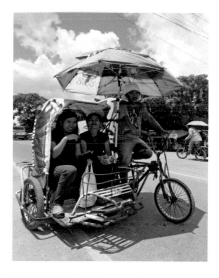

ABOVE A tricycle driver and passengers pose for a photo in Moalboal in northern Cebu.
OPPOSITE PAGE, TOP A woman snorkels the clear waters of Cebu Island over a brightly-colored coral reef.
OPPOSITE PAGE, BOTTOM Scuba divers look up in awe as a shoal of sardines swirls overhead.

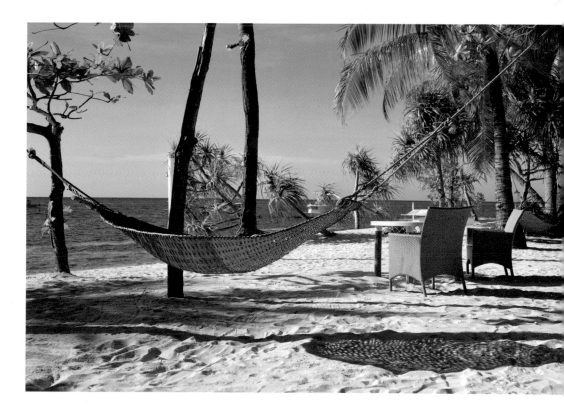

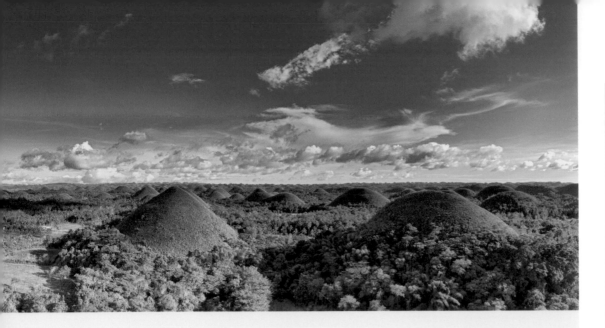

Tear Drops of a Giant

Designated a National Geological Monument, the Chocolate Hills are conical karst hills that geologists believe were formed from coral and limestone following centuries of erosion. It is thought there are 1,268 cone-shaped hills that vary in size. Legend says they are the calcified tears of a broken-hearted giant named Aroyo, whose lover Aloya died, causing him much pain and a never-ending flood of tears. Another somewhat less romantic legend says they were the result of a carabao's leaky bowel, who left behind a mound of feces, which formed the hills. At sunrise and sunset the hills are at their most spectacular, when they are bathed in a gentle glow. During the dry season (December–May) their grass turns chocolate-brown, making them appear like huge chocolate bonbons.

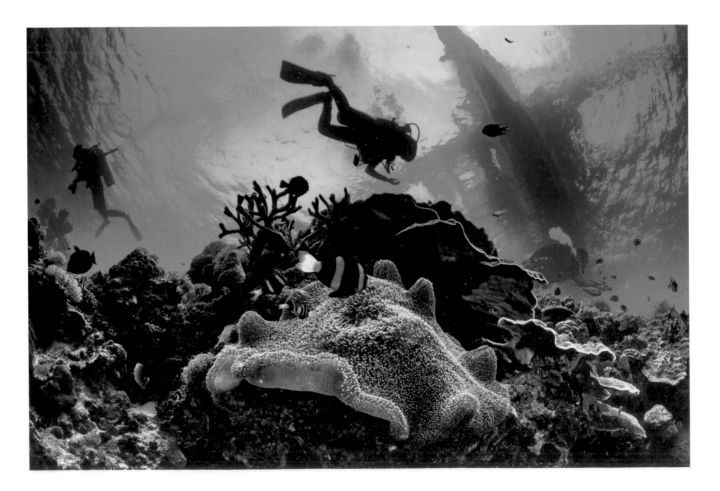

South of Cebu is Bohol, a small attractive island where one of the country's major tourist attractions, the Chocolate Hills, is located. Northeast of Tagbilaran, the island's port capital, is the Tarsier Visitors Center, which gives travelers the opportunity to come close to tarsiers, curious wide-eyed animals that are one of the world's smallest primates. From Tagbilaran a bridge crosses to Panglao Island, home to wonderful beaches, excellent diving and ancient Spanish churches. Alona Beach has gained increasing popularity over the years, and is today sprinkled with beach resorts and restaurants.

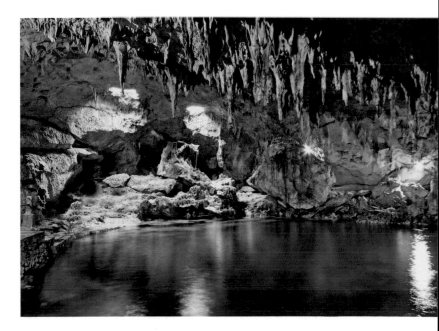

OPPOSITE PAGE, TOP Formed of coral and limestone, Bohol's Chocolate Hills consist of over 1,200 cone-shaped formations.
OPPOSITE PAGE, LEFT Divers observe marine life at one of the many brightly-colored coral reefs of the Visayas.
TOP River cruises along the jungle-fringed Loboc River pass towering palms and rural villages.

ABOVE Men take a break from swimming in the water pool of a pounding waterfall in Bohol.
ABOVE RIGHT A bamboo bridge crosses the murky waters of the Loboc River.
RIGHT Hinagdanan Cave contains a deep lagoon and sinkholes that allow sunlight to flood in.

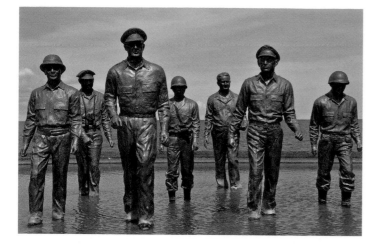

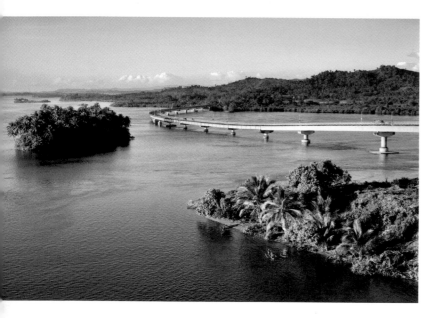

The nearby island of Leyte suffered hugely during World War II, when the Americans returned in late 1944 to recapture the country from the occupying Japanese. The island played an important role in Filipino history: it was in the provincial capital of Tacloban that General Douglas MacArthur waded ashore in 1944, fulfilling his promise, "I shall return." Largely overlooked by tourists, the island is fringed by beautiful beaches, while the rugged interior is peppered with gorgeous lakes. It is worth visiting the islands of Maripipi for their white-sand beaches and caves, while Padre Burgos attracts its share of divers.

Samar, the country's third largest island after Luzon and Mindanao, is a spelunking paradise, with more karst cave systems that anywhere else on Earth. Accessed from the town of Bahey, the 840-hectare Sohoton Caves and Natural Bridge National Park features underground rivers, limestone walls and impressive cave systems. The country's largest cave system is the Langun-Gobingob Caves, near the town of Calbiga. It is the second largest in Asia and reputedly the world's third largest karst formation.

Bahey is famous for its hand-woven *banig* mats, made with the leaves of the local *tikog* weed. The stems are dried, dyed and woven into elaborately-designed mats and home accessories. The mat-weaving industry is one of the town's prime sources of livelihood, especially among women. Sadly, large swathes of the island were destroyed and hundreds of people killed in 2013, when tropical cyclone Typhoon Haiyan made landfall at Guiuan on Samar's southeastern tip.

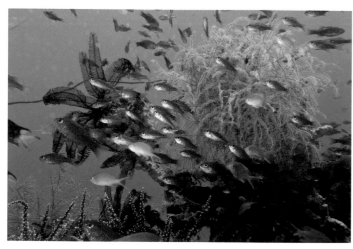

OPPOSITE, TOP LEFT A tricycle driver and his passenger travel along the streets of Borongan in Eastern Samar.
OPPOSITE, TOP RIGHT The Panhulugan Cliff towers over a floating dock in the Sohoton Natural Bridge National Park.

OPPOSITE, BOTTOM Youngsters play in the deep blue waters off the palm-fringed shore of Biri Island.

TOP The MacArthur Landing Memorial Park near Tacloban is a war memorial commemorating General Douglas MacArthur's historic landing to liberate the country from the Japanese during World War II.
ABOVE MIDDLE Stretching across the San Juanico Strait, San Juanico Bridge connects Samar to Leyte.

ABOVE The waters of Sogod Bay teem with underwater life and are home to some of the most pristine reefs in the country.
RIGHT The powerful swells of the Pacific Ocean off the coast of northern Samar attract experienced surfers.

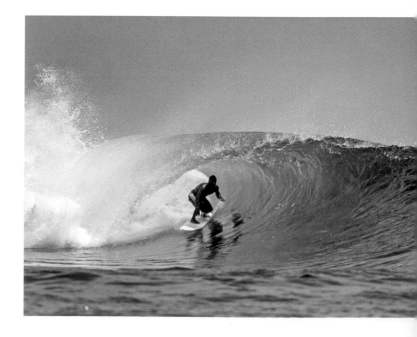

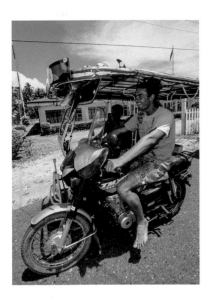

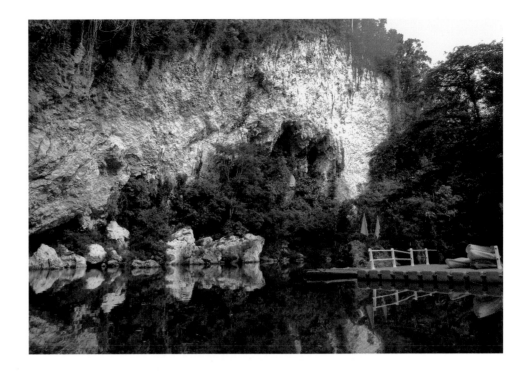

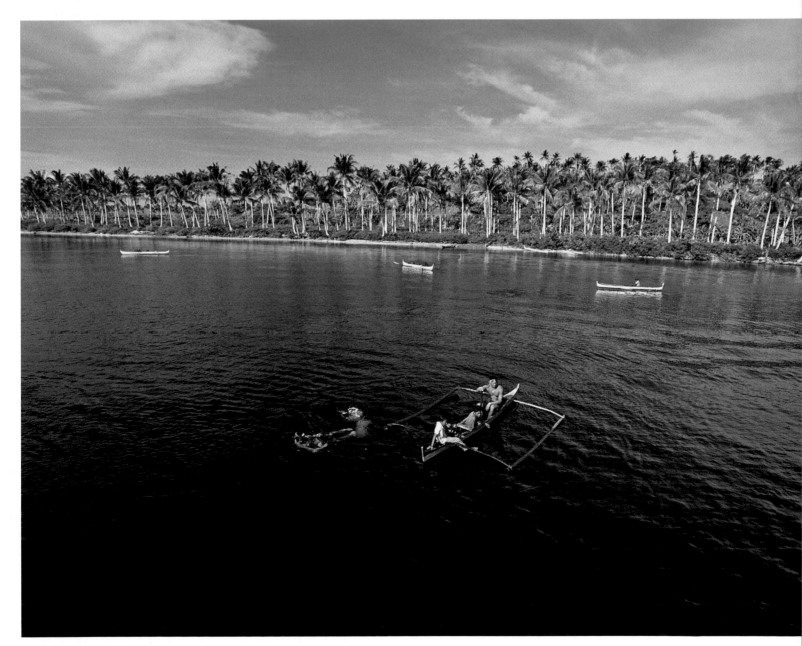

MINDANAO

OFF THE BEATEN TOURIST TRAIL

The country's second largest island, Mindanao is a melting pot of indigenous tribes where Christians and Muslims live side by side. Despite offering world-class surf and spectacular scenery—including white-sand beaches, gushing rivers and jungle-clad volcanic mountains—the island largely remains off the tourist trail as a result of its volatile security situation.

Mindanao is home to a large Muslim minority, with Islam first spreading to the region via Arab traders in the second millennium, although it wasn't until the 14th century that the first mosque was constructed. The Spanish met a lot of resistance when they colonialized Mindanao, as did the Americans when they occupied the island in the late 19th century. Mindanao is today a conflict zone, with various indigenous factions calling for autonomy from Manila. Travelers should check the security situation before planning a trip. That said, much of the island is safe for travelers. Northern Mindanao attracts the bulk of tourists, thanks to its beautiful natural attractions, including caves, national parks and white-sand islands, along with some of the world's best surf at Siargao.

The Museum of Three Cultures in Cagayan de Oro, the capital of Misamis Oriental, provides an insight into the history and culture of the island, with displays on various indigenous tribes and artifacts, from ancient Chinese porcelain to musical instruments and local crafts. One of the highlights of a trip to Mindanao is the Hinatuan Enchanted River, a breathtaking spot with sapphire blue water teeming with tropical fish and surrounded by thick jungle. Adrenalin-seekers must not miss a whitewater rafting trip down the 14 rapids of the Cagayan de Oro River, one of Mindanao's major highlights.

About 25 miles (40km) southeast of the city is the Dahilayan Adventure Park, nestled in the mountains of Dahilayan, where the climate is substantially cooler than in the city. Visitors can zip through the rainforest canopy on what is allegedly Asia's longest dual zipline, with an average speed of 40–55 mph (60–80km/h).

Occupying 34,000 hectares on the western side of the island, Mount Malindang National Park harbors rare species of flora and fauna including the Philippine eagle, tarsier and flying lemur, who inhabit its dense virgin forests.

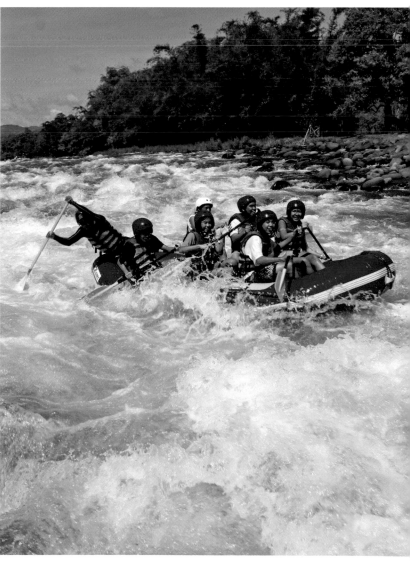

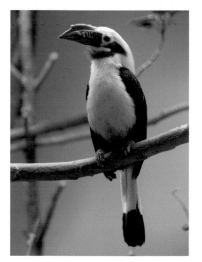

OPPOSITE PAGE, TOP LEFT A couple zipline through verdant jungle at the Dahilayan Adventure Park.
TOP The coast of Davao is characterized by spectacularly clear waters.
ABOVE MIDDLE A jetty protrudes towards the renowned Cloud 9 reef wave on Siargao Island.
RIGHT Whitewater rafting along the choppy waters of the Cagayan de Oro River is a popular activity in Mindanao.
LEFT The highly endangered Visayan hornbill can be found in some rainforests in the Philippines.

ABOVE Fishermen row to the shore of Siargao.
RIGHT Water tumbles down over lush vegetation in a series of cascades at Asik-Asik Falls in Cotabato province.

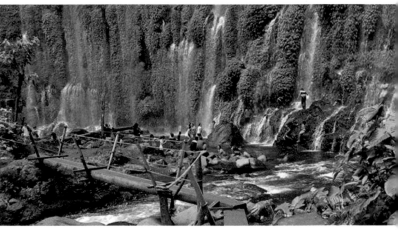

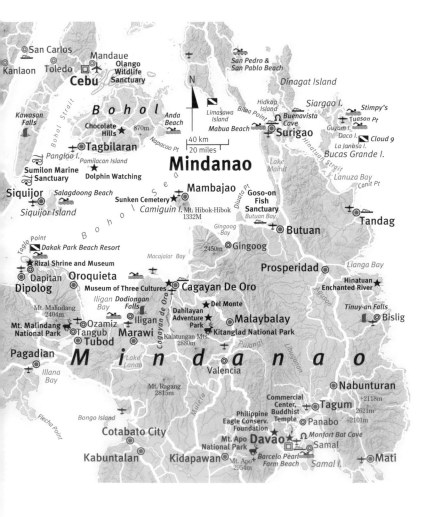

North of the park is the coastal city of Dapitan, closely linked with the country's national hero, José Rizal. Accused of masterminding the Philippine Revolution, he was exiled here in 1890. A stroke of luck two months after his arrival had him win the Spanish lottery. With his newly-acquired riches, he bought a 40-acre estate, today home to the Rizal Shrine and Museum, where he built a farm, a school for boys and a hospital where he treated patients.

Off the north coast of Mindanao is Camiguin, a tranquil volcanic island with golden beaches, offering exciting adventure activities, including trekking, climbing and scuba diving. Held annually in October, the Lanzones Festival is a tribute to Camiguin's sweet and juicy *lanzones* fruit, which is a staple of the island. The festival celebrates an abundant harvest with street dancing, parades and heritage shows. Houses, carriages and street poles are decorated with fruits and leaves, while partygoers don elaborate costumes as they dance along the city streets.

Lying off the northeastern tip of Mindanao is the small island of Siargao, which hosts the annual Siargao Surfing Cup

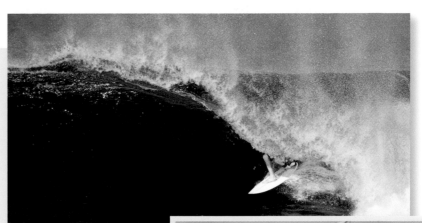

Riding Cloud 9

Located on the Pacific typhoon belt, the Philippines offers excellent surf, no more so than at Cloud 9. When conditions are right, this acclaimed reef break forms a perfect hollow tube that is considered to be one of the world's top surfing waves. The tear-shaped island of Siargao has long been attracting keen surfers, thanks to its world-class breaks. Today, the international competition draws in visitors from the world over, who come to watch professional surfers making deep tube rides at Cloud 9. The island has excellent surfing conditions between August and November, during the southwest monsoon. Cloud 9 can get particularly crowded, but there are plenty of other excellent alternatives nearby, including Stimpy's and Tuason Point.

every late September or early October. It attracts professional surfers from far and wide, from Australia to the US, who come to surf the world-renowned Cloud 9 break. It's worth renting a *bangka* to explore the seas around Siargao, which are peppered with rarely-visited islands, including the small Guyam Island, a tropical paradise with palm trees and crystal-clear waters ideal for a swim, sunbathe and picnic. The most popular trip from Siargao is to Sohoton Cove, an impressive inland lagoon on the east side of Bucas Grande Island. *Bangkas* take visitors through the cave entrance into a lagoon skirted by rugged cliffs, where giant non-stinging jellyfish float in the waters.

From Siargao *bangkas* travel west to the beautiful island of Dinagat, with powdery white-sand beaches and jagged cliffs that in recent years have started to attract their share of rock climbers.

Mindanao's largest city, Davao, is located on the island's southeast coast. Known as the "durian capital of the Philippines", it serves as a base for a number of attractions in the surrounding countryside, the most notable of which is Mount Apo (9,692 ft or 2,954m), the nation's highest peak, which attracts trekking and climbing enthusiasts from all over the country and beyond. Samal Island is another popular spot, with lovely beaches and coves, along with great scuba diving and the impressive Monfort Bat Cave, home to around 1.8 million fruit bats.

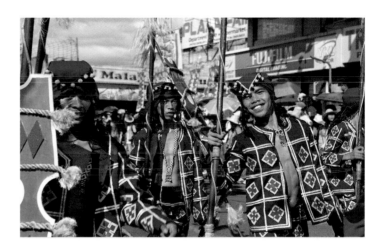

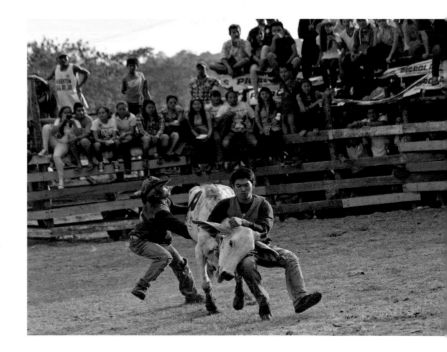

TOP Experienced surfers flock to Siargao from the world over to surf the famous Cloud 9 waves.
TOP INSET Jutting out into the ocean, the Cloud 9 viewing point gives onlookers the chance to watch surfers ride a wave or two.

ABOVE RIGHT, MIDDLE Men wear traditional ethnic costumes at the Kaamulan Festival, which celebrates the culture, folklore and traditions of the seven tribes of Bukidnon province.
RIGHT Students wrestle cattle in Bukidnon as part of the 103rd Foundation Anniversary and Alumni Homecoming of Central Mindanao University, Musuan.

SPECTACULAR BEACHES, KARST LANDSCAPES AND DIVING

Comprising 1,780 remote islands and islets, the province of Palawan remains largely unexplored. It features magnificent white-sand beaches and jagged limestone cliffs jutting out of crystal clear waters. Most visitors tend to stay in northern Palawan, with the provincial capital of Puerto Princesa serving as the jumping-off point to the island's wealth of gorgeous beaches, bay and islets.

A couple of hours north of the provincial capital is the Puerto Princesa Subterranean River National Park. Declared a UNESCO World Heritage Site, the park features imposing limestone karst landscapes and what is thought to be the world's longest navigable underground river. It flows through a cavern with impressive rock formations and spectacular chambers. Heading further north, visitors can stop off at Port Barton, roughly half way between Puerto Princesa and the town of El Nido on Palawan's northwestern coast. Port Barton Beach is a pretty spot sprinkled with laidback budget beach hotels, but the main draw are the 14 beautiful white sand islands of Pagdanan Bay, a short *bangka* ride away.

The resort town of El Nido is one of Palawan's main attractions, thanks to its astonishing landscapes of jugged limestone cliffs coated in jungle and bays with dazzling crystal-clear waters. The town has a laid-back feel, with pleasant beach hotels and informal restaurants lining the beach, but it's developing fast. Island-hopping trips take visitors around the

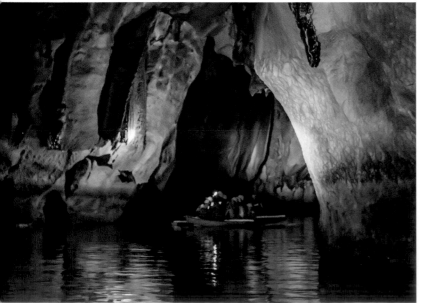

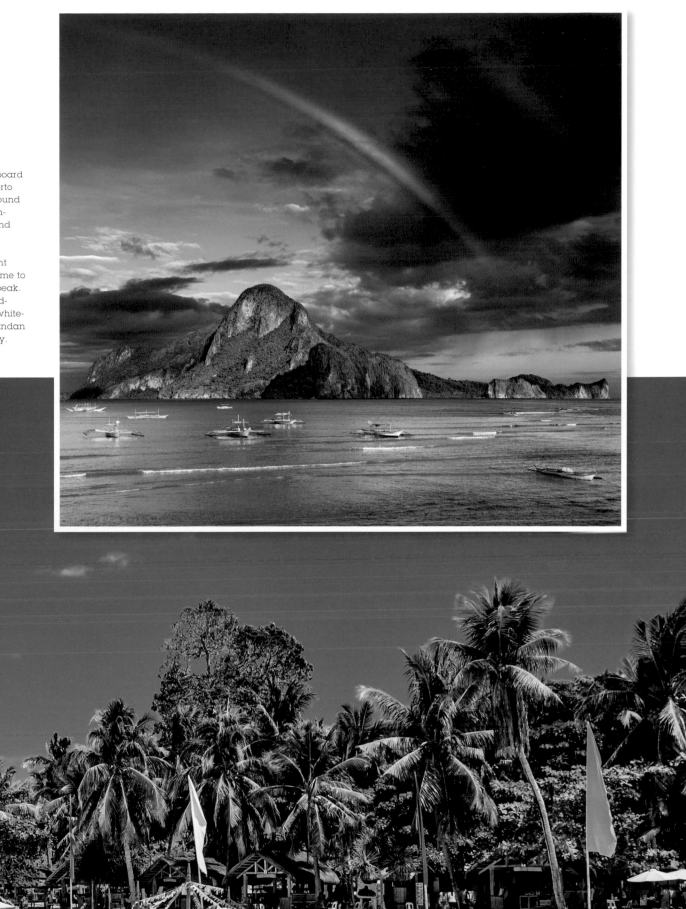

OPPOSITE PAGE, BOTTOM Visitors aboard pump boats on Puerto Princesa's Underground River take in breath-taking chambers and rock formations.
RIGHT Across from El Nido Bay, verdant Cadlao Island is home to the area's highest peak.
BELOW The emerald-green waters and white-sand beaches of Pandan Island in Honda Bay.

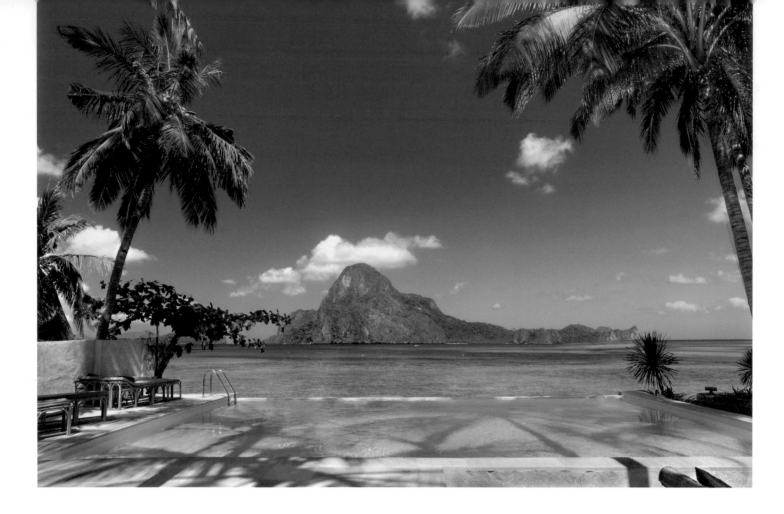

ABOVE El Nido has developed a number of upmarket beachfront resorts offering gorgeous views of the bay.

BELOW Tourists enjoy the sea views from Taraw Peak, a towering karst formation in El Nido.

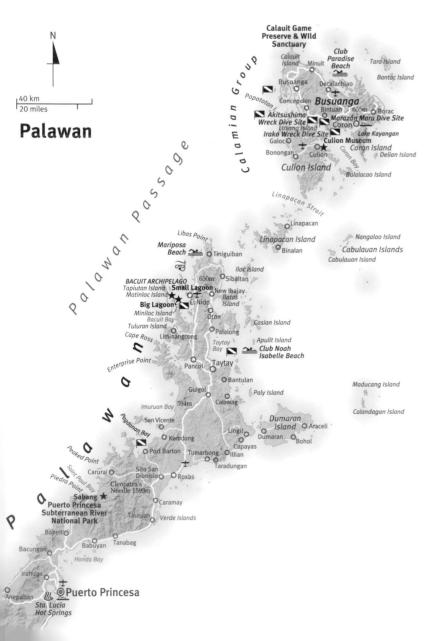

Palawan

N

40 km
20 miles

Calauit Game
Preserve & Wild
Sanctuary

Calauit Island
Minuit
Club Paradise Beach
Tara Island
Bantac Island

Busuanga
Decalachiao

Concepcion
Bintuan
655m
Borac

Popototan I.
Calamian Group

Akitsushima Wreck Dive Site
Morazán Maru Dive Site
Lusong Island
Coron
Iraco Wreck Dive Site
Galoc
Lake Kayangan
Bonongan
Culion Museum
Coron Island
Culion
Coron Bay
Delian Island

Culion Island
Bulalacao Island

Linapacan Strait

Linapacan

Linapacan Island
Nangalao Island

Libas Point
Binalan
Cabulauan Islands
Cabulauan Island

Mariposa Beach
Tiniguiban
Iloc Island

650m
Sibaltan

BACUIT ARCHIPELAGO
Tapiutan Island
Small Lagoon
New Ibajay
Matinloc Island
El Nido
Batas Island

Big Lagoon
Oton

Miniloc Island
Bacuit Bay
Casian Island
Tuluran Island
Palalong

Cape Ross
Liminangcong
Apulit Island
Taytay Bay
Club Noah Isabelle Beach

Enterprise Point
Pancol
Taytay
Palawan Passage

Bantulan
Maducang Island

Guigol
Paly Island

Imuruan Bay
594m
Calawag
Calandagan Island

San Vicente
Lingit
Dumaran Island
Araceli

Pagdanan Bay
Komdong
Dumaran
Bohol

Peaked Point
Port Barton
Tumarbong
Capayas

Carurai
Roxas
Illian

Saint Paul Bay
Sito San Dionisio
Taradungan
Piedra Point
Cleopatra's Needle 1593m
Caramay

Sabang
Puerto Princesa Subterranean River
National Park
Tinituan
Verde Islands

Baheli

Bacungan
Babuyan
Tanabag

Honda Bay

Irahuan

Puerto Princesa

Anepahan
Sta. Lucia Hot Springs

Palawan

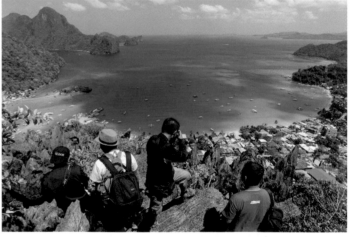

beautiful Bacuit Archipelago, where 45 limestone outcrops are punctuated by blue lagoons. The highlight of Miniloc Island, about 45 minutes from El Nido by boat, is one of the area's most beautiful attractions: the Big Lagoon. Hemmed in by craggy limestone cliffs, it is an incredible sight. Nearby is the Small Lagoon, which can only be accessed by swimming through a small gap.

North of mainland Palawan, the Calamian Islands offer excellent kayaking, trekking, island-hopping and world-famous wreck diving. The largest island of the group, travelers to Busuanga usually head to the fishing village of Coron Town, which serves as a base to explore World War II shipwrecks

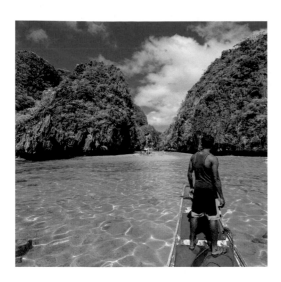

ABOVE A *bangka* glides through the crystal-clear waters of the Big Lagoon on the northeastern tip of Miniloc Island.
RIGHT Island-hopping in the Bacuit Archipelago is a highlight of any trip to Palawan.
BELOW The jagged limestone cliffs of Matinloc Island are rich in thick vegetation.

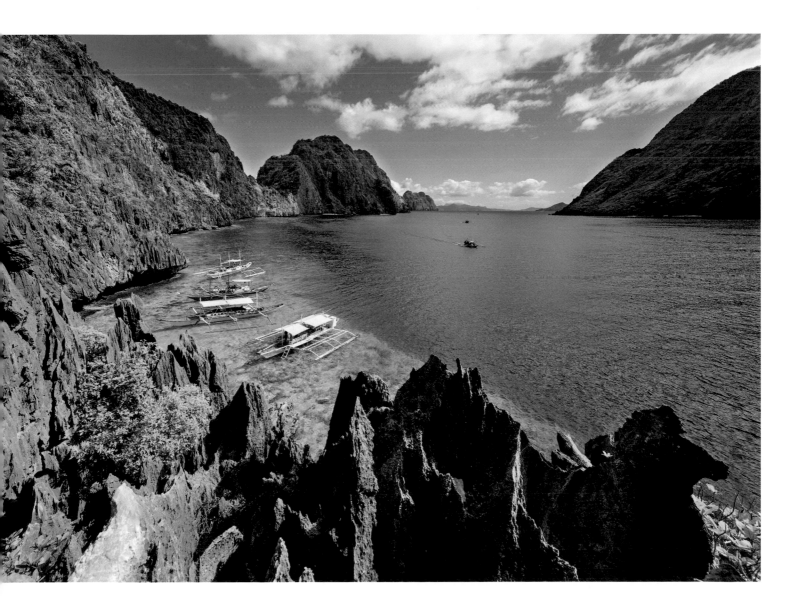

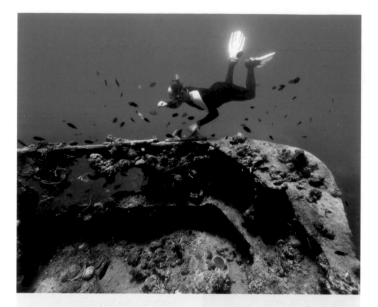

Wreck Diving at Coron Island

Coron attracts history buffs and divers from the world over because of its World War II Japanese shipwrecks. Sunk by US aircraft on 24th September 1944, the 24 wrecks were destroyed in what was then the longest-range carrier-based air strike in history. The best-preserved wreck is *Irako*, a food supply ship, which today teems with groupers, sea turtles and schools of tuna and lion fish. Another popular dive is to the Japanese seaplane tender *Akitsushima*, a large ship that includes an enormous crane used to lower a four-engine flying boat that has never been found. It attracts schools of barracuda and giant batfish. One of the most unusual wrecks is the *Morazán Maru*, a freighter and passenger liner originally built in England in 1908. It was captured by the Imperial Japanese Navy in 1941 and subsequently used as a cargo vessel. She sits upright at 90 feet (28m), and attracts large shoals of puffer fish and giant batfish.

in Coron Bay. Scattered with magnificent islands and coves that truly are a sight to behold, Coron Bay offers numerous island-hopping trips. The most popular is Coron Island, dominated by craggy limestone cliffs and offering excellent snorkeling. The island houses the Tagbanua people, one of the country's oldest ethnic groups, who live off fishing. Today they supplement their income by serving the tourist industry, charging visitors to see the island's attractions. Among the other draws are the beautiful volcanic Lake Kayangan, which can be reached by climbing a steep flight of steps from where there are unobstructed views of the lagoon below.

One of the province's most unusual islands is probably Culion Island, a two-hour *bangka* ride south of Coron Town. In the early 20th century the Americans established an isolated leper colony here, which was to become the world's largest. The Culion Museum, located in what was once the leprosy research lab, sheds light on the history of the colony and displays equipment, photographs and patient records.

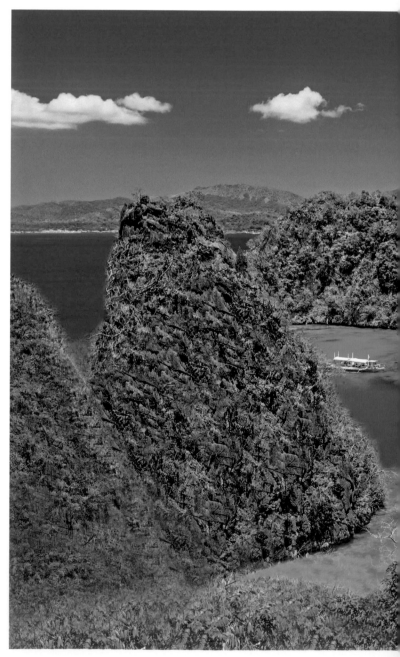

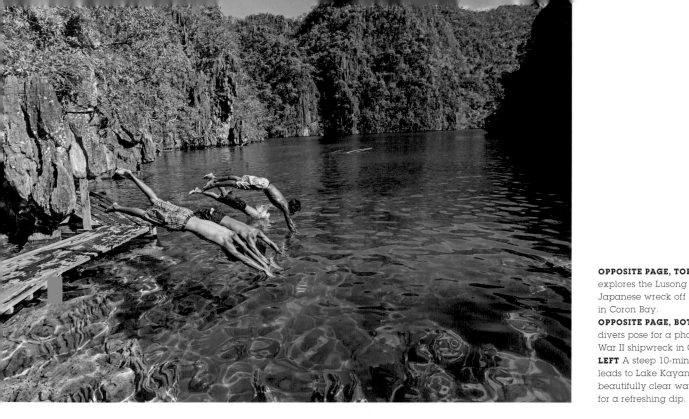

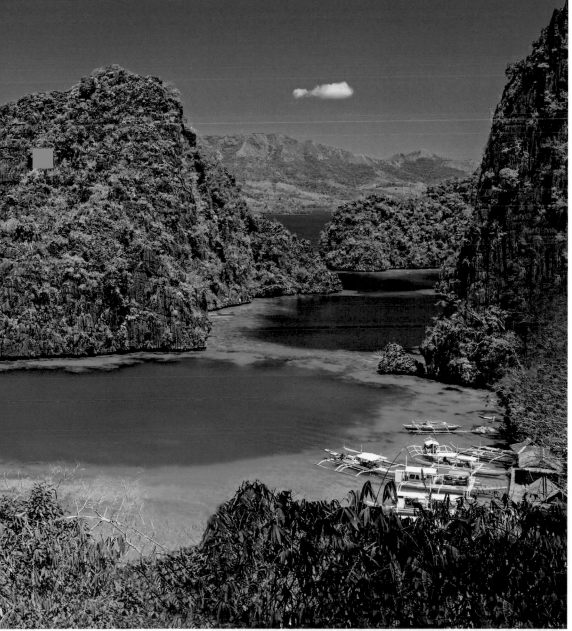

OPPOSITE PAGE, TOP A diver explores the Lusong gunboat, a Japanese wreck off Lusong Island in Coron Bay.
OPPOSITE PAGE, BOTTOM Scuba divers pose for a photo on a World War II shipwreck in Coron Bay.
LEFT A steep 10-minute climb leads to Lake Kayangan. Its beautifully clear waters are ideal for a refreshing dip.

ABOVE A snorkeler shows off a black sea urchin.
LEFT Coron Island is sprinkled with magnificent lagoons and clear turquoise waters.
INSIDE BACK COVER Sailboats sit at sunset off the coast of Boracay.

Airports and Access Flying to the Philippines from outside Asia tends to involve stopovers in Dubai, Hong Kong or Singapore, although there are direct flights from America and Australia. Philippine Airlines is the only airline to offer direct flights from Europe (London). Long-distance flights land at Manila Ninoy Aquino International Airport, while several budget airlines from cities in Asia serve Clark International Airport, 50 miles (80km) north of the capital. A number of international airlines fly direct to Cebu, the transport hub of the Visayas. With over 7,000 islands, travelers will need to catch at least one internal flight to reach their destination.

Best Time to Go The best time to visit is during the dry season between November and May. The wet season, running from June to October, often sees heavy rain that comes down in short strong bursts, typically in the afternoons, although it's not uncommon for it to rain much of the day. Typhoons occur frequently.

Electricity The Philippines has wall sockets operating at 220 volts. Plugs are the two flat, rectangular pin variety used in the US and Canada. Power cuts, locally known as "brownouts", are common in the provinces, and take place more frequently during the rainy season.

Getting Around Ferry services and planes connect major destinations across the Philippine archipelago. Road transport mainly comprises buses and jeepneys, vehicles that were left in the country by Americans at the end of WWII, which are brightly painted and decorated with fairy lights, religious messages and all manner of trinkets. Tricycles (motorbikes with small side cars) are commonly used for short journeys, while vans compete with buses over long distances; they are slightly more expensive but much faster, with destinations marked clearly at the front.

Health and Safety The Philippines has a reputation as a dangerous place to travel, although this is not the case in most areas of the country. Mindanao has largely remained off the tourist track due to violent factions calling for autonomy from Manila. The rest of the country is largely safe, as long as you exercise common sense and caution. As a sprawling capital, Manila inevitably sees more crime than elsewhere. Keep car doors and windows locked to be on the safe side, and always watch your belongings. Don't spend too much time in the sun and be careful with what you eat and drink, especially when it comes to street food. Hospitals in major cities are generally of a good standard, while in remote provinces it is much harder to find professional medical assistance. Head straight to Manila for anything serious. Virtually all doctors and nurses speak English, and a number of them have been educated in the UK and US.

Internet There are dozens of Internet cafes sprinkled around major cities, and Wi-Fi is commonly available at hotels and hostels. In smaller urban areas, Internet access is likely to be very slow, although you shouldn't have too many problems getting online to send emails.

Mobile Phones Roaming charges can be extortionately expensive. If you're planning on making local calls, it'll work out cheaper to buy a local SIM card, available at convenience stores and in malls. Opt for a pre-paid package with a fixed rate—most offer unlimited local calls, a given number of text messages and Internet access.

Money The national currency is the peso, abbreviated to P. Money can easily be withdrawn at ATMs around the country, although in remoter areas these are not common—make sure you carry some cash with you to keep you going. Most hotels and restaurants in tourist areas accept credit cards. Tipping is expected in cafés and bars (the amount is up to your discretion), while in restaurants you should leave about 10 per cent. Make sure you carry around small notes to tip porters; taxi drivers normally expect a small gratuity on top of their fee.

Time The Philippines is eight hours ahead of Greenwich Meridian Time (GMT), the same as Western Australia, Singapore, Hong Kong and Malaysia.

Visas Most foreign tourists can stay in the country for up to 30 days without a visa, though passports must be valid for at least six months and onward flight details are essential. For a fee it's possible to extend trips by 29 days, for a total of 59 days in the country—travel agents in tourist areas can assist with this. Visitors can apply for a temporary visitor's visa lasting 59 days at a Philippine consulate before travel.

ACKNOWLEDGEMENTS
Many thanks to Eric Oey and Kimberly Tan for commissioning me to write about such a captivating country. Much gratitude goes to the warm Filipino people I have met on my travels, all of whom were exceptionally hospitable and more than willing to assist me at all times of the day.

RECOMMENDED READING
- *America's Boy: the Marcoses and the Philippines* by James Hamilton-Paterson —A biography of the US-supported Marcos dictatorship that provides a fascinating political insight into the history of the country.
- *In Our Image: America's Empire in the Philippines* by Stanley Karnow—Portrays America's empire building for the first time in its history at the end of the 19th century.
- *Dusk* by Sionil José—This is the first historical novel of José's Rosales Saga, five books that follow the life of a family through 100 years of history.
- *Noli Me Tángere* by José Rizal—A passionate love story that unfolds against a backdrop of oppression and torture, exposing the injustice of European colonialism.
- *Ilustrado* by Miguel Syjugo—A saga taking in over 150 years of history told through a series of sources, including newspaper cuttings and jokes.
- *Pacman: My Story of Hope, Resilience, and Never-say-Never Determination* by Manny Pacquiao—This autobiography charts Pacquiao's life from the rough streets of Mindanao to his fame as multi-millionaire world boxing champion.
- *The Food of the Philippines* by Reynaldo Alexandro—A range of tantalizing recipes, from classic dishes such as *adobe* to the spicy foods of the Bicol region.

ONLINE RESOURCES
- http://itsmorefuninthephilippines.com/ —the official website of the Philippine Department of Tourism
- http://www.clickthecity.com—restaurant listings, shopping and events in Manila and other cities around the country
- http://www.inquirer.net—the Philippines' most widely read newspaper
- http://www.visitphilippines.org—plenty of information on the country, including culture, food, sights, art and literature

PHOTO CREDITS

Front cover main image ID 634025597 © R.M. Nunes | Shutterstock.com; **1st column** ID 471504565 © h3ct02 | iStock.com; **2nd column** ID 274546853 © Rich Carey | Shutterstock.com; **3rd column** ID 225166048 © Richie Chan | Shutterstock.com; **4th column** ID 116003776 © leoks | Shutterstock.com; **5th column** ID 140073553 © Tappasan Phurisamrit | Shutterstock.com; **Front flap** ID 124512115 © Pichugin Dmitry| Shutterstock.com; **Back cover 1st row, far left** ID 29967438 © Plotnikov | Dreamstime.com; **back cover 1st row, left** ID 1379 Ifugao People © Kiki Deere; **back cover 1st row, middle** ID 37927885 © Ismedhasibuan | Dreamstime.com; **back cover 1st row, right** ID 53518831 © donsimon | Shutterstock.com; **back cover 1st row, far right** ID 51830809 © shadow216 | Shutterstock.com; **back cover 2nd row, far left** ID 294652076 © Rich Carey | Shutterstock.com; **back cover 2nd row, left** Aiza Seguerra and Ai Ai de las Alas performing at the Big Dome at Bente Singko © Cen Sulit | Philippineconcerts.com; **back cover 2nd row, middle** ID 9096668 © Ric510 | Dreamstime.com; **back cover 2nd row, right** ID 277366805 © Perfect Lazybones | Shutterstock.com; **back cover 2nd row, far right** ID 4614048658 © Andy Nelson | Flickr.com; **back cover 3rd row, far left** ID 20328583 © Samideleon | Dreamstime.com; **back cover 3rd row, left** ID 12565780 © Antonio V. Oquias| Shutterstock.com; **back cover 3rd row, middle** ID 342902474 © Lano Lan | Shutterstock.com; **back cover 3rd row, right** ID 487622657 © tropicalpixsingapore | iStock.com; **back cover 3rd row, far right** ID 195059393 © r.nagy | Shutterstock.com; **back cover main image** ID 271692161 © wallix | Shutterstock.com; **inside front cover** ID 5249288888123392 © Marco Paolo Arroyo | Pixoto.com; **half-title** ID 12565780 © Antonio V. Oquias | Shutterstock.com; **2-3** ID 112156757 © joyfull | Shutterstock.com; **4-5** ID 50301036 © Flocutus | Dreamstime.com; **6-7** ID 40277777 © Softlightaa | Dreamstime.com; **7 bottom** ID 30459093 © Suronin | Dreamstime.com; **8 top** ID 42297269 © Whitcomberd | Dreamstime.com; **8 middle** ID 29967438 © Plotnikov | Dreamstime.com; **8 bottom** ID 140268766 © Tappasan Phurisamrit | Shutterstock.com; **9 top** ID 25951945 © Joyfull | Dreamstime.com; **9 middle** ID 51348439 © michael pine | Dreamstime.com; **9 bottom** ID 26055904 © Andrey Golubev | 123rf.com; **10 top left** ID 35130878 © Hrlumanog | Dreamstime.com; **10 top right** ID 289630817 © leoks | Shutterstock.com; **10 middle** ID 147495821 © DmitrySerbin | Shutterstock.com; **10 bottom left** ID 230246197 © Chris Warham | Shutterstock.com; **11 main image** ID 28618070 © fazon |123rf.com; **12 main image** ID D159XK © Children | Alamy Stock Photo; **13 top left** ID 1379 Ifugao People © Kiki Deere; **13 top right** ID 31350749 © h3k27 | Depositphotos; **13 bottom** ID 51778690 © Tony Magdaraog | Shutterstock.com; **14 top** ID 27173333 © Danilo Jr. Pinzon | 123rf.com; **14 middle left** ID 37315142 © Florian Blümm | 123rf.com; **14 middle right** ID D157NY © Philippine Islands | Alamy Stock Photo; **14 bottom** Worshippers Lighting Candles IMG8501 © Art Phaneuf Photography; **15 top** ID 25684733 © Neriza Tavera | 123rf.com; **15 bottom** ID 31356375 © Hrlumanog | Dreamstime.com; **16 top** ID 458995737 © h3ct02 | iStock.com; **16 middle** ID 25490695 © h3k27 | Depositphotos; **16 bottom** ID EA6Y8F © Philippine Islands | Alamy Stock Photo; **17 top** ID 27901107 © Hrlumanog | Dreamstime.com; **17 top right** ID D159DT © Children | Alamy Stock Photo; **17 middle** ID 135474375 © James Bokovoy | Pixoto.com; **17 bottom** ID 524818685 © tropicalpixsingapore | iStock.com; **18 bottom left** Philippines Night Barbecue Stand IMG2658 © Art Phaneuf Photography; **18 bottom right** ID 48535383 © Danilo Jr. Pinzon | 123rf.com; **19 top left** ID 6586996000555008 © Marco Paolo Arroyo | Pixoto.com; **19 top right** ID 284615987 © Maria Maarbes | Shutterstock.com; **19 middle** ID 46069771 © NAMHWI KIM | 123rf.com; **19 bottom left** ID 23781895 © Al Sonza | 123rf.com; **19 bottom right** Filipino Street Vendor Selling Steamed Corn IMG0397 © Art Phaneuf Photography; **20 top** ID F4H522 © Philippine Islands | Alamy Stock Photo; **20 middle** Philippine Food © Philippine Department of Tourism | Wikimedia Commons; **20 row 1** ID 90555862 © johannviloria | Shutterstock.com; **20 row 2** ID 20125167 © Jmaentz | Dreamstime.com; **20 row 3** ID 292096661 © AGfoto | Shutterstock.com; **20 row 4** ID 270888983 © Fanfo | Shutterstock.com; **21 row 1, left** ID 325376468 © Dolly MJ | Shutterstock.com; **21 row 1, middle** ID 37927885 © Ismedhasibuan | Dreamstime.com; **21 row 1, right** ID 287579177 © richardernestyap | Shutterstock.com; **21 main image** ID 60969943 © Ronald De Jong | Dreamstime.com; **21 row 2** ID 29110723 © Karen H. Ilagan | Shutterstock.com; **21 row 3** ID 60961106 © Ronald De Jong | Dreamstime.com; **21 row 4, left** ID 169114994 ©Paul_Brighton | Shutterstock.com; **21 row 4, middle** ID 188770229 © richardernestyap | Shutterstock.com; **21 row 4, right** ID 20689365 © Imy Lou Del Rosario| 123rf.com; **22 top left** ID 11139037 © Arjan Huijzer | Shutterstock.com; **22 top right** ID 178189249 © gece33 | iStock.com; **22 bottom** ID 2916648 © donsimon | Depositphotos; **23 top left** ID 56587294 © Sjors737 | Shutterstock.com; **23 top, above** C-U C-ME Hanging Lamp © Kenneth Cobonpue; **23 top, below** Andres Side Chair © A. Garcia Crafts; **23 top right** Crokkis Vase Wall © Kenneth Cobonpue; **23 top, far right** Nautilus in White BC Lighted © Kenneth Cobonpue; **23 middle left** ID 11139019 © Arjan Huijzer | Shutterstock.com; **23 middle right** Benedicto Reyes Cabrera, Dancing at Rock Session © Christie's Images Ltd; **23 bottom** BenCab Gallery © BenCab Museum; **24 top** ID 29452454 © Hrlumanog | Dreamstime.com; **24 middle** ID 22922512 © Junpinzon | Dreamstime.com; **24 bottom** ID 144220063 © Norlito | iStock.com; **25 top left** ID 2339516 © fleyeing | 123rf.com; **25 top right** Alegre Guitar Factory, Lapu-Lapu City Philippines © Masashi Bitou; **25 middle left** Antique Payneta Hair Comb © Mireille de Guia-Jison, for TambourineJewelry.etsy.com; **25 middle right** ID 26609379 © evdoha | Depositphotos.com; **25 below left** Antique Gold Fruits Earrings with Diamante or Rough-Cut Diamonds © Mireille de Guia-Jison, for TambourineJewelry.etsy.com; **25 bottom left** Earrings with Diamante or Rough Cut Diamonds and Old Rings © Mireille de Guia-Jison, for TambourineJewelry.etsy.com; **25 bottom, center** Antique Tamborin Necklace © Mireille de Guia-Jison, for TambourineJewelry.etsy.com; **25 bottom right** ID 55800801 © Junpinzon | Dreamstime.com; **26 bottom** ID 187882757 © junpinzon | Shutterstock.com; **26 - 27** ID 18723997 © Danilo Jr. Pinzon | 123rf.com; **27 top** ID 18724005 © Danilo Jr. Pinzon | 123rf.com; **28 top** ID 51842692 © Tony Magdaraog | Shutterstock.com; **28 middle** ID 324952391 © Lano Lan | Shutterstock.com; **28 bottom left** ID 4322530 © Antonio Oquias | Dreamstime.com; **28 bottom right** ID 93704782 © Tony Magdaraog | Shutterstock.com; **29 top** ID 25684732 © Neriza Tavera | 123rf.com; **29 bottom left** ID 212526022 © Frolova_Elena | Shutterstock.com; **29 bottom right** ID 51830806 © shadow216 | Shutterstock.com; **30 middle** ID 20252681 © Salvador Manaois Iii | Dreamstime.com; **30 bottom left** ID 274546853 © Rich Carey | Shutterstock.com; **30 bottom right** ID 28244574 © Michael Elliott | Dreamstime.com; **31** ID 186130745 © Kjersti Joergensen | Shutterstock.com; **32 top** ID 50156684 © Jennermb | Dreamstime.com; **32-33** ID 89715658 © Vitaly Titov | Shutterstock.com; **32 bottom** ID 115961957 © Joey Rico | Pixoto.com; **33 top** ID 24301513 © Vitaly Titov | Shutterstock.com; **33 bottom** ID 285536267 © r.nagy | Shutterstock.com; **34 top** ID 262121588 © Rich Carey | Shutterstock.com; **34 middle** ID 294652076 © Rich Carey | Shutterstock.com; **34 bottom** ID 412964521 © David Evison | Shutterstock.com; **35 top** ID 5341375507726336 © Rens Tuzon | Pixoto.com; **35 bottom** ID 182850041 © soft_light | Shutterstock.com; **36-37** ID 5300825610518528 © Pet Salvador | Pixoto.com; **38-39** ID 210384175 © KieferPix | Shutterstock.com; **39 top** ID 165212321 © cpaulfell | Shutterstock.com; **40 top** Intramuros © Francisco Guerrero | The Peninsula Manila; **40 middle** ID 139157783 © Tappasan Phurisamrit | Shutterstock.com; **40 bottom** ID 140073553 © Tappasan Phurisamrit | Shutterstock.com; **41 top left** ID 139474874 © Tappasan Phurisamrit | Shutterstock.com; **41 top right** ID 139475048 © Tappasan Phurisamrit | Shutterstock.com; **41 middle left** ID 139312787 © Tappasan Phurisamrit | Shutterstock.com; **41 middle right** ID 174843923 © Jomar Aplaon | Shutterstock.com; **41 bottom** ID 202781470 © Tooykrub | Shutterstock.com; **42 top** ID 110238926 © joyfull | Shutterstock.com; **42 bottom** Rizal Execution Monument at Rizal Park, both pictures © Angelo Academia; **42-43** ID CCP-Tanghalang_Aurelio_Tolentino © Nixenzo | Wikimedia Commons; **43 bottom** ID 165810962 © saiko3p | Shutterstock.com; **44 top left** A display of Imelda Marcos's shoes | Marikina.gov.ph; **44-45 top** ID 313800572 © KieferPix | Shutterstock.com; **44 bottom** ID 6085508075 © Stefan Krasowski, rapidtravelchai.com | Flickr.com; **45 bottom** ID 172798067 © joyfull | Shutterstock.com; **46 top left** ID 49997307 © Mosaic23 | Dreamstime.com; **46 top right** ID 37109777 © Hrlumanog | Shutterstock.com; **46 bottom left** ID 70446784 © Tony Magdaraog | Shutterstock.com; **46 bottom right** ID 44893999 © Agaliza | Shutterstock.com; **47 top** ID 101317309 © Jomar Aplaon | Shutterstock.com; **47 middle** ID 189311948 © Tooykrub | Shutterstock.com; **47 bottom** ID 183049388 © Tooykrub | Shutterstock.com; **48-49** ID 81479380 © skyearth | Shutterstock.com; **48 bottom left** ID 99464579 © joyfull | Shutterstock.com; **49 top left** ID 43004546 © Junpinzon | Dreamstime.com; **49 top right** Aiza Seguerra and Ai Ai de las Alas performing at the Big Dome at Bente Singko © Cen Sulit | Philippineconcerts.com; **49 middle** ID 467345670 © gionnixxx | iStock.com; **49 bottom** ID 259992050 © EQRoy | Shutterstock.com; **50 left** ID 4824493369327616 © Jerome Bacani | Pixoto.com; **50-51** ID 19096670 © Ric510 | Dreamstime.com; **52 top left** ID 132801005 © Rico Laurel | Pixoto.com; **52 top right** ID 5971691073175552 © Cesar Cambay | Pixoto.com; **52 middle left** ID 5440781609811120 © Neil Sinadjan | Pixoto.com; **52 middle right** ID 112995883 © James Enriquez | Pixoto.com; **52 bottom** ID 143330038 © saiko3p | Shutterstock.com; **53 top left** ID 21741203 © Rogz Necesito Jr. | Pixoto.com; **53 top right** ID 4820872110538752 © Joey Tomas | Pixoto.com; **53 middle** ID 5955600832266240 © Erico Claudio | Pixoto.com; **53 bottom** ID 5998958182662144 © Rico Laurel | Pixoto.com; **54 top** ID 25264355 © Salvador Manaois Iii | Dreamstime.com; **54 bottom** ID 20896672 © Salvador Manaois Iii | Dreamstime.com; **55 top** Mt pinatubo crater © Thedandyman | Wikimedia Commons; **55 bottom** ID 108434924 © Mati Nitibhon | Shutterstock.com; **56 top right** ID 535938413 © Mason Vranish | iStock.com; **56 middle** ID 401273200 © LunaseeStudios | Shutterstock.com; **56 bottom** ID 64553457 © Lawrence Peter McGuire | Dreamstime.com; **56 bottom right** ID 1268703 © Jonald John Morales | 123rf.com; **57 top left** SandBaggers Bar at Subic Bay © Art Phaneuf Photography; **57 top right** ID 160939367 © Jung Hsuan | Shutterstock.com; **57 top, right inset** ID 259930463 © SARAWUT KUNDEJ | Shutterstock.com; **57 bottom left** ID 19096668 © Ricardo Esplana Babor | Dreamstime.com; **57 bottom right** ID 259632695 © SARAWUT KUNDEJ | Shutterstock.com; **58 top** ID 15967367 © Antonio Oquias | Dreamstime.com; **58 -59** ID 220014745 © SeenTheWorld | Shutterstock.com; **58 bottom** ID 24306638 © Edward Lemery Iii | Dreamstime.com; **60 top** ID 44652879 © Homar Ivan Tiamzon | Dreamstime.com; **60 middle left** ID 29451727 © Hrlumanog | Dreamstime.com; **60 middle right** ID 67283816 © Takeashot | Dreamstime.com.

Published by Tuttle Publishing, an imprint of Periplus Editions (HK) Ltd

www.tuttlepublishing.com

Text copyright © 2021 Kiki Deere
Maps copyright © 2021 Periplus Editions (HK) Ltd

ISBN 978-0-8048-4689-9 Hc
LCC Number: 2016944504
ISBN 978-0-8048-5526-6 Pb

25 24 23 22
10 9 8 7 6 5 4 3 2 1

Printed in Singapore
2111TP

Distributed by

North America, Latin America & Europe
Tuttle Publishing
364 Innovation Drive, North Clarendon
VT 05759-9436 U.S.A.
Tel: 1 (802) 773-8930;
Fax: 1 (802) 773-6993
info@tuttlepublishing.com
www.tuttlepublishing.com

Asia Pacific
Berkeley Books Pte. Ltd.
3 Kallang Sector #04-01
Singapore 349278
Tel: (65) 6741 2178
Fax: (65) 6741 2179
inquiries@periplus.com.sg
www.tuttlepublishing.com

"BOOKS TO SPAN THE EAST AND WEST"

Tuttle Publishing was founded in 1832 in the small New England town of Rutland, Vermont [USA]. Our core values remain as strong today as they were then—to publish best-in-class books which bring people together one page at a time. In 1948, we established a publishing office in Japan—and Tuttle is now a leader in publishing English-language books about the arts, languages and cultures of Asia. The world has become a much smaller place today and Asia's economic and cultural influence has grown. Yet the need for meaningful dialogue and information about this diverse region has never been greater. Over the past seven decades, Tuttle has published thousands of books on subjects ranging from martial arts and paper crafts to language learning and literature—and our talented authors, illustrators, designers and photographers have won many prestigious awards. We welcome you to explore the wealth of information available on Asia at www.tuttlepublishing.com.